DESIGN AND SCIENCE

The Life and Work of WILL BURTIN

DESIGN AND SCIENCE

The Life and Work of

R. Roger Remington and Robert S.P. Fripp

WILL BURTIN

Lund Humphries

Published in 2007 by

Lund Humphries
Gower House
Croft Road
Aldershot
Hampshire
GU11 3HR
and

Lund Humphries
Suite 420
101 Cherry Street
Burlington
VT 05401-4405
USA

Lund Humphries is part of Ashgate Publishing

www.lundhumphries.com

British Library Cataloguing in Publication Data

Remington, R. Roger
 Design and science : the life and work of Will Burtin
 1. Burtin, Will, 1908–72. Graphic design (Typology) –
 United States – History – 20th century 3. Graphic design
 (Typology) – Germany – History – 20th century 4. Designers
 – United States – Biography 5. Designers – Germany –
 Biography
 I. Title II. Fripp, Robert S. P.
 741.6´092

ISBN: 978-0-85331-968-9

Library of Congress Control Number 2007927789

Design and Science: The Life and Work of Will Burtin
© 2007 Lund Humphries
Text © 2007 The Authors

R. Roger Remington and Robert S.P. Fripp have asserted their right under the Copyright,
Designs and Patents Act, 1988 to be identified as the Authors of this Work

For additional information on Will Burtin, please visit
http://library.rit.edu/depts/archives/willburtin

Designed by Chrissie Charlton & Company
Typeset in Monotype Bulmer, Firmin Didot and News Gothic Condensed
Edited by Sue Dickinson
Printed in China by 1010 Printing International Limited

LIST OF CONTENTS

ACKNOWLEDGMENTS

The idea for this book probably took root in the late 1980s, when R. Roger Remington interviewed Cipe Pineles in her Stony Point home. Cipe's first husband, William Golden, died in 1959. Fifteen months later she married Will Burtin, whose wife Hilda died in 1960. Encouraged by her son, Thomas Golden, and her daughter, Carol Burtin Fripp, Cipe bequeathed the accumulated works of three superb American designers to the Graphic Design Archives at the Wallace Library in the Rochester Institute of Technology. With the help of enthusiastic students, Roger, who is the Massimo and Lella Vignelli Distinguished Professor of Design at RIT, loaded the lifetime works of William Golden, Will Burtin and Cipe Pineles into a large rental truck and carted them north to Rochester in 1993. With grant support from The J. Paul Getty Trust, the Burtin Collection was fully catalogued. The largest of the three, it became fully usable in 2007, months before publication of this book.

Meanwhile, Robert Fripp had read the book that Cipe co-edited shortly after Bill Golden died, *The Visual Craft of William Golden* (New York, George Braziller, 1962), and Martha Scotford's *Cipe Pineles: A Life of Design* (New York, W.W. Norton, 1999). Robert considered that publishing the achievements of two out of three was not enough. Will Burtin had to have his own book! – the more so since Robert had met Burtin's daughter Carol in 1961 and corresponded with her across the Atlantic for much of the next four years. Robert and Carol married at the Golden-Pineles-Burtin home in Stony Point in 1965. Their

wedding present from Cipe and Will? Return tickets to Carbondale, Illinois and delegate status at Will Burtin's conference, *Vision 65*. Decades passed. In part a commercial writer, Robert preserves in his computer the first document that would eventually germinate into a collaboration with Roger to create what the authors called for almost a decade "the Burtin Book." That document is dated October 7 1996.

Many people have collaborated with the authors to bring about this book. We acknowledge their help and extend them our gratitude. We express our special appreciation to Mark and Maura Resnick whose generous grant facilitated the publishing of this book.

The first person on our alphabetical list of acknowledgments, William Abbate, was an apprentice at Structural Displays, Inc. when his father ran the company. William Abbate, Sr. supervised fabrication of Burtin's *Uranium Atom* in 1960, and large-scale Plexiglas models of blood vessels for *Defense of Life* a decade later. The last person on this list, Yves Zimmermann, was a student apprenticed at Will Burtin, Inc. in 1956, having been recommended by Emil Ruder and Josef Mueller-Brockmann. Fifteen years later, having established himself in Barcelona, Zimmermann commissioned what would be Burtin's final, perhaps most prescient, essay on roles for design in the science age, *Basta ya!* (Enough!).

We offered the first and final names on this list for description in order to illustrate the enormous range of skills and talents possessed by people whom Will Burtin

consulted, on whom he relied, and whom he touched. In return, we have good reason to know that many people who assisted us feel richer for knowing Will Burtin by reputation; or for having known him in person as teacher, employer, colleague, family member, friend.

R. Roger Remington, Rochester, N.Y./
Robert S. P. Fripp, Toronto, Ontario

William Abbate	Celia Brody Mitchell
Ellen Alers	Howard Mont
Jennifer Bass	Chris Mullen
Jon W. Benjamin	David Pankow
Roger Black	Santo J. Provenzano
Jill Chapman	Barbara and
Ivan Chermayeff	Constantine (Conny)
Mary Condon	Raitzky
Donald Crews	Peter Rauch
Myrna Davis	Kay Reese
Lou Dorfsman	M. Suzanne Remington
Estelle Ellis	Mark and Maura
Don Ervin	Resnick
Ruth Ellowitz	Ann Schirripa
Mark Fletcher	Martha Scotford
Carol Burtin Fripp	Rebecca Simmons
Will Burtin Fripp	Mafalda Spencer
Thomas Golden	Erica Stoller
Betti Broadwater Haft	David A. Sutton
Kari Horowicz	Ruut Van den Hoed
Jill Kepler	Anne-Marie Van de Ven
George Klauber	Massimo and Lella
Burton Kramer	Vignelli
Elizabeth Lamark	Amy Vilz
Mimi Leipzig	Howard Wexler
Arthur Leydin	Yves Zimmermann
Bruce Ian Meader	

1908 Born Cologne, Germany, to August and Gertrud Bürtin (January 27).

1922 Studied typography at Handwerkskammer Köln (1922–26), and graphic and industrial design at the Kölner Werkschulen (from 1926) with Richard Riemerschmied and Jacob Erbar.

1922–26 Apprenticed in typesetting studio of Dr. Philippe Knöll, Cologne, while studying typography and art.

1926 Worked for Knöll on exhibitions at GeSoLei in Dusseldorf.

1927–38 Opened design studio in Cologne, creating booklets, posters, type books, exhibitions, displays, advertising and movies for German, French and other clients.

c. **1930** While teaching in Berlin met art student Hilde Munk.

1932 Married Hilde Munk (1910–1960).

1937 Josef Goebbels asked Burtin to become design director at the Propaganda Ministry. Burtin stalled for time. Hilde Munk Burtin wrote to her cousin Max Munk, requesting his sponsorship into the United States.

1938 Hitler repeated Goebbels' demand that Burtin become Propaganda Ministry's design director. Pressure to accept this post triggered hasty escape to u.s. Entry sponsored by Max Munk, aeronautics pioneer and wind tunnel inventor.

1938 Burtin's first job in u.s. was designing flex O prop logo, trademark of Munk Aeronautical Laboratory. Within months he won contract to design Federal Works Agency Exhibition for u.s. Pavilion at New York World's Fair.

1939 Supervised 80 people to create the Federal Works Agency Exhibition. Designed cover for New York World's Fair issue of *The Architectural Forum* magazine. Established design practice in New York; created advertisements, booklets, magazines, covers and exhibits. Awarded Art Directors' Club medal for cover design.

1940 Designed booklet *Vesalius*, perhaps his first project for The Upjohn Company. Assignments for *Architectural Forum* led to work for other Time-Life titles.

1939–43 Taught communication design at Pratt Institute, New York.

1941 Was awarded Art Directors' Club medal. Designed cover for Upjohn's first *Scope* magazine. Cover featured a "test-tube baby" decades before concept became reality.

1942 *A-D* magazine printed a supplement featuring Burtin's u.s. work between 1938 and 1941. Publication featured first work for The Upjohn Company and *Fortune* magazine. The Burtins' only child, Carol, was born on October 10.

1943–45 Drafted into u.s. Army and assigned to Office of Strategic Services (oss); designed visual presentations of "strategic subjects" at oss. Family moved to Washington, d.c., living with Max Munk and

his twin sister, Thekla. Burtin designed gunnery manuals for U.S. Air Forces' aerial gunners.

1945–49 *Fortune* magazine asked the Army to discharge Burtin; recruited him as art director. His contract permitted freelance work, and assignments for Upjohn and other clients grew in number. He resumed teaching at Pratt. Several awards from the New York Art Directors' Club.

1948 Burtin's exhibition, *Integration: The New Discipline in Design* ran at The Composing Room, New York. Continued major work for The Upjohn Company, Kalamazoo, MI. Burtin began working on a never-completed *The Will Burtin Book*.

1949 Burtin left *Fortune*. Will Burtin Inc. rented offices at 11 West 42 Street. Burtin gave lectures about *Integration: The New Discipline in Design* in several cities, Chicago (Bundscho Library) and Los Angeles (Art Center School) among them. *Graphis* printed "Integration" as an article. Burtin teamed with writer Lawrence Lessing to describe the seminal wartime gunnery manuals project.

1949–71 As design consultant for Upjohn, Burtin and a growing team created new Upjohn text-only logo; replaced Lester Beall as *Scope* magazine designer and occasional editor; unified design of all Upjohn packaging and printed materials. Among the first American designers to propose a unified design concept, Burtin is known as the father of "corporate identity."

c. **1949** Appointed a director, American Institute of Graphic Arts.

1949– Worked as designer and consultant in advertising, industrial and editorial projects for major clients: Eastman Kodak, IBM, Upjohn, the Smithsonian Institution, Mead Paper, Union Carbide, Herman Miller Furniture, George Nelson Design, the U.S. Information Agency, several publishers …

1950 Member of founding group for International Design Conference at Aspen, Colorado.

1950s Taught at Parsons School of Design, New York, as well as at Pratt. Editor of *Architectural Forum* James Marston Fitch appointed Burtin design consultant to the magazine.

1951 Burtin commissioned new family home on South Mountain Road, New City, Rockland County, N.Y. Architect, James Marston Fitch.

1952 Family moved from 13 West 106 Street to 475 South Mountain Road. Traveled with family to Ecuador on assignment for client Life Farmaceuticos. Family visited war-displaced Munk family members in Argentina, Brazil and Uruguay.

1954 *Print* magazine featured Burtin and his work for Upjohn: "A Program in Print: Upjohn and Design."

1955 Served with Saul Bass as program co-chair and speaker at International Design Conference, Aspen, Colorado. Was awarded Art Directors' Club medal.

c. **1955** Will Burtin Inc. moved to 132 East 58 Street. Was active in the American Institute of Graphic Arts (AIGA).

1956 Program chairman (with Bass again) of AIGA conference at Aspen.

1957 Began design of a walk-in *Cell* exhibit for Upjohn. Designed traveling exhibit *Kalamazoo – Window on America* for the U.S. Information Agency. Exhibit was shown in several British cities. USIA requested a version for Germany.

1958 The *Cell* exhibit opened at the American Medical Association convention. The *Cell* gained wide national and international attention. The AMA awarded Burtin its Gold Medal; the Art Directors' Club awarded a medal. Burtin chaired the First World Seminar on Typography at Silvermine. Designed the "Upjohn Pharmacy" exhibit for Disneyland. The German version of the Kalamazoo exhibit drew record crowds in Berlin. Will and Hilda Burtin saw the new Helvetica font in Zurich, returning to New York with sample sheets.

1959 Pratt Institute named Burtin professor and chair of Department of Visual Communications. He organized and chaired *Typography USA* conference, New York. The *Cell* exhibit arrived in London to become a television set for two BBC science specials, *What is Life?* Shell Oil filmed it at BBC and dedicated the film to the Royal Society. The *Cell* traveled to Edinburgh.

1960 Burtin's massive *Brain* exhibition for Upjohn anticipated "multimedia" by 30 years. Upjohn exhibited the *Brain* in its home town, Kalamazoo, MI. Hilda Munk Burtin died on October 10, her daughter's 18th birthday.

1961 Burtin's massive *Uranium Atom* exhibit opened in the lobby of the new Union Carbide building on Park Avenue. Burtin married art director and long-time family friend Cipe Pineles, widow of CBS art director William Golden. Will and Carol Burtin moved to Pineles' home in Stony Point, New York. The *Brain* exhibit toured major cities in Europe, including the USA Pavilion of *Italia 61* in Turin, where Carol Burtin accompanied the *Brain* as a guide. The U.S. Information Agency shipped elements of the *Brain* exhibit to Moscow for display.

1962 Burtin designed a spread in *Comment 200* publication using Ezra Stoller's time-lapse photography from the Union Carbide Atom. Burtin's touring exhibit *Visual Aspects of Science* and booklet featured work for four major clients: Kodak, IBM, Upjohn, Union Carbide. Burtin's friend Willem Sandberg enabled the *Cell* and *Brain* exhibits to visit Amsterdam. Presentations also in London, Paris and Brussels. Burtin designed a proposal for Chrysler's exhibit at upcoming New York World's Fair.

1963 Burtin designed a large-scale *Metabolism* exhibit for Upjohn. The Royal College of Art, London, hosted an exhibition of his works.

1964 Will Burtin Inc. designed the Eastman Kodak pavilion and exhibit at New York World's Fair, with film and slide show by Saul Bass and Sy Wexler. Designed the Abraham Lincoln exhibit for the Fair's Illinois State Pavilion, with film by Saul Bass. The *Brain* exhibit featured in New York State's pavilion, and a multiple-projector slide show in the Hall of Sciences.

1965 Burtin organized, chaired his *Vision 65* conference at Southern Illinois University. Futurist Buckminster Fuller served as consultant, inviting the conference to

his SIU campus. Will Burtin, Inc. designed and fitted a large-scale exhibit for Brunswick Corporation in Chicago. Burtin's essay, "Design and Communication", was published in *Education of Vision*, for the Vision+Value Series, Gyorgy Kepes (ed.). Burtin proposed a pavilion for IBM at Montreal's Expo '67.

1966 Will Burtin, Inc. designed *The Pantheon Story of Mathematics for Young People* entirely in Helvetica. Upjohn released Burtin's *Genes in Action* exhibit (aka The Chromosome Puff) at the AMA convention. *Life* magazine (July 8) featured "Walk-in Portrait of a Gene at Work" about Burtin exhibits, including *Genes in Action*.

1967 Burtin organized and chaired his *Vision 67* conference at New York University. *Genes in Action* transformed into *Heredity and You* for display to a lay audience in lobby of Time-Life building in New York.

1968 Will Burtin, Inc. developed signage for the University Circle Development Foundation, Cleveland, Ohio. The studio began work on his final major exhibition for Upjohn, *Defense of Life*.

1969 *Defense of Life* opened at the AMA convention in New York's Coliseum, with a film produced by Sy Wexler. Burtin designed *Defense of Life* booklets and related materials.

1970 The AIGA awarded Burtin a solo exhibit for the following year. He proposed, and won, preliminary acceptance for an exhibition called *The Biosphere*, for the United Nations Conference on the Human Environment (the Earth Summit), in Stockholm, 1972. Former employee Yves Zimmermann asked Burtin to contribute keynote article for first edition (1971) of Spanish-language periodical, *Documentos de comunicación visual*.

1971 Burtin's article, *Basta ya!* published in Spanish. Harvard University appointed him Research Fellow in Visual and Environmental Studies at its Carpenter Center. The Alliance Graphique Internationale elected him President, American Sector. The American Institute of Graphic Arts awarded him its medal. In demand as a speaker, he addressed *The Roving Eye and the Constant Image* conference, in Chicago. His one-man exhibition for the AIGA, *The Communication of Knowledge*, opened in New York. He continued teaching at Pratt. A change of client, and Burtin's failing health, effectively cancelled his *Biosphere* project for the U.N.

1972 Will Burtin died on January 18, in Mount Sinai Hospital, New York. Saul Bass gave the eulogy at a memorial gathering in New York (January 28). In September, the United States Embassy in London hosted a two-week long memorial exhibition. The Cleveland Health Museum and Education Center took the *Cell, Defense of Life*, the *Brain* and the *Chromosome Puff* as permanent exhibits.

1973 Cipe Pineles adopted Carol Burtin Fripp.

1980 *The Journal of Typographics* (March, Vol. 7, No. 1) published an illustrated profile of "'graphic innovator' Will Burtin."

1985 Burtin's work was placed on display at the "*Fortune*'s America" exhibition, in the University of East Anglia Library.

1986 "*Fortune*'s America" toured, displayed in the Bevier Gallery at Rochester Institute of Technology.

1989 R. Roger Remington and Dr. Barbara Hodik included a chapter about Burtin in *Nine Pioneers in American Graphic Design*, MIT Press. Chris Mullen developed a *Fortune* magazine database in the U.K. as a learning resource at the University of Brighton. Mullen also sponsored annual editorial design projects, many inspired by Burtin's work.

1993 The Rochester Institute of Technology received the Burtin Archive into the Wallace Library (along with the archives of Cipe Pineles and her first husband, William Golden).

1995–2005 Chris Mullen administered a Ph.D. program at University of Brighton. Graduate Jackie Batey wrote her thesis "The Safe Cigarette" inspired by Burtin's *Fortune* magazine piece, "The American Bazaar."

1997 Rochester Institute of Technology presented Burtin's life and work as major case study in an on-line course, "20th Century Information Design".

1998 R. Roger Remington and Robert Fripp, Burtin's son-in-law, proposed a Burtin monograph, *Design and Science: The Life and Work of Will Burtin*.

2005 R. Roger Remington wrote a case study article on the Burtin *Brain* exhibit, "Document Design," published in *Information Design Journal*.

2006 A Getty Foundation grant facilitated archival organization and rehousing of Burtin collection at Rochester Institute of Technology. Chapbook *Will Burtin and the Display of Knowledge* proposed for publication by Cary Graphic Arts Press, Rochester Institute of Technology.

2007 Lund Humphries, London, published *Design and Science: The Life and Work of Will Burtin*.

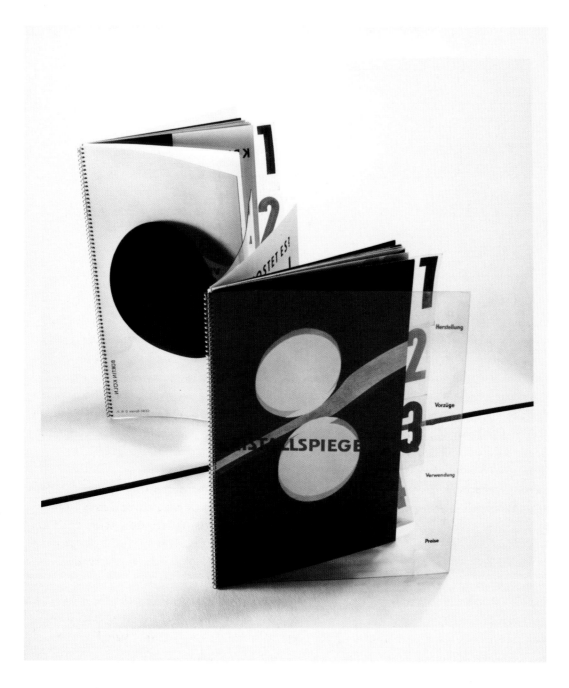

Figure 1
The spiral-bound *Kristallspiegelglas* (20.5cm x 15cm) from the late 1920s
uses unusual materials. Acetate covers and tabbed pages provide a high-
tech look and tactile contrast between acetate and paper. Integrating
photographs and typography is novel, as is Burtin's use of sans serif fonts,
contradictory type directions and photomontages combining
silhouetted images with full tone photographs.

1

LAUNCHING A CAREER: THE GERMAN YEARS

To step off a steamer at the Battery and, three years later, to walk off with the [New York] Art Directors' Club Gold Medal is a capsule American biography of Will Burtin.[1]

Will Burtin was born in Ehrenfeld, a suburb of Cologne, on January 27 1908. August and Gertrud Bürtin gave their first child and only son a name to live up to: they named him for Kaiser Wilhelm. Will Burtin more than lived up to his parents' hopes. His career of more than forty years made him an internationally renowned name in graphic design, a leader in exhibition design and a pioneer in the visualization of scientific concepts.

Burtin's reign of influence spans the middle decades of the twentieth century. He established his reputation in Germany through the dismal years of the late 1920s, the Depression-era 1930s and the rise of Nazi power. After fleeing to the United States with a Jewish wife and little English in the summer of 1938, he rapidly acquired another reputation for excellence in his adopted country. The mid-point of Will Burtin's professional life pivots around the very center of his century, the year 1950. He would have liked that observation: he was in most respects a product of German precision.

In 1908, Köln-Ehrenfeld was a working town. Money and influence lay farther east, around the Hohestrasse and the cathedral, the Kölner Dom, close to the prosperity unleashed along the broad, flowing body of the Rhine. Köln-Ehrenfeld generated the products, the cinders and smoke of the industrial Ruhr. Sometimes the air could smell sweet: Ehrenfeld is still home to the factory that makes 4711, das echt Kölnisch Wasser, the original eau-de-Cologne.

Will Burtin's father, August Bürtin, has been variously described in books and articles about his son as an industrial worker, a glass-blower and a chemist. Part of his job entailed blowing glassware for the chemical laboratory in the rubber factory where he worked.

Gertrud *née* Sieger Bürtin bore three more children, all girls, kept house and stretched the family's food rations through the privations of the First World War and the dismal decades that followed.

The children had a religious upbringing. As the only son, Will Burtin had the "misfortune" (as he put it decades later) of being "eligible" by virtue of his gender to perform the duties of an altar-boy at Gereonskirche, the church of St Gereon, one of Cologne's patron saints. The boy's duties involved setting out at five

o'clock in the morning to walk to the church, lighting candles in the often freezing chancel, then walking home after mass in time to go to school. Paying to ride the streetcar to perform these sacred duties was beyond the family's means. His time as an altar-boy cured him of religion.

Burtin's education was interrupted in the First World War when the German army commandeered his primary school for use as a cavalry barracks. His lack of formal education would influence the rest of his life, but not in a negative sense. Indeed, when one looks back over his career, one sees that the practical effects of this privation were positive. His lack of schooling spurred him to learn, often from those at the pinnacle of their professions: from typesetter and mentor Dr. Philippe Knöll in Cologne; from Albert Einstein at Princeton; from neurologist Dr. Wilder Penfield at McGill University; from futurists Buckminster Fuller and IBM's Bruce MacKenzie; from a principal client and friend, Dr. Garrard Macleod, of Upjohn Pharmaceuticals.

Burtin developed an extraordinary ability to learn intuitively – on the spot, on the job, in a client's laboratory – wherever, whenever, whatever he needed to learn. He devoted much of his professional life to translating the latest research in pharmacology, microbiology, biochemistry and nuclear physics into publications, graphics, exhibitions and films for medical and scientific audiences and the public. "Bacteriology, a subject which would baffle most artists, only stimulated [Burtin] into exhaustive investigation."[2]

Burtin never graduated from the German equivalent of high school. At the age of 14 he enrolled in a grueling four-year apprenticeship in typography – *Schriftsetzer Handwerk* – at the Handwerkskammer Köln. His graduation certificate states that "Apprentice Wilhelm Bürtin" studied there from April 1 1922 to March 31 1926. Exactly four years. Not one day more, not one day less. At the bottom of his certificate, three undoubtedly distinguished, but illegible, signatories bear witness to

the excellence of their student, while the imprint of the school's rubber stamp bangs down, precisely aligned beside them, to affirm their verdict. *Lehrling* (Apprentice) Wilhelm Bürtin is passed, pronounced *gut*, and shown the door.

Germany teeters between hyperinflation and a world-wide depression while its government struggles to meet crippling reparation payments to the victorious Allies. The old, predictable order is dead; Kaiser Wilhelm and the Prussian mindset, gone. The word 'army' attains a new meaning: it refers to the legions of the unemployed, to food riots and street battles between factions on the left (newly triumphant in Russia), and the right, resurgent in a populist and ultimately virulent German form. Will Burtin is 18 years old and out on his own, diploma in hand, to thrive or to fail.

The name Dr. Philippe Knöll features prominently in Burtin's early years, both during and after his formal training. Since the early nineteenth century the German educational system has interwoven classwork with industrial apprenticeships. Dr. Knöll put Burtin to work in his typesetting shop during and after the apprentice-ship at Handwerkskammer Köln. In fact, Dr. Knöll ensured that his promising protégé took evening courses in graphic design at the Cologne Werkschulen. Where typography demanded extreme precision, graphic design encouraged freedom of expression. Burtin became fluent in both, and at integrating both. Until the end of his life he acknowledged his debt of gratitude to and affection for Dr. Knöll.

In 1926, Dusseldorf's *GeSoLei* exhibition, dedicated to healthcare, social welfare and physical exercise, was "the event of the year" that "brought every man, woman and child in Dusseldorf to their feet."[3] Preparations for *GeSoLei* kept apprentice typesetter Burtin busy. One hundred and fifty pavilions featured exhibits on contemporary diet, agriculture, the improving quality of post-war life, industrial discoveries and the fight against diseases such as tuberculosis and smallpox. Purpose-

built stone buildings were monumental, the better to advertise Dusseldorf and serve as exemplars for new building styles. (Several survive as the NRW-Forum, an art gallery, a concert hall and the Rhine Terrace.) The scope and scale of *GeSoLei* were indelible models for the young Will Burtin. Much that he achieved in his second, American, career in graphics and exhibition design he took from the agenda and the impressive scale of *GeSoLei*.

After 1927, Burtin was also working independently, opening a design studio to produce product brochures, exhibits, posters and catalogs (Figure 2). A surviving catalog, spiral-bound in fine wire, offers drainage and industrial pipes and fittings – building supplies – in an easy-to-reference format, with specification tables.[4] The format suggests that he designed the booklet to fit the coat pockets of site engineers. A die-cut peephole in the front cover reveals two words, *Einst/Jetzt* (You once got …/ Now you can have …). A reader follows the die-cut aperture to open the book to the chosen page (Figure 3).

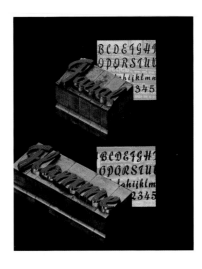

Figure 2
Burtin designed this *Fanal Flamme*-type specimen brochure for Schelter and Giesecke AG, announcing a new font.

Figure 3
Einst/Jetzt ("You used to get …/Now you can have …") A historical survey of building pipes leads into a new-product catalog. This 30cm x 22cm catalog from the early 1930s shows Burtin's interest in experimental printing materials and techniques. Die-cut windows in a metallic paper cover let readers preview contents.

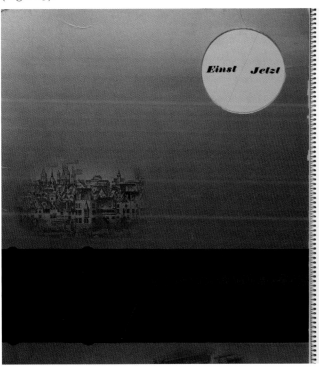

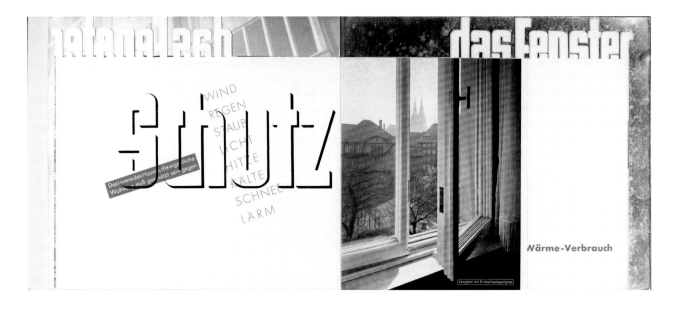

Figure 4
Sie Wollen Bauen! ("So you want to build!"). Small (17.5cm x 20cm) and unusual in a nearly square format, this booklet for a glass company shows Burtin's graphical experimentation, giving readers an interactive experience. Burtin runs typography at angles while dramatically cropping photographs. Avant-garde influences mark his formative years.

Burtin's 1931 brochure for the German Association of Glass and Mirror Manufacturers (*Spiegelglas*) conveys an instant sense of transparency. The front cover, as well as section-break and page-tab pages, are printed on clear celluloid. (Acetate came later.) His innovative designs soon attracted other clients who made products in glass and demanded a sense of light and clarity (Figure 1).

His brochure, *Sie Wollen Bauen!* ("So you want to build!"), makes the same point in different ways. The words are die-cut into the front cover so that a reader must open the book to get more than a glimpse of the photomontage behind the mask (Figure 4). The words *das Fenster* (the window) are die-cut as if forming a tab across the tops of the following pages, an effect suggesting actual depth. Finally, the inside back cover is full size, silvered to reflect back the die-cut words from

the rest of the book. To pick up this brochure is to be led, without conscious resistance, from front to back.

The brochure contains a product shot of a window, a vertically hinged, slightly open, double-glazed casement. This window from 1930 looks as if it might meet modern standards. Indeed, the word *wärme* (warmth) stresses effective insulation. But the set-up introduces more than practical excellence: it suggests a supernal quality, that of a spiritual light beyond the glass. What we see beyond the open window is something Burtin could easily have shown us *through* the glass. Instead, framed in the space *between* the open halves of the window, distant but distinct, rise the twin towers and spires of Cologne Cathedral.

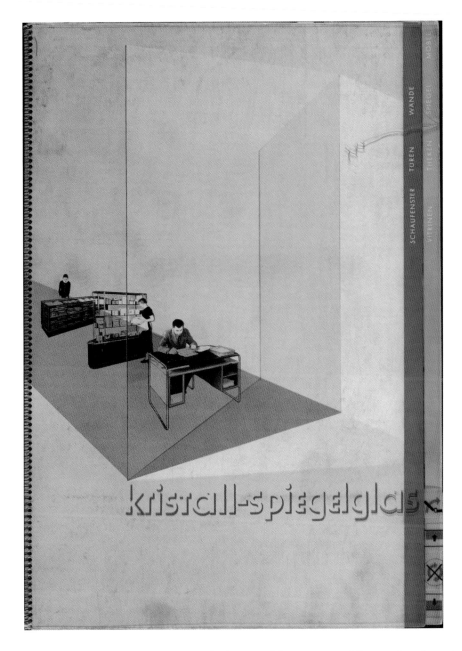

Figure 5
Kristall-spiegelglas (crystal-mirror glass) is large-format, 29.5cm x 22cm. Like other Burtin catalogs of the late 1920s, it features tabbed sections for fast reference. Printed on clear acetate (now opaque) the cover simulates clear glass.

Burtin's success with information design won him a contract to produce another product catalog, *Glass in Building: Technical Potentials* (Figure 5). The book lists manufacturers and their products, ending with a section for advertisements. These strike an informative contrast between Burtin's innovation, clarity and font selections, and the traditional look of "camera-ready" supplied by advertisers.

These printed products from Germany in the 1930s are marked by generous leading and even more generous margins. In a decade of biting austerity, one imagines Burtin struggling to convince hard-nosed clients that the aesthetic value of white space would somehow translate into sales.

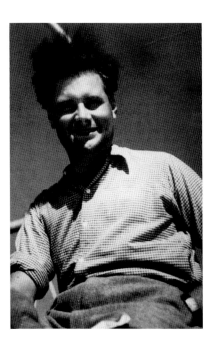

Figure 6
Burtin in Germany,
1936.
Photo by Hilde Burtin.

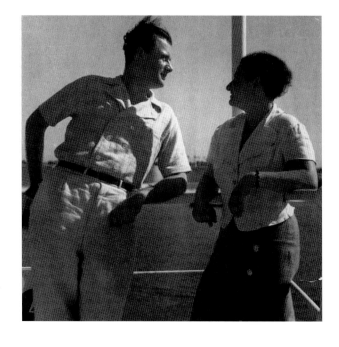

Figure 7 (right)
Will and Hilde Burtin,
c.1932,
on a holiday cruise.

His surviving products from Germany indicate that, while the Bauhaus (literally "house building") movement was creating simplicity of form on the ground, Burtin was striving for equivalent clarity in exhibits and on paper. He was bringing to industrial graphics the components so crucial to the Bauhaus era. In this he was guided by precedent: as early as 1902, after an "industry, trade and art exhibition" in Dusseldorf, attended by the Kaiser, an editorial in the *General-Anzeiger* had commented: "Industry has helped art into the saddle. Now let us see if she can ride."[5] In Burtin's hands, art followed industry's example, and proved she could certainly ride.

Barely out of school himself, after 1930 Burtin taught in Berlin, where one of his students was Hilde Munk. They married in 1932, Hilde becoming a partner in Entwurfe Bürtin (Designs by Burtin), based in Cologne (Figures 6 and 7).

Hilde Munk was born and raised at the opposite end of German-speaking Europe, in the East Prussian town of Osteröde (now Ostrode, in Poland). Her specialties

were photography and illustration. (Their daughter, Carol, recalls watching her mother draw the Disney character Pluto fluently, in seconds. Hilde had worked for Disney in Berlin.) But it was mainly as a photographer that Hilde advanced Entwurfe Bürtin. She may have taken the product shot in *Sie Wollen Bauen!* through the window. She certainly took the photos for an English-language trade-show hand-out promoting Walt Busch & Son Razor (Figure 8) (complete with ampersand). Four folding panels capture close-ups of a youthful, smiling Will Burtin, his face lathered with soap as he shaves his cheek with a Walt Busch & Son safety razor.

The dummy for the Busch & Son handout suggests that his partnership with Hilde brought a note of whimsy to Will Burtin's work, if not his character. The sunny mood is similar in two adverts assembled behind celluloid, for St. Maurice wine. In one panel the designer's laughing father, August, poses in his Sunday suit, with waistcoat, pocket-watch and chain. He holds his right arm aloft, his fingers cupped as if holding the large bottle of wine that Burtin has air-brushed into his

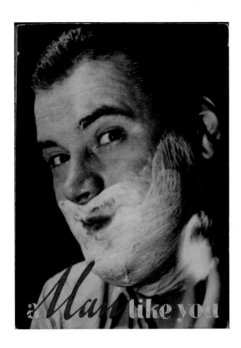

Figure 8
Burtin created an English-language "a man like you" promotion for Walt Busch und Sohn. A prototype sketch indicates type over photos by Hilde Burtin of Burtin shaving. Accordion-fold format, 15.5cm x 11cm.

Figure 9
Burtin's sister Leni, Burtin himself, and his father August Burtin pose for Hilde Burtin in St. Maurice wine posters. Burtin airbrushed the bottles. Aged acetate adds an unintended opaque effect.

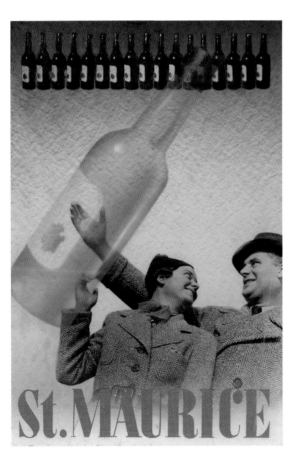

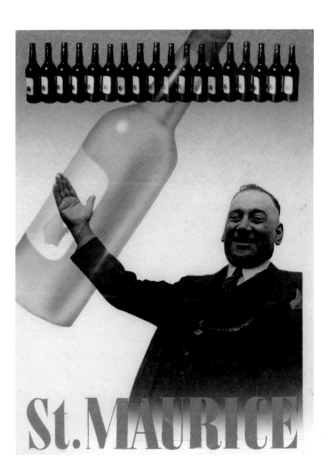

hand. The other advert is similar, except that the two happy people supporting the bottle are Burtin himself and his sister, Leni (Figure 9).

Will Burtin might have remained among the leaders of Germany's graphic and typographic avant-garde. Still in his twenties, he was already achieving iconic status in his native land. But the rise of Nazi power intervened.

Hilde's parents, Ernst and Selma Munk, owned a small department store in Osteröde. Ernst was planning to retire and enjoy a more cultured milieu. His comment to Selma, "When one of us dies, I'll move to Berlin," remains a wry family joke. But Ernst was not destined to retire. The Nazis seized the store and he was fortunate to die of natural causes: he suffered a heart attack. It was Selma who moved for a time to Berlin.

Propaganda was crucial to the Nazi cause. Party leaders, aware that the British had won every battle for public opinion in the 1914–18 war, were determined not to repeat the mistake. This had the unfortunate effect of bringing Entwurfe Bürtin to the party's attention. Designs and brochures emerging from the Burtins' studio were light-years ahead of the old gothic (*fraktur*) fonts and humorless "worker realism" style. Nazi officials began asking Burtin to work for the cause, while trying to persuade him to divorce his Jewish wife.

A decade later, safe on a post-war beach at Fire Island, New York, Burtin confided to Celia Brody – among the Burtins' first and firmest friends in the United States – that walking in Berlin with a Jewish wife and mother-in-law had been nerve-wracking. In 1946, as they sat in bathing suits on the beach at Robin's Rest, he attempted to explain the rash on his arms and his back: "He was always in a very anxious state, being seen in public with them," Celia Brody recalled. Just thinking back to his days with Hilde in Nazi Germany could still bring him out in a rash.

Burtin's Catholic family in Cologne fared better than his Jewish in-laws in East Prussia. Cologne had long been an international city, receptive since its days as a Roman colony to the liberating influence of traffic on the Rhine.

Nevertheless, the climate of anti-Semitism was taking hold. A devout Catholic, Gertrud Bürtin received regular visits from her priest until he ventured to suggest that her son had made an inappropriate marriage to a Jew. The discussion ended with Frau Bürtin chasing the priest towards the main street, Venloerstrasse, brandishing a skillet.

Then there was Christa. The youngest of Gertrud's three daughters, Christa Bürtin was mildly retarded. She did not meet Nazi standards for the master race. One day she disappeared from a hospital, never to be seen again.

Burtin was able to reject early Nazi attempts to retain his services: he claimed he was always too busy. However, in 1937, Nazi Propaganda Minister Josef Goebbels made an official request for Burtin to become the Ministry's director of design. The rise of the Thousand-year Reich would be documented: on film by Leni Riefenstahl; in graphics and print by a team to be led by Will Burtin. Burtin stalled for time, pleading business pressures from his many private clients.[6]

Hilde Burtin took advantage of this delay to write an urgent appeal to her cousin, Max Munk, in Maryland, asking him to sponsor the couple's immigration into the United States.

Dr. Max M. Munk was a brilliant engineer and mathematician who had studied under the renowned Ludwig Prandtl at the University of Göttingen. Munk had worked for Graf Zeppelin on wartime airships. In his own right, Max Munk invented the wind-tunnel. The U.S. military recruited him after the First World War. Since 1921 he had been living in Cottage City, Maryland with his twin sister, Thekla, and their mother.

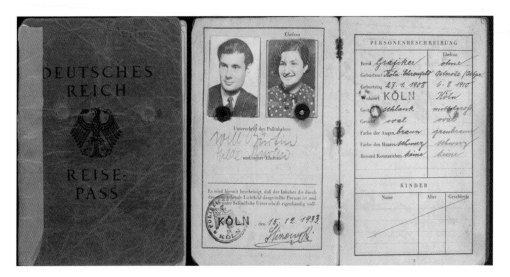

Figure 10
Will's and Hilde Burtin's German passport, 1933.

Munk responded to Hilde's letter by sending an affidavit, dated November 15 1937, sworn in Washington, D.C., "for the purpose of inducing the United States Consular authorities to grant [Will and Hilde Burtin] a visa." His affidavit states that he

> is a citizen of the United States; … that he is an aviation scientist, employed as a university professor, and engaged in the business of an aviation expert and patent attorney; … that his average weekly income is $100.- or more; that he owns unencumbered property to the value of $40,000.- or more; that he is a First Cousin of Hilde Burtin, nee Munk; that Will Burtin … and Hilde Burtin … desire to immigrate into the United States; … that he is most anxious to have them admitted as immigrants, and … he hereby promises and guarantees, that he will receive and take care of said relatives … and will at no time allow them to become public charges to any political subdivision of the United States.

In Germany, meanwhile, Burtin was summoned again to Berlin, this time to meet Adolf Hitler. Pressed again to lead the design team at the propaganda ministry, Burtin mentioned that his wife was Jewish, an excuse that seemed certain to disqualify him from holding a senior position in the Third Reich. Hitler replied that

that posed no obstacle: Göring's wife was Jewish, too. Burtin's first assignment would be to create an exhibit projecting the impacts of Nazi culture.[7]

Playing for time, Burtin replied that the Führer's invitation was an honor that he, Burtin, needed to consider. If the Führer would permit him and his wife a short ocean cruise, he would be more rested, more able to think things through … .

Will and Hilde Burtin decided that under no circumstances could Will work for the Nazis. They booked their passage, packed one small bag each – "One of the last things Will packed when he left Germany was a specimen sheet of the type Firmin Didot"[8] – abandoned everything else and fled their flat at 50 Balthasar Strasse. All that mattered was getting out of Germany.

The Burtins had traveled widely since being issued a joint passport (Figure 10) on December 15 1933. It contains a dense cluster of stamps: business had taken them as far as Romania; vacations, to a preferred destination, Lake Como. They were fortunate that their passport was issued before Nazi regulations required *Jude* - Jew - to be stamped beneath Hilde's name.

Now, in the summer of 1938, they were fleeing Germany. But, to reach their ship at Rotterdam, they had to leave Germany through passport control. Years later, the Burtins told Celia Brody what happened that day.

> Will, who could look like a Prussian general [he was 1.95m tall; 6 ft 4in], stood in front with the couple's passport, while Hilde [1.54m; 5ft 2in] stood behind him. Will had convinced the Germans that he was working for Germany on designs for the 1939 New York World's Fair. And they were trying to get him to divorce Hilde. At one point he kind of indicated that he would leave her there [abandon Hilde in the U.S.] and come back by himself. And they bought it!

> And you know, Will is not a talkative person. But he maintains a conversation with this young man, telling him he's going to the World's Fair site, and telling him what he's going to do for Germany. And this guy is stamping the book while he's talking … and didn't even question him. Hilde was not even in the man's line of sight because she was standing behind Will.

Burtin's reputation had preceded him to the U.S. in the widely read pages of *Gebrauchsgraphik*. He had American contacts with whom he might have discussed the upcoming World's Fair. The Burtins had even drawn mock plans for a proposed German pavilion and exhibits, for no other reason than to get them through passport control. The couple certainly had an unassailable exit visa, a note from Hitler which they had to hand over. Whatever happened that day, their shared experience became a trauma that lasted for years. But they were allowed back on the train to travel through Holland to board their ship.

Not long after they fled Cologne, the elder of Burtin's surviving sisters bicycled to their flat at 50 Balthasar Strasse to see what she could rescue. Then in her late teens, Rosa saw police at the door. She didn't stop. She pedaled around the block and cycled home.

On July 13 1938, Will and Hilde Burtin disembarked from the steamship *Statendam* in the Port of New York. There, they were photographed and issued with dated Immigrant Identification cards. Will's card survives. The photo taken that day shows no sense of relief. His prevailing emotion, worry, is etched into his face. Nevertheless, they had arrived.

FORTUNATE: FROM "FLEX O PROP" TO GUNNERY MANUALS

Will Burtin's first task in the United States was to create a logo for the man who had sponsored the couple's entry to the country. Max Munk's affidavit had enabled the couple's escape from Germany: they missed *Kristallnacht*, the Nazis' formal declaration of war on Jews, by four months.

Born in 1890, Max M. Munk, Ph.D. was 20 years older than his cousin, Hilde. The fact that German authorities had classified his work during the Great War only made him more desirable to the Americans. Between the wars he held two jobs: as chief aerodynamicist to the National Advisory Committee for Aeronautics (NACA, which became NASA in 1958); and as a professor at the Catholic University of America, in Washington.[1]

Munk is remembered for developing the wind-tunnel. Propeller-driven air currents powered his first models. He pressurized his later designs. By the time the Burtins stepped off the *Statendam*, Cousin Max was working on problems involving torsion in airscrews, as the increasing weight of aircraft was fueling a drive for new technology. The Munk Aeronautical Laboratory needed a trademark to market its "flex O prop" technology. Will Burtin designed it (Figure 11).

From Maryland the Burtins moved to New York, dropping the umlaut and changing Hilde's name to Hilda.

"Burtin has been more fortunate than many another talented newcomer to the U.S.," wrote Howard Myers, introducing *A/D Presents: Will Burtin*, a supplement published with the February–March edition of *A/D* magazine in 1942 (Figure 12).

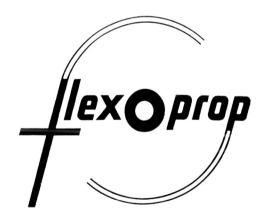

Figure 11
Burtin designed the "flex O prop" identity mark for Hilde's cousin, Max M. Munk, and his Munk Aeronautical Laboratory (1938). Burtin later ran this logo, his first commission in the U.S., in *Seven Designers Look at Trademark Design* (ed. E. Jacobson) 1952.

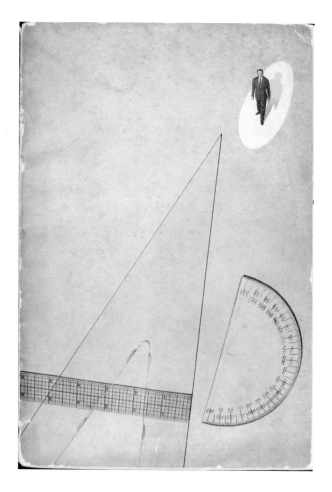

Figure 12
Dr. Leslie sponsored a 32-page insert, *A/D presents: Will Burtin*, in *A/D* magazine, 1942, giving Burtin visibility in New York's graphics and advertising worlds. His cover shines a spotlight on a miniature photograph of himself, while a triangle, ruler and protractor combine to form letters A–D.

That Burtin was fortunate – blessed and lucky might have been more apt – owed much to the fact that he met Bob Leslie soon after reaching New York. Leslie was that rarest of men, a natural "networker" who knew everyone in or connected with his field, and made a point of discovering anyone he hadn't met. Immigrants and newcomers were his special delight: he managed to help almost everyone who crossed his path – among them, Will and Hilda Burtin.

Born in New York in 1885, Robert L. Leslie had, like Burtin, begun working for a printer at the age of 14. In 1900, at 15, he enrolled at City College of New York while working a four-year apprenticeship to De Vinne Press. Twelve years of varied experience later he earned an M.D. degree from Johns Hopkins, having paid his way by working as a proofreader at the *Baltimore Sun*. In 1921 he became a partner with typesetter Sol Cantor; and in 1927 Leslie and Cantor established The Composing Room, Inc., intending it to be the best typesetting shop in New York. As it grew, The Composing Room sponsored related activities, giving courses in graphic arts, and publishing a printer's journal, *PM*. After Germany's *Gebrauchsgraphik* stopped publishing in 1934, The Composing Room created *A/D* ("Art Director") magazine to fill the gap. Then came the A/D Gallery, established in The Composing Room offices to show the work of young or immigrant artists and designers.

Apart from giving Will Burtin commercial contacts, Bob Leslie introduced the Burtins to their future social circle. Celia Brody was a close personal friend of Leslie and his wife, Dr. Sarah Greenberg, the only woman doctor at the Brooklyn Hospital, and Celia's obstetrician.[2] Celia remembers a phone call in the fall of 1938:

> Bob called and told me about Will and Hilda, and he thought that we would be very good friends, but that they didn't know anybody in New York. And so we were the first people they met. And we introduced them to all the people who later remained their close friends: the Levys [artists Edgar and Lucille Corcos Levy]; the Fitches [James Marston and Cleo Rickman Fitch]; [artist] Dorothy Dehner and her husband, [sculptor] David Smith.

Before long, the Levys introduced the Burtins to Cipe Pineles, then an artist at *Vogue*, and her future husband, William Golden, who had moved from Condé Nast to CBS. This nucleus of friends was destined to last until death did them part.

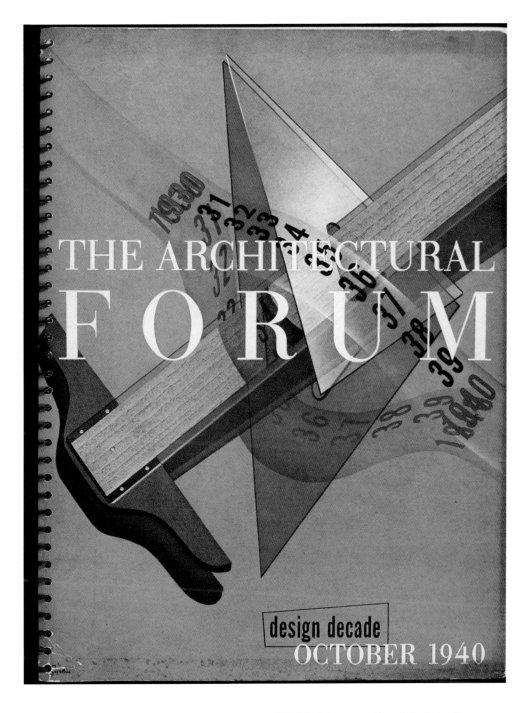

Figure 13
The Architectural Forum (October 1940) featured the "design decade" of the 1930s, stating that "the decade just closed, nearly two hundred years after the Industrial Revolution, has for the first time shown a substantial accomplishment in relating machine inspired design to a machine inspired way of life." Burtin's cover combines design tools with a transparent overlay marking the decade's years. Interior spreads show Burtin at his best. They flow from page to page and spread to spread, showing design progressing through the 1930s. Included in his *A/D* insert, this cover won the 1941 Art Directors' Club award.

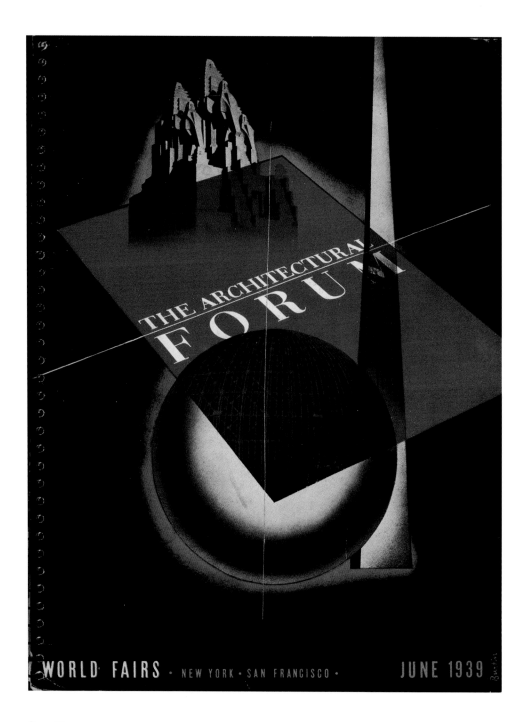

Figure 14
The Architectural Forum explored New York and San
Francisco World Fairs, both held in 1939. Burtin's signed
cover combines the two fairs' symbols. Inside, black-and-
white spreads feature Fair buildings.

James Marston Fitch was an editor on *The Architectural Forum*, and Burtin was soon designing a series of double spreads. One such spread, "The Skyline of the U.S.," features a collage of high-rise buildings. They form a metropolis stretching from coast to coast across an outline map of the continental United States. The buildings sit on a horizontal baseline that forms an equator across the landscape-format paper. The composition leads the eye to the right, and down the natural pointer provided by the Florida panhandle. Here, a block of text balances the graphic images in the upper half of the paper. Generous leading manipulates the block of text into a square, giving it definition and authority. The text invites readers to subscribe:

> First through the doors of most notable new buildings are FORUM photographers, researchers and writers. Even the stay-at-home is a seasoned traveler via his FORUM subscription … See architectural America every month in THE ARCHITECTURAL FORUM.

Among those "FORUM photographers" was Ezra Stoller. Over the next thirty-one years, Stoller would take perhaps the majority of the photographs for Burtin's layouts, exhibitions and large-scale medical and scientific models.[3]

In 1940, "Skyline" won Burtin the National Industrial Advertisers Association Award. His growing body of work for *The Architectural Forum* allowed him to build his New York portfolio. The Burtins had had to abandon much of their German portfolio in Cologne: fortunately, *Gebrauchsgraphik*, which was widely known by New York designers, had published examples of that work. Covers and spreads for *Architectural Forum* helped pay the rent on a single room, into which Hilda had smuggled an illegal hotplate, so they could cook. Celia Brody recalls a night when the Burtins were down to their last five dollars. They ventured one dollar on tickets to a bingo game, and won fifteen –"a fortune!" Celia's choice of words was prophetic: Burtin would become the art director for *Fortune* magazine – five

years later. It was winning the 1941 Art Directors' Club Gold Medal for his *Architectural Forum* cover [4] (Figures 13 and 14) that brought Will Burtin to the minds and Rolodexes of those who could give him work.

Also in 1941, The Upjohn Company, a pharmaceutical manufacturer, launched a monthly magazine targeted at doctors, called *Scope*. The mandate of *Scope* was to explain the latest medical research, to report advances in diagnosis and treatment – and to advertise Upjohn's prescription drugs. The designer selected to create the cover for the first edition: Will Burtin (Figure 15).

His approach to this important cover is technically similar to his posters for St. Maurice wine. A black-and-white photo of a male hand combines with a compound illustration. It's not his father's hand, this time; it's his, in a photo taken by Stoller. The greytone photo draws the eye to the illustration, a bright rectangle in which a naked baby sits on a leaf while reaching for a butterfly. The effect of putting the illustration behind a test-tube places the baby inside the glass. A test-tube baby! Burtin's seminal graphic expressed that concept as a work of art 37 years before the phrase took form in words.

> The task was to design a new magazine for [Upjohn] which would at once link the character of the advertiser with the nature of the pharmaceutical business and its scientific background … A human hand holding a test tube was an immediate, almost telegraphic symbol of science … [V]arious symbols were placed in or behind the test tube – a herbal leaf, a flower, a da Vinci infant. The result was a symbol, simple in its effect and memorable, which threw open again the whole panorama and function of the medical and pharmaceutical sciences.[5]

The symbol did indeed throw open the "panorama and function of the medical and pharmaceutical sciences," although Burtin would not live to read about the *in vitro* birth of the world's first "test-tube baby," Louise Joy Brown, in 1978. His symbol said much about the

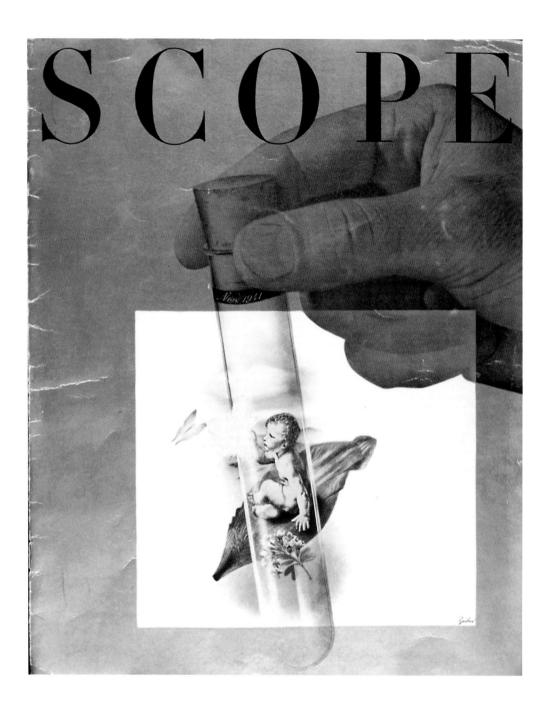

Figure 15
Burtin designed this dramatic initial cover for *Scope*,
Volume 1, Number 1, in 1941. His visual pun preceded first
use of the phrase "test tube baby" by 37 years. In 1955,
an Upjohn publication commented: *"Scope* has gone a long
way, and there is good reason, nowadays, to say that *Scope*
is the pace-setter for pharmaceutical advertising design."

Burtin was modest about his cover's success: "It was fun
doing this first cover, but I think our present [mid-1950s]
covers are more exciting." *Printer's Ink* magazine approved
of Burtin's baby, commenting that it had brought the industry
a reputation for good taste in visual communications.
Used by permission of Pfizer Inc.

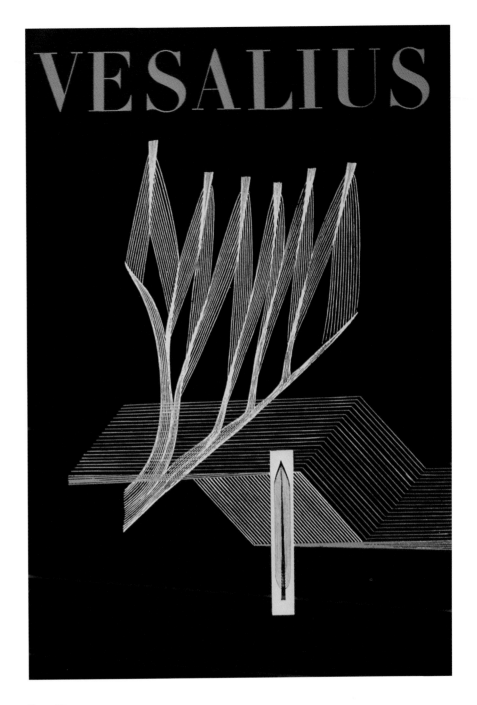

Figure 16
Burtin's choice of Bodoni for his *Vesalius* title complements
stark, stylized muscle fibers. This medical journal was named
for the Flemish anatomist sometimes called the father of
human anatomical study.

depth of his researches for *Scope* and his other scientific projects. He liked to quote a Japanese axiom: "First, discover all you can about the subject, commit it to memory, then solve the problem intuitively." Intuition was often his guide. Exhibition designer Constantine (Conny) Raitzky, who worked with Burtin for 11 years, commented, "Will's intuition seldom failed."[6]

Upjohn's Dr. Garrard Macleod thought highly of the test-tube baby graphic; so highly that he preserved the original. More than six decades later, his sons still treasure the dummy of Burtin's graphic.

Upjohn had used Burtin designs before his test-tube baby brought *Scope* into the world. He had designed the cover for a one-off publication celebrating the author of the first complete textbook on human anatomy, *Vesalius* (d. 1564) (Figure 16). In contrast to his representational work for *Scope*, Burtin expressed *Vesalius* in geometrical patterns of abstract lines, bundled to simulate muscle fibers.

In 1938, the Burtins had used the New York World's Fair as a pretext for leaving Germany. In 1939, working out of their single room on Central Park West, they won the contract from the Federal Works Agency to create the Agency's World's Fair exhibit. Here was an example of life imitating, if not art, then wishful thinking!

The Federal Works Agency, a major weapon in the arsenal of President Roosevelt's New Deal, was charged with building public infrastructure while putting Americans back to work. Roads, Housing, Public Building, Public Works and Work Projects – Burtin's challenge was to highlight the accomplishments of five FWA Administrations in one major exhibit.

Furthermore, to get the word out, the FWA exhibit (Figure 17) had to travel. It was here that Burtin made his successful transition to three-dimensional traveling displays. FWA taught him secrets of modular design for easy take-down, crating and reassembly. He put these

lessons to good use in the enormous, biomedical and scientific models he would craft in the years to come.

Roosevelt's goal of putting the nation back to work required an educated workforce. FWA's adult education programs had to reach out to two million Americans each week while bringing "knowledge of the 3Rs" to over a million illiterates. As a spin-off from the World's Fair exhibit, Burtin was soon working with educators to create "visual education aids" which the FWA sent to schools, museums and libraries across the nation. Not bad for a recent immigrant who had yet to master English.

In 2006, one of the present authors (Remington) came across the June, 1939 edition of *Architectural Forum* (Figure 14). He noticed that Burtin had designed the cover. The issue features the New York World's Fair, opening that month with much fanfare.

Years later, at the dinner table, Burtin spoke of discovering the communicative power of pictures while serving as an altar-boy in Cologne: cold and bored, he had been gazing around Gereonskirche when he had his moment of epiphany. Church illustration, intended to school the illiterate, speaks without text. There is much in Burtin's work – in exhibitions and print – to suggest that he drew on lessons learned from iconography. These were both positive (the power of image to communicate), and negative (his penchant for avoiding visual clutter came to include dislike for serif fonts). This is already apparent in his choice of sans-serifs for everything except body text in the Burtin *A/D* supplement he designed in 1941–2. His brilliance as a visual communicator began with those frigid mornings in Gereonskirche.

He was quick to share his knowledge. In the early 1930s he taught at the Kölner Werkschulen. In 1939 he joined the faculty at Pratt Institute (Figure 19) in Brooklyn, teaching advanced design, a post he would hold for life. He would joke about his first classes at Pratt: "I taught them design; they taught me English."

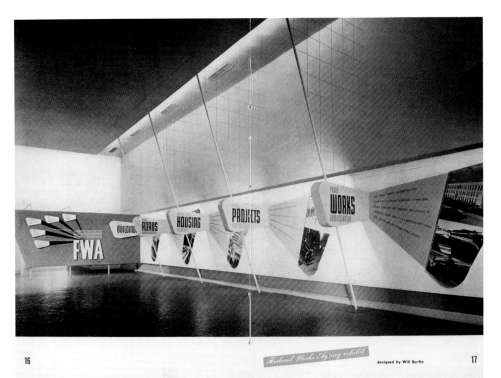

Figure 17
Burtin's exhibition for the New Deal Federal Works Agency was probably his first major three-dimensional commission. It was designed to travel. His careful attention to sequencing images and text for passing visitors presages his later exhibits.

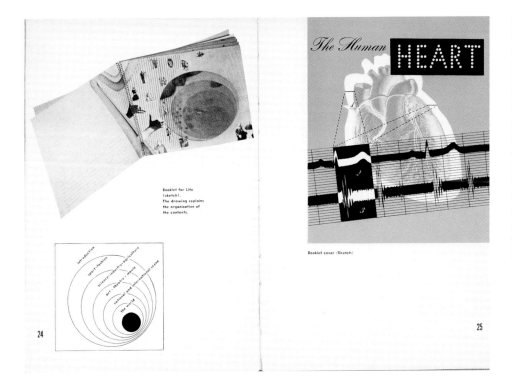

Figure 18
Howard Myers, publisher and one of Burtin's first American clients, wrote the introduction to *A/D Magazine, A/D presents: Will Burtin*, stating, "The material on these pages will explain our enthusiasm for him." Burtin's insert showcased covers, pages and spreads for *The Architectural Record*, *Life*, and *Fortune*. At left is a two page spread which presents a booklet for *Life* magazine with a drawing explaining the organization of the contents. At right is a booklet cover for Upjohn.

Figure 19
Will Burtin, teaching at Pratt Institute, 1942.
His lack of formal education spurred him to
teach. Ben Rosen, author of *Type and Typography:
The Designer's Type Book*, later wrote: "I studied
with Will Burtin at Pratt. He confirmed and
advanced his expectation that graphic design
could indeed be a creative and uncompromising
pursuit for aspiring young artists in the 40's"
Burtin hired Rosen as an assistant in Rosen's
student days.

In late 1940 Burtin designed a Christmas subscription
form for *Fortune* (Figure 20), set to the theme, "And
month after month throughout 1941 – as FORTUNE
unfolds its vastly important story … ." A year later he
did the same for *Life* magazine's Christmas card and
gift order form: "In just a day or so the first of
fifty-two weeks of LIFE to come will be delivered at your
door … ."

More remarkable is his 1941 Christmas card for
Fortune, with its die-cut front cover and its graphic
theme printed on clear celluloid. The timing was
remarkable: two weeks before Christmas the United
States declared war after Pearl Harbor. One imagines
Burtin scrapping an earlier card, calling the mail room,
even stopping the presses before going back to the
drawing board and coming up with a design brilliantly
integrating themes of peace and war. Three searchlights
stab through a dark blue sky. Criss-crossing beams form
a six-pointed Christmas star. There is hope after
tragedy, his message seems to say.

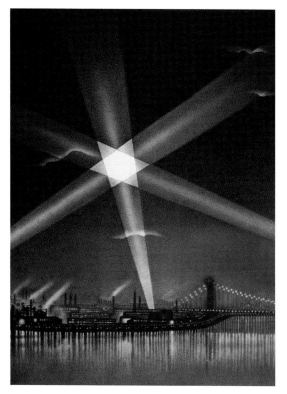

Figure 20
Burtin designed this Christmas card for *Fortune* in December 1941,
just after the outbreak of war. Searchlights stab the sky to form a
Christmas star, merging symbols of peace and war.

To handle this card is to touch Burtin's mind at work. Challenged for time, but not originality, he seizes on a technique that worked in German product brochures. Here is a front cover die-cut with 12 stars, one representing each upcoming issue of *Fortune* for 1942 while teasing with glimpses of the picture inside. The cover opens to reveal his startling graphic printed on clear celluloid. Then the inside back cover, on paper, positions the type so that the converging searchlights and the Christmas star seem to illuminate the message, "A Merry Christmas and a New Year of Fortune."

This Christmas card for *Fortune* is evidence that Burtin practised what he preached, even if, as a teacher, another goal eluded him:

> In our design schools we teach the meaning of esthetics, we define rules of designs, we teach working procedures. But what we cannot teach is the feeling for continuity, how to remain alert to the sudden excitement of a better idea two hours before the engraver picks up the completed art work, how to keep a staff electrified and unified in the dedication to perfection[7]

He may not have been able to inculcate students with the courage to innovate under pressure, but he certainly carried it through in his own work.

It is 1943: the world is at war. Burtin's u.s. Army record is blunt: "Date of induction 14 Jul 43." The Army's précis of his life condenses the man to a few typed lines. In a curious way, the brevity speaks volumes:

CIVILIAN EDUCATION
Highest grade completed, 8. Year left school, 1922. Name and address of last school attended, Germany. Other training, Print technician [to] 1927 3 years, Art & Architecture [to] 1930 3 years.

CIVILIAN OCCUPATIONS
ARTIST. Designed avertising [*sic*] layouts, magazine and architectural displays in color. Prepared preliminary sketches and worked them up in detail, doing all illustrations, writing copy designed to carry out psych. intent to overall plan. Designed and supervised execution (80 subordinates) of exhibitors of Federal Works Agency at N.Y. Worlds Fair. Received prize awards. Self-employed, 418 Central Park West, New York, N.Y., 13 years [to] 1943

TEACHER, ART (Concurrent). Taught advertising design and psychology, illustrations, experimental design--14 hours weekly at Pratt Institute, Brooklyn, N.Y., 4.5 years [to] 1943

Perhaps it was the curious sentence, "writing copy designed to carry out psych. intent to overall plan" that consigned "Burtin, Will (No Middle Name) 32 983 939 Pvt." to the Office of Strategic Services (Figure 21) (the oss, Intelligence and Special Operations), Major-General William J. (Wild Bill) Donovan commanding.

Hilda and her nine-month-old baby, Carol, followed Burtin to Washington (Figure 22). They moved in with the Munks, who shared a semi-detached house. By mutual consent, a "privacy door" separated Max Munk from his mother, his married twin, Thekla, and her pharmacist husband, Alfred Lawson.

By mid-1943, the Presentation Branch at the oss may have been among the most creative design shops in the

Figure 21
Burtin, Will, 32 983 939, U.S. Army,
Office of Strategic Services, 1943.

u.s. Burtin's fellow draftees included Dong Kingman, whose watercolors had already made him a critical success. Then came Saul Steinberg, a Romanian who had studied architecture in Milan, escaped an internment camp and washed up in Santo Domingo, whence he mailed drawings to *The New Yorker* magazine. Editor Harold Ross committed to be a guarantor for Steinberg, whom he had never met. Steinberg would contribute to *The New Yorke*r for the rest of his life; but first he joined the Army, working with Burtin and Kingman before the oss sent him to China, where he drew pictures showing Chinese partisans how to blow up Japanese bridges. Another inductee, essayist Russell Lynes, was writing propaganda. Burtin would later recruit artist Max Gschwind, expert at diagramming and visual sequencing, from the oss to work for him at *Fortune*.

The arcane aspects of Burtin's work for the oss have not come to light. When he left the Army in 1945, his exit package included a letter from Donovan ordering discharged personnel to say nothing and write less. Burtin summed up that aspect of his military work – 'developed visual-auditory presentations on ... strategic subjects' – in a 'profile' he wrote about himself four months before he died.[8]

However, several of his training projects entered the public record. He designed *Gunner's Information File: Flexible Gunnery*,[9] and at least four training manuals 'designed to make aerial gunners out of American high school boys'[10] for the u.s. Air Force and the Army Air Force. Tens of thousands of young, often uneducated – some illiterate – men relied on these manuals in training. In combat they would have to defend their aircraft against squadrons of enemy fighters attacking from every quarter. In seconds, and under fire, they would have to determine multifactorial vectors involving airspeeds (their own and the enemy's), wind speeds (real and apparent), range, trajectory and attack angles. Before trainee gunners could be given a chance to aim their guns, the visual content of Burtin's manuals had to be second nature, drilled into their heads.

The Air Forces gave this project top priority. To give their designer personal knowledge of the challenges trainees would face, Burtin was given parachute training and ordered aloft. With his large frame squeezed into assorted gun turrets he was repeatedly buzzed by friendly fighters, attacking singly and in strength, their pilots briefed for the task.

The Air Forces gave Burtin a skilled team for the *Gunner's Information File* project. They found key personnel by asking Time-Life, Inc. for a list of creative employees who had been drafted, then requisitioned them from every branch of the armed forces. Photographer Roy Stevens had already spent a year with the u.s. Navy, photographing models of known German and Japanese ships and aircraft; Bernard Quint would later become the art director at *Life*; and Peter Blake had been Burtin's client as the once and future editor of *The Architectural Forum*.[11]

Burtin discussed his task with Max Munk, who contributed his wealth of knowledge about aerial dynamics. Burtin also compared notes with his opposite number in the Army. Seconded from CBS, Bill Golden had served in the Office of War Information before being drafted as Art Director for U.S. Army training manuals.

Burtin's design team had to explain a complex, interdependent set of variables as clearly and simply as possible.[12] These manuals (Figure 23) are among the finest examples of Burtin's ability – indeed, any designer's ability – to present a complex stream of fast-moving, time-variable data in two static dimensions that users could understand. Design courses teach Burtin's manuals as models of concept to this day.

These layouts are extraordinary for the amount of information they manage to convey. One double page spread shows an enemy fighter closing in to attack. The attacker's first tiny head-on silhouette gets larger as it arcs wing-over and dives at the gunner's point of view. Burtin explains what his graphics intended:

> The problem was to teach the gunner a method for measuring off gun deflections against a fighter plane attacking his own bomber, in which the gunner had to judge the correct angle of the fighter's attack, its duration, and allow for the fighter's motion and the speed of his own bomber. To create an understanding of this space-time-motion relationship, the problem was attacked in three steps. First, the area around the bomber was laid out on a one-dimension plane using color to illuminate its measurements. Then the one-dimensional changed into the three-dimensional by the projection of imaginary, transparent cones in space. Finally, the gunner was shown how the angle measurements of these cones were carried forward and backward in space and measured with the rings of his gun sight.

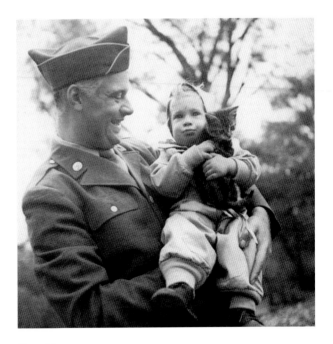

Figure 22
Burtin, on leave with daughter Carol, 1943.
Photo by Hilda Burtin.

All Burtin's Air Forces training manuals, including the best-known, *Gunnery in the B-29*, make effective use of graphics, which dominate the narrow, disciplined blocks and columns of sans-serif text. Burtin marshals his blocks of text as a general might form up columns of infantry. Wide leading creates white space, while adding the commensurate effect of reducing the tonal value of a text block on its page. Burtin employs this technique to create a third, more subtle factor. Time and again he balances the vertical and horizontal dimensions of his text blocks, forming them up in squares and rectangles that pose no jagged visual challenge to the eye. The intended effect is to guide the eye, on its *first* glance, away from the text, plunging it into the dramatic and dominant silhouetted graphics. Reading the text, for those who could read, would come later.

Aiming his guns was one aspect of an air gunner's training. *Gunnery in the B-29* walks him through others. Stripping, maintaining and loading his guns

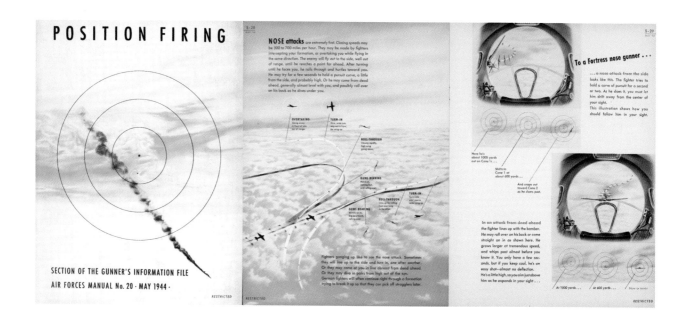

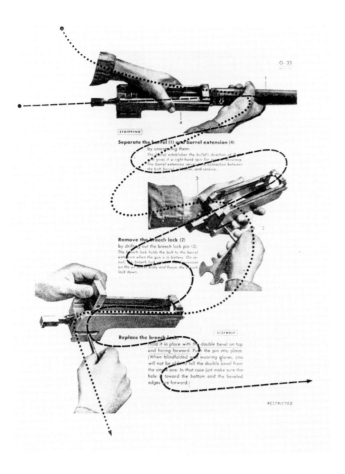

Figure 23
For his gunnery training manuals, Burtin worked with Max Gschwind, who had great skill visualizing technical processes. In 1944, Burtin wrote, "There are so amazingly many problems involved that it is not surprising that pilots and aerial gunners need between 8 and 13 months until they are ready to face the final test: Combat." These pages from his gunnery manuals remain exemplars of information design at its best.

Figure 24
In 1948, writer Lawrence Lessing, author of the text for Burtin's gunnery manuals, teamed with him again to describe their project for *Graphis*. For this, Burtin added lines showing paths taken by trainees' eyes, on a first pass and on subsequent passes.

were feats each gunner had to master. Whether he did these tasks in the dark, in freezing cold, while being tossed around by anti-aircraft fire, strafed by enemy fighters, or just plain terrified – it didn't matter. A man had to service his guns. The pages dealing with these functions were plotted with infinite care. Test subjects were asked to study mock-ups until the designers knew exactly how a trainee's eye would move across each page the first time, and the second. In 1948, Burtin and Lawrence Lessing, who wrote the text for the manuals, published an article in *Graphis*[13] called "Interrelations." For this, the authors superimposed dotted lines to show how their test subjects' eyes had glanced over the graphics the first time they saw them. Dashed lines then showed the subjects' second and subsequent, more detailed passes. Having established how the eye would move, the design team laid out the graphics (Figure 24):

Each gunner had to learn his gun's mechanism inside out in the shortest possible time, so the message had to be direct and swiftly to the point. A movie was considered for this purpose, but tests proved that movies had poor memory value in terms of detail, even upon repeated showings. Therefore, a loose-leaf manual was chosen, but retaining as much as possible of cinematic techniques.

The action of assembling and disassembling a gun was broken down into page sequences, and each page composed so that pictures and text became part of an accentuated, almost cinematic flow. Photographs were silhouetted so as to bring out detail and interpose no square halftone blocks in the visual flow. Titles were pulled out of the text blocks, set bold to facilitate an easy visual grasp of the subject, but set not larger than the body type so as to avoid disruption in the sequence of operations … .

As happens whenever all the elements of a design are recognized, studied, and brought coherently together, the result is hardly ever unpleasing to the eye – indeed, it achieves a certain beauty of clear statement – and it is effective in its purpose. By the use of these visual aids and

principles the training time for aerial gunners was cut exactly in half, from twelve weeks to six.

Rapidly changing technology kept Burtin's team busy. After the section "The B-29 and its guns" came "Instructions for using and harmonizing the remote control system" (RCT). In later versions of the B-29 , this RCT linked four turrets and the tail mount. The sights "connected to computers." The word "computer" had yet to take on its modern meaning: here it implies a tracker enabled by slaved hydraulics. Each new intake of trainee gunners had to master a rising level of complexity. But they were still "American high school boys" risking their lives in the air. At least each man got a good head start from the team's training manuals.

Figure 25
Burtin joined *Fortune* as art director in August 1945. A wall of
page spreads forms his background.

3

FATHERING CORPORATE IDENTITY

On July 25 1945, the publisher of *Fortune* wrote a letter to the Adjutant General's Office of the United States Army. William D. Gear was moved to write his two-page letter about Sergeant Will Burtin, "to explain why we believe his discharge and subsequent employment by us would be in the national interest."

Fortune did not count modesty among its virtues. In 1940, Burtin had designed the magazine's subscription offer around text extolling "its vastly important story." Now, in the summer of 1945, its publisher was telling the Army that relinquishing Sergeant Burtin to *Fortune* would serve "the national interest":

> With its circulation of nearly 200,000 FORTUNE reaches a very large proportion of the industrial and business leaders of the country. Since 1940 the magazine has been almost wholly devoted to the war effort in all its aspects. ...

> For nearly a year, we have been searching for a man capable of assuming the responsibilities of Production Director and Art Editor. This is the third ranking executive position in the editorial department of the magazine. The position demands a rare combination of unusual talent, long experience and above-average managerial ability.

> The Production Director and Art Editor is responsible for not only the appearance of the magazine (which itself requires expert knowledge of typography, engraving, printing, paper technology, layout and format) but also for all the methods of visual presentation such as charts, diagrams and maps for which FORTUNE is noted. In addition, the position calls for directing a staff and the administration of a considerable budget.

> After a thorough investigation of the field, we came to the conclusion that the applicant, Will Burtin, was without question the man best fitted for the position. He was well known to this magazine and to TIME, LIFE and THE ARCHITECTURAL FORUM, which are also published by TIME, Inc. His long and unusually broad experience in the field of design and production, both here and abroad, together with the experience he has had in the Army, fits him for the job, particularly at this time when we are contemplating major changes to improve and develop the magazine for the postwar period. We consider the job so important that we have ... held it open for nearly a year to be sure of finding the best possible man. We are now convinced that Sergeant Burtin is that man.

A corresponding application from Burtin mentions his work for *Time, Life, Fortune* and *The Architectural Forum*. These letters hit the appropriate desk with a

cover note dated July 26 1945 from H.C. Barton Jr., Chief, Presentation Branch of the OSS, stating: "This matter was referred to me by General Donovan and has his approval." Sergeant Will Burtin was forthwith discharged from the Army and drafted by *Fortune.*

Henry Luce had launched *Fortune* in 1930 with an eye to beauty. He intended his magazine to become the "undisputed most beautiful" of all. And so it was, for many years. But, although *Fortune* was the industry leader, competition for readers' dollars during the Great Depression stirred creative trends. First, the visual element on the inside pages was striving to gain a new, competitive role. Second, color, with its costs and complexity, was commanding a growing number of pages in magazines. Third, The Composing Room and other typographic leaders had been raising the bar on standards in type since 1927, pulling the industry forward. *Fortune* was a major beneficiary: launched under the direction of T.M. Cleland, from the start it "epitomized the best in the American typographic vernacular."[1] Fourth, crafts such as illustration, visual composition and layout were gaining ground, as creative and business managers saw the importance of combining these factors pleasingly – but cost-effectively – to win subscribers in the Depression's tough market. "The 'layout man' was becoming an editor … . It wasn't long before he began to design the page before it was written, and writers began to write to a character count to fit the layout."[2]

Somebody had to manage these burgeoning standards of excellence. Exit the layout man; step forward the newly-important art director! The 1930s saw the art director rise through the hierarchy to emerge near the top. He, or rarely she – Eleanor Treacy at *Fortune* in the early 1930s; Cipe Pineles at Condé Nast – needed a rare combination of experience: practical and production skills to steer the new excellence from first concept right through the press; and the aesthetic judgment to balance the warring demands between illustration and type, between advertising and editorial, and to do so with managerial authority.

That is why, in 1945, the publisher of *Fortune* saw fit to lecture the Army on the anxious year his managers had spent head-hunting the right man in Will Burtin – before laying claim to him "in the national interest." Management's faith was justified: the *Fortune* cover for June 1946, "designed by Burtin, executed by Arthur Lidov," won the Art Directors Club Award for Distinctive Merit that year.

Ezra Stoller has appraised Burtin's role in advancing American graphics and publishing via the pages of *Fortune.* Stoller describes editors in the 1940s as "primarily literary people," meaning they needed to have an idea expressed in writing in order to envision it. Art departments existed to "package" copy and make writers' pieces attractive. That attitude persisted until

> Will Burtin was made art director of *Fortune* [Figure 25]. Aside from his flawless sense of design and proportion, he brought to his assignment … a whole new spatial vision of graphic design. [His] layouts suddenly invested *Fortune* with a new dimension. Copy and illustrations were not just neatly organized; they were presented as counter point to each other. Indeed, one could get the sense of a story by simply following the layout with the text acting as a clarification and reinforcement.

> Often resentment cropped up on the part of some of the writers … . But to Burtin a piece was a totality and in many ways his was a practical application of [Marshall] McLuhan's later ideas. It was in the Portfolios where Burtin had a free hand so we had "Power of the West", "Cosmic Rays", "Taliesin" and "Taliesin West" and "Astrophysics" where Burtin's efforts shone forth, often being printed by the special gravure process that *Fortune* lavished on these inserts. Never again were these heights to be reached.[3]

Figure 26
Burtin brought *Fortune* fresh ideas, raising the level of design sophistication
in America's premier business magazine through his own talents and his
selection of freelance artists, illustrators and photographers. In 1946, Burtin's
staff created a series of experimental covers, suggesting new treatments for
the magazine's name and a Modernist style of abstract imagery.

Curiously, Burtin's own typed résumés – he called them "profiles" – record his four-and-a-half-year tenure at *Fortune* as a bare statement of fact in fewer than two lines. Objective commentators attach more importance. Here is Ladislav Sutnar: 'In the second half of the nineteen forties *Fortune* magazine spearheaded the exploitation of new visual techniques for maps, graphs and charts.'[4] In this, Burtin's success owed much to Max Gschwind, whom he brought as an artist to *Fortune* from the oss.

And William Owen writes: "[F]rom 1946 under the art direction of Will Burtin and, subsequently, Leo Leonni, [*Fortune*] presented a perfect synchrony of European modernism and American exuberance."[5] Owen's observation about 'perfect synchrony' is perceptive. Twenty years had passed since Burtin graduated from the Handwerkskammer Köln. By 1946 he had trained in and practised "European modernism" and "American exuberance" in roughly equal parts. Post-war *Fortune* was the major beneficiary of his varied experience and hard-won talents.

An aspect of Burtin's work stands out, both at *Fortune* and in Upjohn's *Scope* magazine, which he took over from Lester Beall in 1948 while still at *Fortune*. (He took on more than *Scope*. He acquired the job description "design consultant on all visual problems for The Upjohn Company.")[6]

Burtin imposed what he would later call his "new discipline" on design (Figure 26). He integrated every possible graphic element – photography, sketch, air brush, antique line-cuts (much in vogue) – to explain to readers the major research findings and challenges of the day. Under his tutelage multiple elements merge into explicit visual presentations that, deceptively, appear elementary, even simple. Simplicity, of course, was the whole point, as when he changed the font for the magazine's title to Firmin Didot. Burtin's integrating style was superbly suited to explain advances in science, medicine and technology in a decade that unleashed V-1

rockets, V-2 missiles, atomic and hydrogen bombs, antibiotics, jet engines, synthetic insecticides, television, polyesters, plastics, the Iron Curtain, the Cold War and the first computers.

> Beall and Burtin had in the 1930s developed newer graphic forms and [used] words and images on the printed page to communicate. In their hands these images were employed to make a statement clearer, faster.[7]

Not many designers had the insight to transmit complex information succinctly. More than sixty years later it is easy to underestimate the importance, the sheer power to convey, even to influence, wielded by the Burtins, the Bealls, the Gschwinds. (Ladislav Sutnar and Herbert Bayer followed.) *Fortune* really did lead with trail-blazing stories (Figure 27). Consider this feature from January 1946, sixteen years before Rachel Carson would cast doubt on the safety of DDT in her book, *Silent Spring*: "DDT: Just Begun to Fight. Hysterical Accounts of Miracles and Disasters Wrought by DDT Bedeviled the Debut of a First-Rate Insecticide."

In a troubled world approaching mid-century, carefully-wrought magazine spreads were the wide-screen images – equivalent to cinematic animations – of the day. People lucky enough to own a television in the 1940s watched a silvery blur not much bigger than a postcard. And movies, as the Air Forces discovered in their gunnery training research, "had poor memory value in terms of detail, even upon repeated showings." In the still-dominant medium of paper, with its halftone, type and growing use of color, a first-class art director was much in demand.

Fortune and competing magazines disbursed knowledge about the war-fueled technological rush of the 1940s (Figures 28 and 29) with the same urgency that the FWA had given to spreading "knowledge of the 3R's" a decade earlier. "To facilitate understanding is the task of design" is the title of a column bylined by Burtin for *Print* magazine, where he writes:

Figure 27
Burtin commissioned Lester Beall to create the Modernist April 1947 "British Railways" cover. Beall's cover remains a leading example of the graphic "layering" technique which would become increasingly common in the post-Modern years. *Fortune* is a trademark of *Fortune* magazine, a division of Time, Inc. All rights reserved.

BLACK AND WHITE TELEVISION

Light entering the camera strikes a mosaic of photoelectric cells at the back of the Iconoscope tube, creating tiny electrical charges in the cells. When the mosaic is bombarded by an electron gun, the charges flow as a current.

By cable, the current goes to the broadcast transmitter, usually located in a tall tower. (N.B.C.'s is atop the Empire State Building.) There the weak impulses, after being amplified electronically, are used to modulate an outgoing carrier wave.

When the carrier wave, eddying out into space, encounters a receiving antenna on top of a house, its radio-frequency signals are converted back into an electrical current, which flows down to the receiver.

The current, vastly amplified, is fed onto the grid of a cathode-ray tube called a Kinescope. Thus controlled, the cathode-ray beam paints on the tube face 250,000 pin points of light, which vary in intensity as the current varies at the grid. The resulting picture may be viewed directly or magnified (as shown) by lenses and mirrors, then projected on a screen.

Figure 28
Television was an exciting new medium in the late 1940s. For "Television—a case of war neurosis" (*Fortune*, February 1946), Burtin commissioned Matthew Leibowitz to show the complex process by which the new medium traveled from studio to viewer. Burtin was adept at picking the right creator: Leibowitz had worked for IBM, RCA Victor and the Container Corporation of America. Burtin used similar diagrams to present complex information simply, at *Fortune*, and in later years.
Fortune is a trademark of *Fortune* magazine, a division of Time, Inc. All rights reserved.

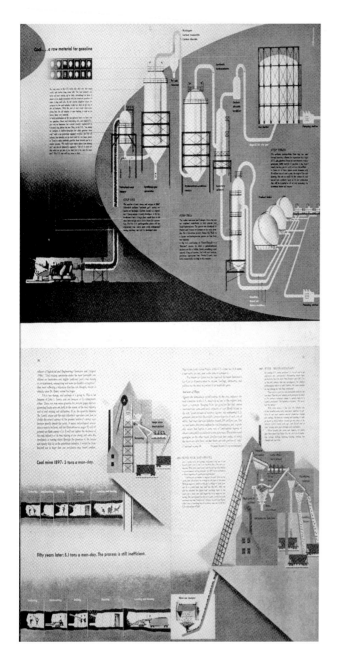

Figure 29
Burtin commissioned Alex Steinweiss to draw diagrams showing complex processes in 'Coal is what we make it' (*Fortune*, March 1947).
Visuals complementing text helped busy readers digest information quickly.
Fortune is a trademark of *Fortune* magazine, a division of Time, Inc.
All rights reserved.

The great advances in basic design theory and visual-graphic techniques during the Stijl and Bauhaus period highlight the towering achievement of those exuberant twenties. Much of our present design teaching and practice is still performed in the shade of this tower. … [But] we recognize now that their conclusions were based on too narrow an interpretation of technology and on their inability to see science as part of the creative process.[8]

Will Burtin saw his role clearly. Art was a powerful tool with which to explain science, and art in the service of design would do much to increase the range of human comprehension – especially comprehension of science:

To convey meaning, to facilitate understanding of reality and thereby help further progress, is a wonderful and challenging task for design. The writer, scientist, painter, philosopher and the designer of visual communication, in commerce, are all partners in the task of inventing the dramatic and electrifying to a more comprehensive grasp of our time.[9]

Burtin's high-purposed prose seems to exalt the creative process; as if the designer is somehow raised above the fray. In fact he drove his colleagues as hard as he drove himself. Designer George Klauber joined *Fortune* in 1948, then moved with Burtin when he opened his studio, staying with Will Burtin, Inc. until 1958. Designers measure space in picas and points. Klauber remembers designers at *Fortune* inventing a term to cover almost indiscernible adjustments on a page. They spoke *sotto voce* of "picas, points and Burtins" as in "Move that headline just a Burtin to the right."

Lest it seem that Burtin was an inveterate micromanager, here's a corrective from photographer Ezra Stoller:

Will Burtin was my best friend. A marvelous man. The reason I had such respect for Burtin is [that] he would never lay out a story until the pictures were in. He would never suggest pictures for his story before he sent me out on assignment. He'd send me out, and when I came

back and the pictures were in, then he'd lay out his story. And when he laid out a story, you could read that story from his pictures and you didn't need a word of type.[10]

The job at *Fortune* returned the Burtins to New York, first to 104th, then to 106th Street at Central Park West. Hilda Burtin and Celia Brody became even closer. Hilda's Jewish family in Germany had suffered greatly under the Nazis, and Celia remembers Hilda referring to Carol as "little Will" because, to Hilda's relief, her three-year-old took after her father. In short, Carol didn't look Jewish. Celia was a case-worker with the Jewish Family Service, a job which had given her a trained, experienced ear. Both Burtins confided in her: Hilda, when the mothers were walking their children; Will, in the evenings, when he would walk Celia home to her own apartment. Speaking almost sixty years later, Celia was of the opinion that neither one fully recovered from the trauma they brought from pre-war Germany. From the moment they stepped off the *Statendam* they never spoke German to each other, difficult as that must have been.

Burtin's absolute refusal to speak German had its light side. In his first year at *Fortune* he visited Albert Einstein at Princeton to research a feature called "The Physics of the Bomb" (May 1946). Celia Brody Mitchell[11] takes up the story: "The magazine was going to do a whole thing on Einstein. He was to be on the cover, and that was the purpose of Will's visit. When he left to go on that interview, he said to me and Hilda, 'I'm not going to speak German to him, and he does speak English. So I think it will work out fine.' We all had a good laugh. But of course Einstein didn't speak English to Will. He spoke only German to Will, and Will answered in English. It was kind of amusing."

That odd bilingual exchange may have been amusing, but the subject was deadly serious. Einstein was then preaching that the world was headed into an atomic war.

The Burtins' friendship with Celia Brody translated easily from Central Park West to warm summers at Robin's Rest on Fire Island. In the 1940s, Fire Island was the place to be (Figures 30, 31 and 32). After staying with the Brodys in 1946, the Burtins bought a house in Ocean Bay Park. Bill Golden and Cipe Pineles eventually sold their Fire Island home to illustrator Joe Kaufman and his wife Evalyn. The Island crowd included the Levys, as well as Cipe Pineles' long-time colleague at Condé Nast, Estelle Ellis, and her husband, Sam Rubinstein.

The leading visual artists and business colleagues whom Burtin met through *Fortune* extended his family's range of contacts. Hilda Burtin's post-war photographs of Carol splashing in Fire Island surf include Celia Brody's son, Daniel Mitchell and the Stollers' daughter, Erica; and there were visits to Lawrence and Dorothy Lessing's home in Connecticut. Will and Hilda became regular customers at the New York restaurant designed by Dong Kingman, in which Kingman had an interest. Burtin and Kingman had worked together at the OSS, where war work transformed Kingman – an established artist skilled in Chinese calligraphy – into a map-maker. For Christmas 1945, Kingman gave Burtin a numbered lithograph: "Passing By" tracks a steam locomotive as it roars through a black-and-white frame, right to left, under a gantry of glowing signals. "Passing By" looks very "*Fortune*." In February 1947, and again, in November 1949, Kingman created covers for *Fortune* magazine (Figure 34).

The sophistication such artists brought to *Fortune* reflected well on Burtin, who commissioned their work. Hananiah Harari (whose cover promoted "Aluminum Reborn," in May 1946) wrote to Chris Mullen, the British design historian and teacher with a special interest in *Fortune*, that Burtin had

> a decidedly sophisticated sensibility in matters esthetic, psychologic and technologic … Burtin's distinctions lay in his extraordinary measure of taste and in his breadth of experience.[12]

Figure 30
Burtin with daughter Carol on Fire Island, 1945.
Photo by Hilda Burtin.

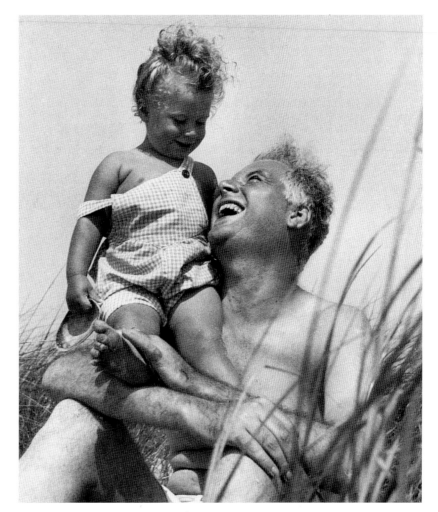

Figure 31
In 1947 the Burtins visited friends Lawrence
and Dorothy Lessing, in Connecticut.

Figure 32
Burtin, with daughter Carol, in 1947.
Photo by Hilda Burtin.

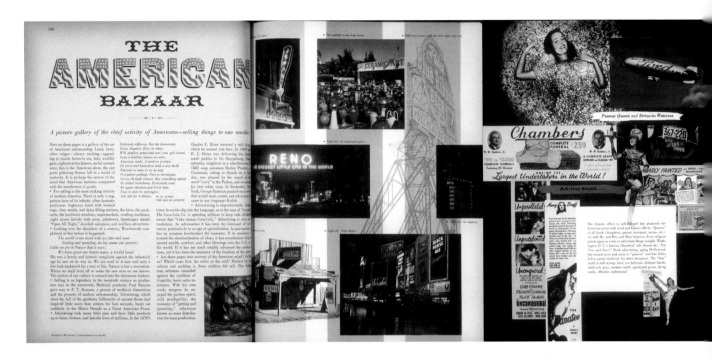

Figure 33 (above)
Burtin's tenure as art director at *Fortune* brought vitality to a staid business journal. He argued for, and was given, 14 pages for his 'American Bazaar' spread. This feature remains among the best examples of combined graphics and images, including Walker Evans' photographs, setting the theme and energizing business writing.
Fortune is a trademark of *Fortune* magazine, a division of Time, Inc. All rights reserved.

Figure 34 (left)
Burtin commissioned the finest artists, photographers and illustrators. Dong Kingman's first cover for *Fortune* ran in February 1947. Another Kingman cover depicted an industrial scene in its dramatic setting (November 1949).
Used with permission of Dong Kingman Estate and Dong Kingman, Jr.
Fortune is a trademark of *Fortune* magazine, a division of Time, Inc. All rights reserved.

Figure 35 (right)
Fortune sometimes ran lighter stories, such as "Hollywood and 'The Movies'" (April 1949). Burtin's silhouettes of movie characters contrast with text about the movie business.
Fortune is a trademark of *Fortune* magazine, a division of Time, Inc. All rights reserved.

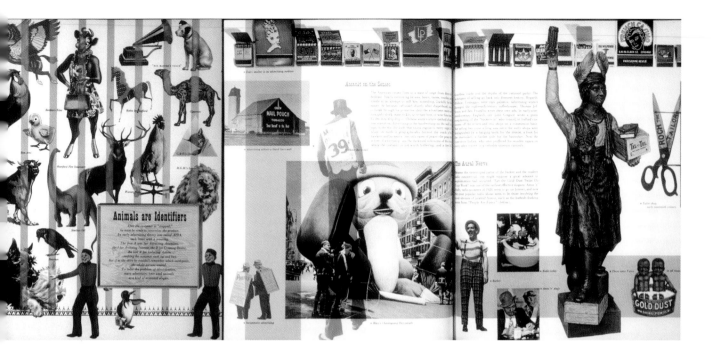

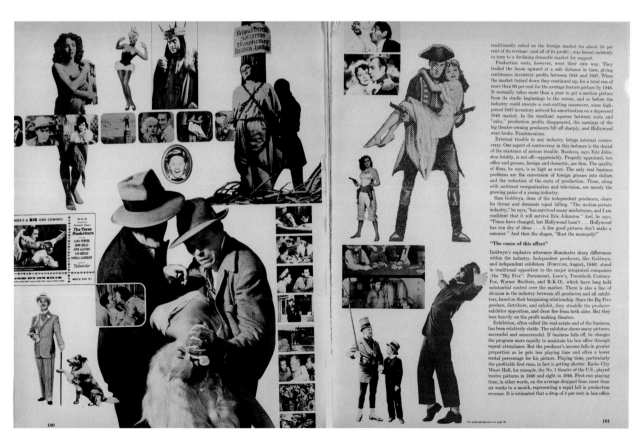

traditionally relied on the foreign market for about 35 per cent of its revenue (and all of its profit), was forced suddenly to turn to a declining domestic market for support.

Production costs, however, went their own way. They trailed the boom upward at a safe distance in time, giving continuous inventory profits between 1941 and 1947. When the market turned down they continued up, for a total rise of more than 60 per cent for the average feature picture by 1948. It normally takes more than a year to get a motion picture from its studio beginnings to the screen, and so before the industry could execute a cost-cutting maneuver, some high-priced 1947 inventory arrived for amortization on a depressed 1948 market. In the resultant squeeze between costs and "sales," production profits disappeared, the earnings of the big theatre-owning producers fell off sharply, and Hollywood went broke. Pandemonium.

External trouble in any industry brings internal controversy. One aspect of controversy in this instance is the denial of the existence of serious trouble. Business, says Eric Johnston briskly, is not off—appreciably. Properly appraised, box office and grosses, foreign and domestic, are firm. The quality of films, he says, is as high as ever. The only real business problems are the conversion of foreign grosses into dollars and the reduction of the costs of production. These, along with antitrust reorganization and television, are merely the growing pains of a young industry.

Sam Goldwyn, dean of the independent producers, clears his throat and demands equal billing. "The motion-picture industry," he says, "has survived many misfortunes, and I am confident that it will survive Eric Johnston." And, he says, "Times have changed, but Hollywood hasn't . . . Hollywood has run dry of ideas . . . A few good pictures don't make a summer." And then the slogan, "Bust the monopoly!"

"The cause of this effect?"

Goldwyn's explosive utterance illuminates sharp differences within the industry. Independent producers, like Goldwyn, and independent exhibitors (FORTUNE, August, 1948) stand in traditional opposition to the major integrated companies (the "Big Five": Paramount, Loew's, Twentieth Century-Fox, Warner Brothers, and R-K-O), which have long held substantial control over the market. There is also a line of division in the industry between all producers and all exhibitors, based on their bargaining relationship. Since the Big Five produce, distribute, and exhibit, they straddle the producer-exhibitor opposition, and draw fire from both sides. But they lean heavily on the profit-making theatres.

Exhibition, often called the real-estate end of the business, has been relatively stable. The exhibitor shows many pictures, successful and unsuccessful. If business falls off, he changes the program more rapidly to maintain his box office through repeat attendance. But the producer's income falls in greater proportion as he gets less playing time and often a lower rental percentage for his picture. Playing time, particularly the profitable first runs, in fact is getting shorter. Radio City Music Hall, for example, the No. 1 theatre of the U.S., played twelve pictures in 1948 and eight in 1946. First-run playing time, in other words, on the average dropped from more than six weeks to a month, representing a rapid fall in production revenue. It is estimated that a drop of 5 per cent in box-office

Ezra Stoller, also writing to Chris Mullen, summarizes the light, and the long shadow, cast by Burtin during his time at the magazine:

> Long after Burtin left *Fortune* the imprint of his ideas lingered on, mostly in "On the Frontier" which was the one color page per issue illustrating a radically new work or industrial process. These pictures often came from photographers working in the field who were asked to be on the lookout for such views. Merely a remnant left behind by the high water mark of the unique genius. There never has been anyone the likes of Will Burtin.[13]

Burtin's contract with *Fortune* allowed him to take on other clients. Apart from giving him an excellent résumé, his position helped him refine his ideas about corporate identity. He composed the montage for his 14-page "celebration of popular advertising art"[14] that he called "The American Bazaar," which demonstrated his conviction that a constant, consistent image would serve a company as a powerful multiplier, boosting that company's chances of being noticed by shoppers.

Burtin's need to collaborate with creative people at *Fortune* generated a certain tact for which he was not well known. For example, Ezra Stoller remarked that Walker Evans was generally averse to accepting assignments: he preferred to follow his own instincts. Yet Evans accepted guidance from Burtin for "The American Bazaar,"[15] and for another, "The Movies" (Figures 33 and 35).

Projects for The Upjohn Company appear with increasing frequency on Burtin's résumé in the late 1940s. Burtin's and Lester Beall's careers overlap in those years. Beall stepped aside as the art director of Upjohn's *Scope* magazine; Will Burtin stepped in. Beall was among the first American designers to develop corporate "branding." Burtin did the same for Upjohn, replacing his client's venerable line-cut logo in favor of a text-only UPJOHN logotype (Figure 37).

Meanwhile, he used preliminary mock-ups for his "American Bazaar" montage to convince Upjohn to accept a consistent packaging look for its full range of products and print materials. He was able to show that a unified look made his client's products stand out from the visual noise.

Beall has been called the father of branding; Burtin, of "corporate identity." Both were masters of composite graphic images – visual metaphors – and both were superb designers. It is not easy to line up editions of *Scope* magazine and guess where one man left off and the other took over. The smooth transition is a tribute to both.

Seven years had passed since Burtin's test-tube baby commanded the first edition's cover on *Scope* in 1941. In 1948 he would put his imprimatur on the whole magazine. For several years he served as editor as well as art director.

Scope was not the first company magazine of its kind. Upjohn launched it to counteract competition from its rivals' publications. Before 1941, the task of educating doctors largely fell to well-informed sales representatives armed with product brochures. At a time when a large proportion of physicians practised from their own small offices, a salesman's personal touch and the leave-behind literature gave doctors a lot of information about prescription drugs – much more than they got from paid advertisements in medical journals. Then came the war. Many traveling reps. joined the forces, breaking the chain of information from drug manufacturers to doctors' offices.

Upjohn's new *Scope* was designed to look and feel different from competitors' magazines. As well as informing and entertaining doctors, its outstanding design enticed them to turn pages, read, be surprised by fine graphics. *Scope* went beyond promoting an Upjohn product in each issue. A "Science and Culture" section discussed current issues; specialists described

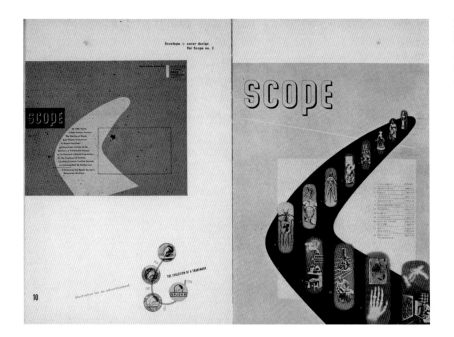

Figure 36
Burtin's insert in *A/D Magazine* (February/March 1942) shows this early cover for Upjohn's *Scope* magazine, designed around images showing specific medical advances.

Figure 37
Egbert Jacobson's *Seven Designers Look at Trademark Design* (1952) includes a chapter about Burtin's work with Upjohn. He illustrates the evolution of Upjohn's marks from 1894 until 1947, when he gave Upjohn its text-only logotype. Jacobson wrote, "The significance that trademarks could be spelled out is demonstrated by the Upjohn mark." Nineteenth-century doctors and patients wanted pills to dissolve easily, hence the original logo showing a hand crushing one. When competitors began producing soluble pills, Upjohn lost that competitive advantage and "the meaning of the [original] trademark was less significant." The simplicity of Burtin's 1947 text logo reinvigorated the mark, freeing it to fill many corporate roles. His timing made Burtin a pioneer in corporate identity design.
Used by permission of Pfizer Inc.

medical breakthroughs and the latest therapies; photographs supported case histories and posed diagnostic challenges.

The magazine's founding editorial board decided against a conservative format. It was inappropriate in a magazine discussing fast-moving, state-of-the-art sciences which, in the 1940s, were adding antibiotics to medicine's arsenal. *Scope* was designed to set up for readers a visual aura that spelled "innovation." Here is a spokesman for Upjohn telling *Print* magazine why the company chose Burtin.

> Will Burtin's designs were chosen because they were highly progressive in concept but couched in an idiom that partook of the scientific in its clarity and definiteness. Furthermore, it was decided to try to use design not merely for its decorative effect but as an integral part of the scientific presentations. Consequently, even the covers of *Scope* are designed not only to be attractive but to suggest some important part of the contents. The internal design is, however, functional first and decorative incidentally. … Many of these presentations have conveyed complicated ideas both accurately and pleasantly and have turned out to have had, in addition, a unique kind of beauty, a part of which is embodied in their sheer functionalism.[16]

Beauty was key in Burtin's ambition for *Scope*. He enlarged on this theme for *Print* magazine, which gave him extensive coverage in a piece called "Upjohn and Design." A designer must consider more than just how a reader perceives an image, Burtin told *Print*. He must consider the emotional response evinced by the choice of a given color, or the mental imagery attached to "things like spoons, seashells, test tubes, or primitive ceremonial masks." It took logical thought to assemble appropriate objects into a "specific unity of conclusion" that a reader might draw. In Burtin's terms, successful design provoked "visual reasoning," making it possible to simplify complicated topics, banishing complexity, creating in its place "a certain beauty of clear statement."[17]

As Burtin expressed it, "Beauty is not necessarily a matter of form or style, but a result of order achieved. To me, the finest and highest order is the one which results in such simplicity of statement that it could not be said more constructively, more encompassing, more spirited. That is beauty. That has human dignity."[18]

4

"INTEGRATION" ANTICIPATES MULTIMEDIA

Will Burtin opened his own studio again in 1949, during the more than six months it took him to disengage from *Fortune*. Will and Hilda no longer had to run their business from a drafting table in their bedroom. They rented space at 11 West 42nd Street, one of New York's finest Art Deco buildings. Cipe Pineles had suggested the location: she was working there as the art director at *Seventeen* magazine. The auspices were good. George Klauber gave up his job at *Fortune* to become Burtin's senior designer. Day One at Will Burtin, Inc. found Klauber helping with the move. Interviewed fifty years later, he still spoke in the plural: "When we left *Fortune*, *Scope* was one of our big projects."[1] The "we" was three people, the Burtins and Klauber. They became four when Burtin hired John Bernhardt, who stayed four years before establishing his reputation as a woodblock- and print-maker.

Burtin was still art directing *Fortune* when he took over from Lester Beall on Upjohn's *Scope*. The booming post-war economy made these productive, innovative years in advertising and design. Design itself had evolved as the urgent demands of war work had led designers to improvise. By the late 1940s, improvisation had led to innovation and improvement as designers continued to probe 'the arrangement of elements' and the 'integration of photography, illustration, overlaid color, and flat graphic elements.'[2]

"Integration" became a major trend in post-war design. In 1948, the A/D Gallery sponsored an exhibition Burtin called *Integration, the New Discipline in Design* (Figures 39 and 40). A steel and aluminum skeleton supported his displays, many of them made for him in colored, transparent plastics, new materials, light-weight, easily molded and shaped. Some of the first plastics had been developed during the war to be molded into the compound curves needed for the transparent blisters in bomber turrets. When he was designing gunnery manuals, Burtin had stared through similar plastics in bomber turrets while friendly fighters buzzed him. It was typical of the man that he pressed these new materials into action, in design. Years later, Klauber, "a close associate of Burtin's for many years," described his use of plastics:

> Burtin, as far as I can see, discovered plastics [as a design medium]. Not the plastics made to look like marble, wood, horn or porcelain, but the broad, clean, light, colorful transparent sheets that are now a familiar medium for sculpture and display, exhibits and architectural interiors.[3]

Klauber goes on to lament the "cheap perversion of design technique as it filters down," regarding plastics used for mass markets, "indirectly derived from the early inspiration of Will Burtin, which goes as far back in this country to the New York World's Fair of 1939."[4]

Figure 38
The image Burtin gave The Upjohn Company extended to consumer advertising. For example, sales campaigns for Upjohn Vitamins took many forms within one corporate identity. Burtin's ad. "I grew a whole inch since I saw you ..." represents one family-friendly approach. Others were more serious. Carol Burtin, age 8, wrote this copy.

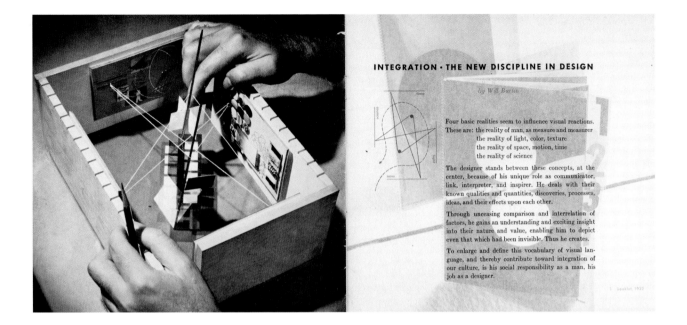

Figure 39

Integration, the New Discipline, came with a booklet. Burtin wrote: "This booklet had to fulfill two functions: To demonstrate a design theory, and to be a guide through the exhibit." At the end he wrote: "With patience and further study, we will ultimately succeed in making our methods of visual organization more precise; and the designer's unparalleled opportunity for integrating the elements of our society clearer to himself and to the world." In 1949, the New York Art Directors' Club awarded the booklet an award of distinctive merit.

Its plastic components, with correspondingly innovative through-the-material lighting, gave Burtin's exhibition, *Integration, the New Discipline in Design*, a "sci-fi" look, ahead of its time. He designed his displays, as he had the FWA project a decade earlier, for easy assembly and take-down. *Integration* toured the United States. Klauber called the exhibition a "three-dimensional statement."[5]

Burtin gave the same name to a short essay that accompanied his exhibition. *Graphis* published the final draft of *Integration, the New Discipline in Design* in 1949.[6] Klauber, who worked late nights designing the brochure that toured with *Integration*, told one of the present authors: "There's so much information in the catalog. It was his philosophy and he articulated that

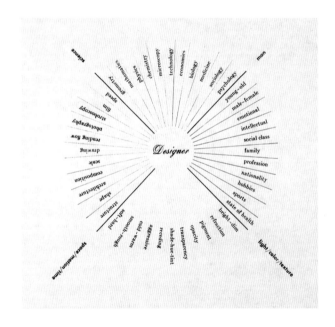

Figure 40

A diagram in *Integration* shows Burtin's view of a designer's role as central to presenting science, man, light/color/texture; and space/motion/time.

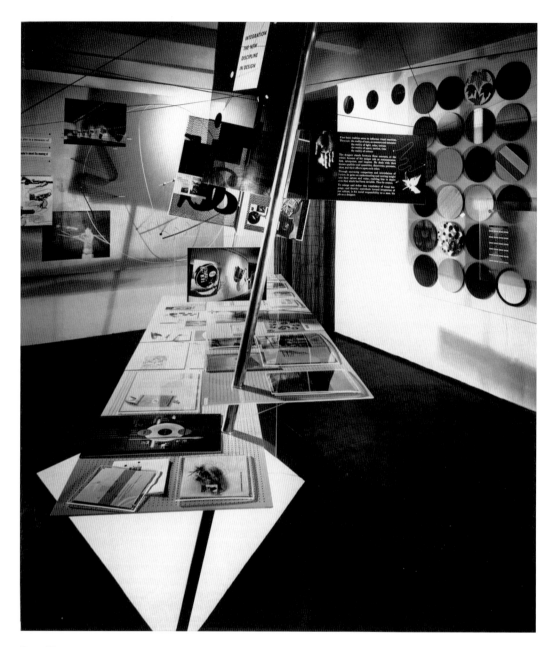

Figure 41

The Art Directors' Club of Chicago sponsored the showing of *Integration*. The catalog included reviews of Burtin and his work. Architect Serge Chermayeff linked Burtin with the "new art of visualization, of giving visual form in two and three dimensions to a message, which may be apprehended simultaneously through the senses and the intellect and is the product of a new kind of artist functionary evolved by our complex society. Among the small band of pioneers who have developed this new language by bringing patient research and brilliant inventiveness is Will Burtin." Painter and art director Charles Coiner wrote: "... It is refreshing to find an artist aware of stimulus from the world outside, who thrills to the job of making it comprehensible to more people."

for this little exhibit. It was way ahead of its time. It was the beginning of this whole [design] era.'[7]

Integration, the New Discipline in Design anticipated by several decades the rise of what we call "multi-media."

After it closed at the A/D Gallery (Figure 41) in New York, the "little exhibit" went on tour, first to Chicago's Information Library, then Los Angeles, where Burtin spoke at the Art Center School.[8] At least one young designer in the audience was struggling to chart his own career. Years later, Rudolph de Harak would tell writer Stephen Heller that his future course was 'profoundly influenced by two lectures' he heard at the Art Center School.

"These experiences had a profound effect on my life," said de Harak. The first was a lecture by Will Burtin, who "not only spoke about design and communications, but he presented an exhibition of his work, which moved the viewer through a series of experiences which were described as *the four principal realities of visual communication* [emphasis in the original]."[9] Notes for the lecture that de Harak heard that day resemble the text of the essay published in *Graphis* months later. Burtin opens his essay notes by stating that 'Visual communications are based on four principal realities:

- the reality of man as measure and measurer
- the reality of light, color, texture
- the reality of space, motion, time
- the reality of science.'

Addressing his first reality, Burtin writes, "Man in design is both – a measure and a measurer. … He is the most important part in a design. We depend on his physical, emotional and intellectual response, on his understanding. … Man is the total sum of his experiences." Therefore, he continues, designers had to remember that they worked in an ever-changing world. They had to respond to perpetual change by 'constantly developing better and more precise ways of expressing

ideas"; by investigating the whole range of possibilities for each new assignment; and by "understanding the mechanics of vision."

Writing about "the reality of light, color, texture," Burtin points out that tastes in color change across generations, cultures – and professions. He cites "Rembrandt's brown, the Victorian purple, Degas' pastel blues and pinks, the beige of the early 20s," before going on to explain that

> One reason for the emotional impact of color lies in the firm roots it has in the subconscious and intuitive background of man. …

> To a physician color means one thing professionally, and something else esthetically, which also holds for the architect or scientist or carpenter. The first is a conscious – that is, rational – the latter a subconscious definition. The first is knowledge based on actual experience, the second stems from emotional depths. Yet, the designer must work with both.

Burtin had been designing for two national audiences, physicians and business leaders, for several years. He was a shrewd judge of "the emotional impact of color" on these groups. To see what he meant, one only need compare contemporary copies of *Fortune* and *Scope*. He considered that the quality of light, the texture of the surface from which it reflects into the eye

> not only influences and dramatizes the color character, but also has structural characteristics of its own, to which our sense of touch reacts. Additionally, through texture we speculate on what may be behind a surface, what it encloses.

As the ear transmits music to the brain, which triggers emotions, so Burtin knew that layouts and graphics could stir senses and feelings beyond the interface that is sight. Several close-up photographs by Stoller for Burtin's projects dwell on surface textures; wider shots

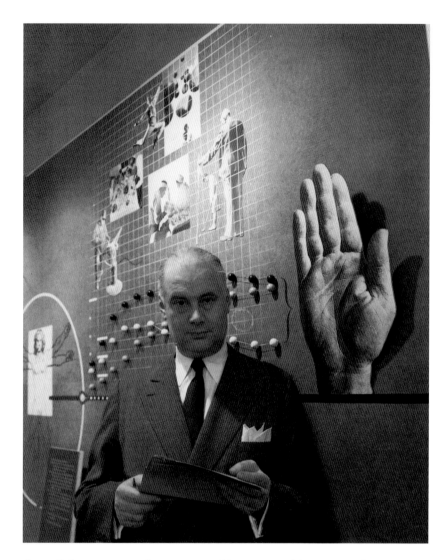

Figure 42
Will Burtin, by noted portrait photographer
Arnold Newman. Photo © Arnold Newman,
Getty Images.

throw light at acute angles to set up *chiaroscuro* or lift the surface details out of features such as floors. Burtin maintained that the "texture" of good graphics could stimulate the sense of touch and, further, prod an observer to speculate on characteristics unseen. Whatever Burtin designed was meant to make its mark upon the mind.

His notion extended to the actual texture of paper. Physicians, accustomed to using their hands as diagnostic tools, responded well to a magazine in which feature stories might be written on rough-textured, ragged-edged paper. In this respect Burtin intended his medical readers to "diagnose" *Scope* in the first place by

its feel, with tactile sensations confirming the magazine as both substantial and benign.[10] The reader then confirmed his or her preliminary diagnosis through what Burtin called, "the emotional impact of color."

Of "the reality of space, motion, time" he writes:

> Understanding of space and time relations is a main requirement in visual organization. … The spaces inside and between letters, between lines of type, their relationship to illustration, are vital factors which determine the eye's access to the basic information.

This point builds on the article he wrote with Lawrence Lessing, also for *Graphis*, explaining his rationale for the layouts and spreads in his gunnery manuals.[11]

> As we read from left to right, a flow develops, which must be utilized to connect the various parts of a message, text and illustration. This movement can be accelerated, by keeping type faces and spacing open, or slowed down, by condensing them. Thus reading time is as important a measure as the space within which visual communications are organized.

Developing his final theme, "the reality of science," Burtin wrote:

> The extra-sensory reality of science provides man with new dimensions. It allows him to see the workings of nature, makes transparent the solid and gives substance to the invisible. …
>
> The designer stands between these concepts, at the center, because of his unique role as communicator, link, interpreter, and inspirer. …Through unceasing comparison and interrelation of factors, he gains an understanding and exciting insight into their nature and value, enabling him to depict even that which had been invisible. Thus he creates.

Months after Burtin's lecture, de Harak heard Gyorgy Kepes speak about the "plastic arts." "I recall my excitement," de Harak told Heller, "as I was able to draw parallels between what he was saying…and what Will Burtin had said concerning the realities of visual communications."[12] De Harak had never heard the phrase "visual communications" before Burtin used it.

Will Burtin, Inc. prospered in the years after mid-century. Burtin worked as a designer and consultant in advertising with George Nelson's studio, Parker Knoll Furniture, Herman Miller Furniture and Charles Eames; on book designs for publishers McGraw-Hill, Random House and others; and on industrial and editorial projects for such clients as Eastman Kodak, IBM, the Smithsonian Institution, Mead Paper, Union Carbide, and the U.S. Information Agency. And always there was Upjohn.

Meanwhile, the American Institute of Graphic Arts (AIGA) recognized Burtin by naming him a director. He had been on the faculty at Pratt Institute since 1939. Now he began to teach at the Parsons School of Design as well.

Burtin had been associated with *The Architectural Forum* since before the war. Now, architect James Marston Fitch, the magazine's editor, appointed him design consultant.

Burtin in turn commissioned Fitch to design a new family home. The Burtins sold their summer house on Fire Island and waited while Fitch built a new, year-round home set into a steep south-facing hillside at 475 South Mountain Road, near New City, New York. Within a few years Jim and Cleo Fitch, Cipe Pineles and William Golden would also move into the neighborhood, to Stony Point, on the north side of South Mountain.

Fitch and Burtin enjoyed a long-standing, curious relationship, their mutual respect for each other alternating with furious arguments over points of esthetics or design. In 1951, argument raged for days over a span of 10.16cm (4 in) – the width of a brick.

Rockland County is well named. Fitch designed the Burtin house to be built into, around, and on top of huge rocks. An enclosed flight of steps leads up from a covered carport, climbing an outcrop of basalt *en route* to the main living area.

The plan for the new Burtin house looked fine, was approved, and work proceeded – until the client visited the site. Burtin knew immediately that something was wrong: the main flight of stairs was too narrow; it

DESIGNED BY WILL BURTIN

Prominent figures in the type fashion parade, these ATF Craw Clarendons! This paragraph is set in the new Craw Clarendon Book, which supplements its bolder companion...forms a balanced contrast, yet retains the dynamic design of Craw Clarendon. Your local ATF Type Dealer delivers promptly from stock. Ask him for specimen brochures, or write directly to the Type Division, American Type Founders, 200 Elmora Avenue, Elizabeth, New Jersey. ATF TYPE NEWS IS GOOD NEWS FOR EVERYBODY

ATF

Figure 43
In the 1950s, Burtin designed this ad for American Type Founders to promote Craw Clarendon Book. It has the force of a poster, the elements unified by grouping numerals inside a large zero, with the catchy header, "Prominent figures."

Figure 44
The Art Directors' Club awarded Burtin the ADC Gold Medal for his *Scope*
cover featuring *gyotaku*, Summer 1954.
Used by permission of Pfizer Inc.

looked wider on the plans. Four inches wider, in fact. The local contractor, Harold Maurer, downed tools and waited while Fitch and Burtin argued the point.

The problem was this: to a designer, a line is a line; to an architect, it may represent a line of brick – a four inch-wide brick. The men eventually resolved the problem, but they told this tale about each other to the end of their lives – on one occasion at opposite ends of the same party in the Goldens' Stony Point home.

In August 1953, the Burtins traveled to South America. The pharmaceutical company Life Farmacéuticos took Burtin to Ecuador, where he did for Life what he continued to do for Upjohn: develop visual branding for product and packaging lines. While he worked with his client, Hilda spent time in Quito with an old friend, Hungarian-born designer Olga Anhalzer Fisch, a fellow Jewish exile and old friend from Germany. Fisch reached Ecuador in July 1939, and despite turbulent times and the distances involved, they had never lost touch. The Burtins had mentioned her to Dr. Leslie when they met him for the first time in New York. He subsequently published her picture, *Ethiopian Wedding Dance*, in the April–May 1939 edition of his *PM Magazine*.

For her part, as soon as Fisch reached Quito she saw the commercial potential in native handicrafts. She began encouraging artisans to represent their world in fabrics, ceramics and crafts while creating international markets for their wares. By 1953, when the Burtins came, she was a national figure who took her visitors to meet weavers and craftspeople working near Quito. Hilda Burtin's photographs survive.

Fisch's colonial-era home in Quito, at Avenida Colón 260, housed Folklore Olga Fisch. The company she founded has flourished, becoming as much a cultural institution as a native crafts boutique. Of her own main attribute, Olga Fisch said only that she knew "how to recognize quality in a work of art."[13]

From Ecuador, the Burtins flew across the Andes. Hilda's older brother, Walter Munk, had escaped to Argentina. Her younger brother, Alfred, had survived the war in Cologne, hidden and employed by Dr. Knöll, the typographer who had supported Will Burtin through his apprenticeship. Hilda's mother, Selma, also survived, escaping Germany with Else, Alfred's wife. After the war, Alfred joined the women in Buenos Aires and set up in business as a printer.

In 1954, the Burtins returned to Cologne for the first time since their hasty departure sixteen years before. They must have gone back with foreboding. They had seen the post-war newsreels and magazine spreads – Burtin had selected photo-spreads for *Fortune* – of bridges sunk across the Rhine; of his city reduced to walls without roofs, of cellars without walls. Only the Kölner Dom, the cathedral, survived. A photograph taken by Hilda shows Will's mother, Gertrud Bürtin, peeling potatoes in a second-floor room with two of its walls blown away. Will's father, August, had died in the intervening years, but not before Will and Hilda learned of his courage. After V-E Day, letters from Cologne described how, in the months after *Kristallnacht*, August Bürtin had risked his life to bring food to one of Hilda's Jewish relatives and her daughter – the mother's

Figure 45
For the opening of Disneyland in 1958, Burtin built a replica drugstore as it might have looked in 1886, the year Upjohn was founded, equipping it with items essential in a pharmacy of that day. Chandeliers came from an old Kalamazoo drugstore, porcelain jars from France. Behind the store, a modern exhibit showed Upjohn's progress through 70 years.
Used by permission of Pfizer Inc.

given name may have been Meta, or Mehta – until the day he arrived to find them gone.

The photo of Gertrud Bürtin peeling potatoes marked the final few days of a ruinous phase in a hard, hard life. She and her daughters were preparing to move their families into a new, multi-apartment home being built for them at 22–24 Geisselstrasse. Carol Burtin celebrated her twelfth birthday in Cologne.

Side-trips to Rome, Paris, Zurich (to meet Josef Mueller-Brockmann) and to Amsterdam (to meet Willem Sandberg) confirmed valuable European

connections for Burtin, and brought him new insights. Mueller-Brockmann represented the new wave in European design, a movement led by the Swiss.

Back in New York, business prospered. In January, Burtin had seen an article in *New Japan* magazine. Intrigued by pictures of "inked-block" fish, *gyotaku*, he wrote to the holding company, English Mainichi, in care of the Japanese Consul General in New York. Months later a package arrived containing several *gyotaku* by the Japanese masters Isshu Nagata and Koyo Inada. Burtin featured these in *Scope* (Summer 1954; see Figure 44). Images that had caught his eye in January now caught the eye of jurors at the Art Directors' Club. They awarded him the ADC Gold Medal for the *gyotaku* edition of *Scope*.[14]

In 1955, Walt Disney was rushing to open Disneyland on one hundred acres in Anaheim, California. Disney himself had planned the site to the nearest detail. Close to the entrance he laid out "Main Street, U.S.A.," the business district of a typical late nineteenth-century town. Here, people could walk through a saloon, a haberdasher's emporium, hardware and dry goods stores, a bank and a livery stable. Disney asked Burtin to design the drugstore for Main Street (Figure 45), with its mortar and pestle, weigh-scales, period glass-ware, "friable" pills, patent medicine powders and various nostrums. Nineteenth-century anatomical, medical and pharmacological books joined the paraphernalia on counter tops and shelves. In pre-war Germany, Hilda Burtin had drawn animation cells of Pluto for Disney. Now she began researching for his Disneyland drugstore.

Walt Disney intended nostalgia, not irony, but his new Disneyland was celebrating commerce in small-town America just when it began to die, migrating along new highways into new city suburbs, new supermarkets, new shopping malls. In the 1950s, boarded-up stores in small towns often reopened as "antique" shops, stuffed with the belongings of people and businesses moving away. The Burtins furnished Disneyland's drugstore from such places in small, dying towns – notably Newburgh and Woodstock, New York. Hilda Burtin's notes list some items. She also collected old books for research. Many of these retain her bookmarks; dozens of yellow slips torn from Will's legal pads mark illustrations that she photographed for wall-mounted advertisements and posters in the drugstore on Disneyland's Main Street, U.S.A.

Expanding business forced an office move, to better space in a less elegant building, a walk-up at 132 East 58th Street. Success brought Burtin more stability, giving him time to devote to the philosophy of design. He was in the founding group for the International Design Conference at Aspen (IDCA), serving as program chairman in 1955 and 1956.

His working notes describe IDCA's mandate as: "a forum for the study of Design in its larger concept as one of the important distinguishing features of our civilization – a social and cultural technique as well as a technological one… It is an attempt to express and integrate ideas expressing the different viewpoints of three groups," Burtin writes – creative professionals, educators, business executives – "that makes the Aspen meeting unique."

Aspen drew delegates from distant places. The young Australian designer Arthur Leydin quit his job at a Melbourne agency to attend the sixth IDCA in 1956, after which Burtin hired him. Leydin would have stayed longer – a letter from Burtin appealing to the U.S. Immigration and Naturalization Service attests to the quality of Leydin's work, but INS refused to renew his visa.[15] Leydin writes of his months in the U.S.:

> A small folio of work was my show and tell armoury to
> such luminaries as Saul Bass, Herbert Bayer,
> FHK Henrion and others … Will's quiet demeanour and
> concern for detail is an overriding impression of my stay
> … His designs were always sound, rational and good.

They were visually arresting but never as a primary purpose. Will endowed design with a professional attitude much to be admired, certainly by myself … . My period with Will was of inestimable value and established a pathway for my design practice.[16]

Papers in the Burtin archive show the degree of care that busy men – they were all men – took in planning IDCA programs and selecting speakers for each annual conference. Many of the memos, invitations, vetoes, criticism and praise came through the program chairman's office, and eventually into his archive.

Conference planners treated the evolution of IDCA, its programs and invited speakers, as design challenges *per se*. "Program Memorandum Number 1" sets out "Thoughts and plans for the Sixth" IDCA, in June, 1956.[17] It begins:

> Preparations for the next conference started immediately upon conclusion of the fifth … . The conference itself is being looked upon as a *problem of design*.

> … The elan and enthusiasm, which the last conference gathered among us, came from the driving force of ideas that were expressed, and from the planned ease of social contact.[18]

Correspondence records committee members debating proposals for IDCA programs and speaker invitations. In 1955, Saul Bass served on the program committee with Burtin, Jim Fitch and others. Bass, like Burtin, was renowned for precision. He designed title and credit sequences for nearly sixty feature films and storyboarded one of the best-known scenes in cinema, Janet Leigh's fatal shower in *Psycho*. In the winter of 1955–6, Bass and Burtin were thrashing out a different scene, the IDCA Conference program for the following June:

> Burtin, in "Memorandum Number 1," asks: "Why conferences? Why do we meet? To 'think aloud' with people in related disciplines, to exchange ideas, to

listen, to learn, and in general to spend our time on subjects which provide us with inspiration."

Bass responded on January 9 1956: "Dear Will … You say 'Why conferences?', 'Why do we meet?' Yes, 'to exchange ideas, to listen, to learn and to spend our time on subjects which provide us with inspiration' … but more particularly to develop values with which we can measure our acts; the acts of others; the meaning of past events; the direction of the present; and the possibilities of the future."

Burtin: "Considering the fateful nature and tremendous creative opportunity of our situation" – [the height of the Cold War, the arms race, nuclear testing] – "it seems quixotic to be merely concerned with narrow professional discussions about art and design no matter how brilliantly delivered. The arts and sciences will not find in themselves the solution to problems of deeper and wider human understanding, unless they leave the harmful position that they are not morally involved and not co-responsible for our environment."

Bass: "To consider the future, we must extrapolate from our environment, and to consider environment means to consider history. … To be contemporary, then, perhaps means to see contemporary events in their historical setting."

Burtin: "It is proposed that the program for the next conference be planned against this background … that the conference should establish a fuller understanding of past and present so that we can arrive at a better estimate of our human future."

Bass: "One of the problems that this conference has constantly faced is the tendency for it to leap over the past and present, and engage in utopian exploration and rambling. … The great appeal of Victor Gruen's presentation at the last [1955] conference … was that in the minds of the audience he was presenting a solution that did not skip the present (and therefore the past) in order to get to his future planned community."

Burtin: "It is proposed … that planning for a better human future transcends most existing problems and … that the formative professions of art and sciences

should define a positive relationship toward this aim."
Bass: "Reacting to your placement of science in relation
to the conference, I believe this must be clarified …
I am reminded of an apt quotation from something
I was reading recently: 'Science is the art of knowing
and art is the science of feeling.'"

Airmail carried these thoughts between Los Angeles
and New York, gaining input from other committee
members.[19] With each iteration, the 1956 IDCA
conference in Aspen took shape. The program that year
shows Burtin promoting innovative Swiss design as a
model for the larger world. A draft of his post-
conference report to *Graphis* states:

> Mueller-Brockmann demonstrated the drive for clarity,
> logic and visual power in Swiss architecture, applied arts
> and advertising, which he felt came close to a harmonious
> interplay of science and art through disciplined 'concrete'
> styling. … The Swiss graphic designer and teacher,
> Armin Hofmann, presented a step-by-step educational
> procedure which starts with elementary propositions and
> allows for increased versatility of approach to a problem
> as skill and inventiveness grow. It became noticeable that
> the "three Swiss" – Max Frisch was the third – represented
> a remarkably unified and disciplined approach to
> architecture, graphics, typography and education, which
> impressed the audience strongly.

Mueller-Brockmann's address shows a man determined
to fight the rush to the lowest common denominator
promoted by commerce. Good design had to assert
clarity in a climate where atomic weapons were
proliferating, and where "loss of direction and purpose
have become the distinctive marks of our time." For
years, he explained, "a number of serious artists, and
with them the 'Schweizerische Werkbund' [Swiss-style
cooperative] have been struggling against this trend."

In the mid-1950s the Swiss were indeed design
pioneers: in at least one area they managed to impose
clarity on worried times. In 1957, Switzerland

produced the Helvetica family of fonts. Mueller-
Brockmann would soon be promoting Helvetica in
what Burtin described as his "drive for clarity, logic and
visual power." Burtin himself would soon promote
Helvetica in North America. But that's another story.

Figure 46
Upjohn pharmaceuticals came in many different packages, a safety
precaution to eliminate confusion on assembly lines. For the same
reason products were color-coded into pharmacological families. These
constraints required Burtin's new logo, layout and typography to imprint the
Upjohn brand. He was acutely aware of "branding" as an American term,
meaning to stamp a rancher's mark on cattle.
Used by permission of Pfizer Inc.

5

SCIENTIFIC VISUALIZATION: FROM VIRTUAL TO REAL

Before anyone else, [Will Burtin] realised the need of science and scientific concepts and theories to be understood by people other than scientists, and he knew that only a designer who can talk to scientists would be in a position to put these concepts clearly and dramatically across.[1]

By 1957, Burtin had been working for Upjohn for over a decade. From 1947, when he created the first text-only version of the Upjohn logotype, through the early 1950s, the company was happy to be a test-bed for his new concept, soon to be called "corporate identity." Designers George Klauber and Ivan Chermayeff spent months with medicine bottles, ointment tubes and assorted packages – Upjohn's product line – as well as company letterhead (Figure 46) and forms. They were creating the new corporate look.[2] Don Ervin, Klauber's former classmate and the future corporate identity specialist, worked with him for a while. Another Klauber classmate, Andy Warhol, dropped in, performed a freelance task for Burtin and presented him with a hand-sewn book.[3]

Early in 1957, Upjohn conducted a survey among doctors receiving *Scope* (Figures 47, 48, 49 and 50). The result was disappointing: the magazine was well respected; it stood out positively from its competitors; respondents linked the distinctive product to Upjohn, giving the company leverage, but few doctors actually

read it. They had too much to read and too little time. Upjohn's decision to discontinue *Scope* might have been disastrous for Burtin, who was paid a retainer as well as fees. But he had sensed his client's move and was prepared, although his fallback position was a huge gamble. In 1957, when Burtin proposed to steer his client's marketing and communications in an untried direction, Upjohn's senior managers must have had serious doubts. In the end they voted to trust his judgment. Trust was essential. The vast majority of companies would have rejected his scheme out of hand. At first glance it must have struck even Upjohn's corporate managers as a huge, unprecedented business risk.

But Burtin had prepared his sales pitch well. The man with a Grade 8 education had made his mark in Depression-era Germany by selling well-designed product catalogs to hard-nosed men in work-boots – building-supply merchants. And, two years before he made his proposal to Upjohn, he had told his audience at Aspen, "Before we sell something to business we should know what we are selling."[4] Burtin had never worked in an ivory tower. When he proposed that Upjohn should commission him to build a gigantic model of a human cell, he knew very well what he was selling, from scientific, communications and marketing points of view. Cytology, the study of the cell, was in

Figure 47
Eggs and capsules combine in Scope *(1957) with
the text, "Birds' eggs and vitamin capsules belie
with their simple exteriors the great and varied
potentialities that lie within." Burtin's power to
devise visual metaphors was one of his strengths.
Used by permission of Pfizer Inc.*

fashion. Researchers and medical doctors believed that
understanding the anatomy of living cells was key to
discovering what ailed them: i.e. cancer. Hence Burtin's
timing. But could he convince his clients to buy into
his vision?

At Upjohn, company president Jack Gauntlett, and Dr.
Garrard Macleod (Figures 51, 52 and 53), the director of
special projects, made the courageous decision to fund
Burtin's first large-scale scientific model, a human cell
7.35m (24 feet) across and 3.67m (12 feet) high. As
Burtin's friend and sometime colleague, British designer

F.H.K. Henrion, put it: "He soon started to conceive
the design and [build] giant models of things nobody
had ever seen and which hardly could be seen, not even
under the microscope."[5]

Henrion's point is crucial. Burtin would eventually
design five large models for Upjohn, and one for Union
Carbide. But it was here, embodied in the Upjohn *Cell*,
that the modern concept of scientific visualization
was born.[6]

Figure 48
From first issue to last, *Scope* magazine may provide the best case study of how a designer's skill can translate complex data into easily grasped, symbolic visuals. This cover flags the story, "Telling lines – some notes on graphs" (Spring 1953).
Used by permission of Pfizer Inc.

Figure 49
Burtin's *Scope* covers illustrate his leadership in information design. Here, diagrams introduce the feature, "Central Control of Blood Pressure."
He wrote in 1959: "I believe that my principal professional calling lies in the simplification of problems as I find them in communications, so that a clearly recognizable and enjoyable order result."
Used by permission of Pfizer Inc.

In 1957, biology had yet to discover many components and functions of living cells. Watson, Crick, Wilkins and Franklin had revealed DNA's double helix just four years before. Electron microscopy was retrieving images of cellular structures which science had not explained. How did cells relate to each other? How did they function internally? Did they invite cancer? What were mitochondria? Everyone wanted to know.

Despite the many uncertainties and competing theories, Upjohn financed, and Burtin designed, a giant walk-through model of a "generalized" human red blood cell.

When complete, this huge model would demonstrate the interrelatedness of cellular functions, linkages among organelles (an organelle is a structure in a cell that performs a specific function), and a vision – Burtin's vision – of a cell's physical structure. When the *Cell* took shape in plastic, wires and light, this vision would not be an actual representation. It couldn't be. Too much was unknown. In its final form, the *Cell* would show organelles and suggest functions and relationships still being debated in learned journals. The soon to be internationally famous model would be a visual, tactile, light–bright representation of a virtual

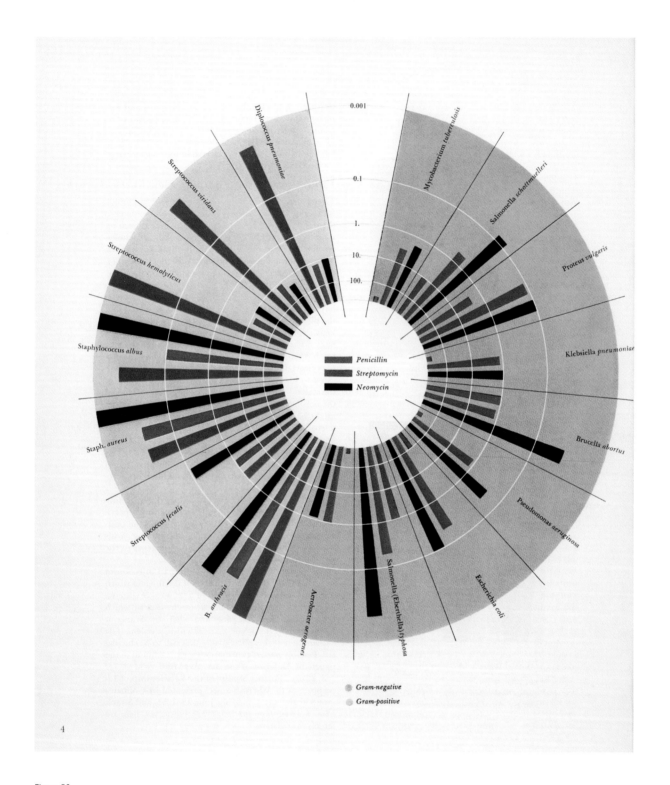

Figure 50
Burtin's diagram compares impacts of Penicillin, Streptomycin and Neomycin on a range of bacteria (*Scope*, Fall 1951). Used by permission of Pfizer Inc.

Figure 51
Burtin with Dr. A Garrard Macleod and part of the *Cell* exhibit.

Figure 52
Burtin, Dr. Macleod and an unidentified executive. Macleod, Upjohn's Director of Special Science Projects, was Burtin's principal client, commissioning *Scope* and championing major models.

human cell – a giant, physical manifestation of a designer's vision, and, as it turned out, a vision that was not far from fact.

Burtin could never have built his vision without the benefit of a new class of materials: easily-worked plastics. He had used them to novel effect in his *Integration* exhibition a decade before. Thanks to The Displayers, Inc., the company that built the *Cell* to Burtin's design, plastics would work for him again.

The *Cell* was designed to impress the same people who had been receiving *Scope* for more than a decade: medical doctors. The walk-through model, one million times larger than life, was unveiled in September 1958 at the American Medical Association's meeting in San Francisco. Upjohn's *Cell* dominated the convention, an object at once monumental and without precedent,

> like a huge plastic tent full of all the invisible components which made up a cell, shown imaginatively, clearly, and in a way which enchanted scientists and the general public alike.[7]

The sheer bulk of this extraordinary thing amazed physician-delegates. The lighting compounded their amazement. The Displayers' electrical team, led by consulting electrical engineer Martin Salz, installed one mile of electric wiring, most of it in the walk-through base,

> to provide lighting from within. The effect of movement and pulsation, giving the appearance of a living structure, is created by rheostat-controlled blue light traveling around the base of the structure at 15 rotations per minute.[8]

Carol Burtin Fripp recalls, "It was alive! The thing was alive!" Seeing the *Cell* (Figure 54) in action assuaged the teenage resentment she felt at having her bedroom used to store a growing number of plastic parts.

Upjohn had taken a huge gamble by backing Burtin's vision. Apart from the scientific uncertainties, nothing so complex had ever been made in modern plastics. Fortunately, Upjohn's gamble paid off. Brochures and press kits were careful to stress that "the Special

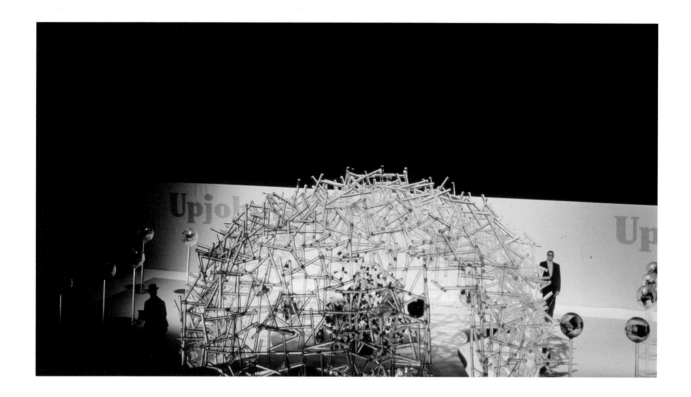

Figure 53
Burtin's walk-through *Cell* exhibition for Upjohn (7.35m x 3.67m). The *Cell* may be the most magnificent among many projects that emerged from the vision he described in his *Integration* brochure (1949): "With patience and further study, we will ultimately succeed in making our methods of visual organization more precise, and the designer's unparalleled opportunity for integrating the elements of our society, clearer to himself and to the world." Here was design innovation on par with the Isotype team interpreting public health standards in 1920s' Vienna, and Herbert Bayer's stylistic break-through in 1930s Germany.

Publications Department of The Upjohn Company [namely, Dr. Macleod and colleagues] ... consulted with many eminent cytologists." So did Burtin's team, including Edgar Levy. Levy, an artist, would sit with a scientist and – as a police artist helps a witness draw a suspect's face – Levy would help the scientist construct a three-dimensional visual interpretation from electron micrographs. He did this with many specialists, comparing and cross-referencing images. Burtin himself went on tour, gathering information:

To make sure that the message was told truly was only made possible by Will travelling from University to University in the US and in Europe ... evolving and checking his ideas in lively dialogue with the experts. It is this activity which is so essential and new which Will pioneered, a designer ... asking questions: 'could this be shown like this? could it have this colour? could it have this shape? should it be like this? would this be possible? would this make it clearer?' [As a result, Burtin designed the] three-dimensional realisation of what was hitherto couched in theoretical, scientific and generally incomprehensible language.[9]

Client and designer knew the risk: experts had to be "sold" on the credibility of the *Cell* before doctors and the press would accept its authenticity. Until it was unveiled, the verdict was touch and go. Here's George Klauber:

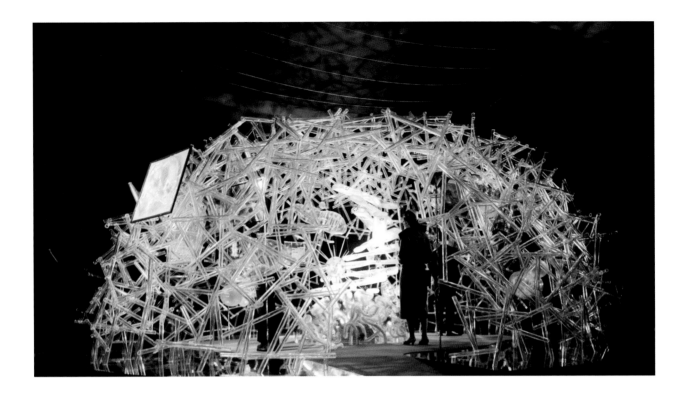

Every doctor and scientist had a different interpretation of what cell structure would look like enlarged one million times. There was absolutely no agreement, so Will, with characteristic audacity and insight, made the decisions necessary to complete a working model. The result was an overwhelming success – although a few of the very men who could never take a stand or commit themselves were quick to challenge it.[10]

The fact that the *Cell* "enchanted scientists and the general public" owed much to the coordinated "form and function related" research. By the end of the AMA meeting, the physician-delegates had accepted the model as an iconic representation of a cell. The national press reflected the delegates' mood, and the stature of the *Cell* blossomed as an icon.

The final physical form of the *Cell* was diagrammatic, rather than literal. It had to be. Despite best efforts by Levy, Klauber, Raitzky and others, multiple

Figure 54
Burtin's relationship with Upjohn lasted 30 years, ranging from print to advertising, packaging and corporate identity. Will Burtin, Inc. was Upjohn's design department before outsourcing became popular. His visionary exhibition models were high points. Burtin called them "exhibit sculptures." Used by permission of Pfizer Inc.

consultations with researchers sometimes yielded to Burtin's best guess – his intuition. "Like any art form, the work has its own reality. The *Cell* was a shot in the dark," Klauber emphasized again, to Remington. "We could not get the doctors to agree. Will took chances where angels would fear to tread."[11]

The team prepared its ground well. In the brochure, matching photographs of a mitochondrion (a cell's energy generator) and a plastic model of it are supported by the caption: "An example of the process of converting the information obtained from an electron micrograph to a three-dimensional plastic structure."[12]

The effect of this quest for authenticity established Will Burtin, Inc. as the pace-setter in scientific visualization. Burtin attracted such comments as, "With a designer's vision, he saw clearly how a molecule of a certain shape might be shown. Scientists were 'eternally grateful for the interchange of visualizations,' said a leading scientist."[13]

The Upjohn *Cell* benefited from the Burtins' friendship with Cipe Pineles and her husband, CBS art director William Golden. Before the *Cell* made its debut at the AMA meeting, The Displayers' team, led by Peter Corn, trucked its five modules from Tenth Avenue to CBS and assembled them in a studio where the model was put to the test. CBS contributed more than a dry-run studio. Correspondent Walter Cronkite recorded the narration.

From the start, preparing the *Cell* for its public debut was a race against time. Yves Zimmermann, fresh from design school in Basel, flew to New York in 1957 to take up a first job with Will Burtin, who put him to work on early models of the *Cell*. Zimmermann was later joined by Burton Kramer, another recent graduate. Given the opportunity of working for either Herb Lubalin or Burtin, Kramer had chosen Burtin, "partly because it was a small office" – a small office with too much work. Kramer's initiation to design work was a baptism of fire. He found himself "working on the *Cell* model at five in the morning in a warehouse [The Displayers' shop] with no air conditioning." Kramer created the model for the final design, but moved on before the *Cell* was complete – although not because of his working conditions. "That first job working for Will had a big influence on my career," he recalls. "It wound up influencing most of my working life."[14]

Many people worked long hours before the *Cell* could make its debut in San Francisco. First, Ezra Stoller had to photograph it: in color, for slides, brochures and posters; in black and white, for press releases. "The Upjohn Cell" featured in publications large and small, including a color spread in *Life*.[15]

Assembling the *Cell* at CBS gave Stoller total lighting control. A standard studio backdrop of black velvet ("limbo" in television jargon) provided the dark surround. Stoller used CBS lights in the *Cell*'s well-known master shot to pick out the model from the limbo behind it. External light painted highlights on, and drew reflections from, many of the 2,200 clear plastic tubes forming the cellular membrane around the nucleus and organelles. The majority of the lighting came from the *Cell*'s internal illumination, built into its base.

The rheostat-controlled blue light traversing the model every four seconds certainly made it look "alive," but posed a challenge to still photography. The blue light did not simply sweep around the structure; rheostats varied its intensity, so that the *Cell* appeared to throb or pulse (giving the effect one sees in a phosphorescent jellyfish). Martin Salz, who had designed the circuitry for The Displayers Inc., adjusted his lighting for Stoller's still photographs.

The *Cell* survived the short truck ride from The Displayers, Inc. to CBS without ill effects, but its journey across the continent proved disastrous. We may guess the extent of the disaster from Upjohn's description of its model:

> Over two-thirds of a mile [approx. 1.06km] of special acrylic plastic tubing was cut, fitted, held in position by unique clamps, and cemented to represent the cytoplasm. There are 2200 pieces of this tubing and more than twice this many hand-made cemented joints. The whole structure is made on a five piece module, continuously repeated, the pieces joined at an angle of 78 degrees. … The plastic acts as a "light-gatherer."[16]

George Klauber, waiting in San Francisco, was appalled when he opened the crates. "In the cross-country ride it was smashed to pieces!" Klauber recalled that he never dreamed he could put the pieces together again. "Will told me, 'Do the best you can.'" And he did. Apart from

giving the model structural strength – the *Cell* had to bear up while a multitude walked through it – the "light-gatherer" tubes could transmit light through the plastic from one to the next only through a tight joint. A broken joint transmitted nothing. "We opened that show with these things scotch-taped!" Klauber, recorded forty years later, still sounds amazed and relieved. "You know, scotch-tape adheres to Plexiglas really well!" Upjohn's walk-through *Cell*, scotch-tape and all, was a major success. "We made front pages of papers all around the country."[17] Scientists and engineers read about the Cell in IBM's *Journal of Research and Development*, in a piece commissioned by the company's director of scientific communication, Bruce MacKenzie. "The Upjohn Cell" featured in newspapers and magazines across the U.S., including a double page color spread in *Life*. In August, *Industrial Design* ran a feature, "The Design of the Cell."[18] In September, to follow up its launch at the AMA, Upjohn featured the *Cell* in an advertising spread in *Scientific American*.

The *Cell* was so popular that Burtin designed a smaller version, 2m across. Stoller photographed the *Cell* (Mark II) by lighting it from behind while posing Carol Burtin in front, creating a dramatic silhouette to show scale. Easier to transport, the *Cell* Mark II stood in for the giant Mark I. For example, Mark II was perfect for a hospital foyer, where it received invited guests:

> The Los Angeles County General Hospital in cooperation with the University of Southern California School of Medicine are pleased to invite you to a special viewing of a unique, three-dimensional model, The Basic Cell, at the auditorium foyer (acute unit) of the hospital, Wednesday, Aug. 12 1959.

Industrial design graduate Constantine (Conny) Raitzky joined Will Burtin, Inc. in time to erect Mark II (he calls it the "six foot *Cell*") in that foyer, "a very beautiful setting," before escorting it to Disneyland, where two million people saw it. Thence it traveled to the San Francisco Academy of Sciences.

Figure 55
In 1959, the *Cell* became a set for two hour-long BBC Science Specials. Presenter Professor Michael Swann (left), BBC Television's chief science advisor, Gordon Rattray Taylor (right) and Burtin prepare for broadcast.

Fifteen months after the giant *Cell* (Mark I) made its debut in San Francisco, BBC television producer Aubrey Singer had the model (Figure 53) shipped to London to feature in two BBC Television science specials. The up-market *Illustrated London News* welcomed the *Cell* to Britain by giving a full page to Stoller's photo of Mark II – 'a glowing and mysterious hemisphere.'[19] Under the headline, 'UNUSUAL PHOTOGRAPHS–NO.16. THE MICROCOSM MULTIPLIED.,' the editor ran a 200-word caption, an indication of the publicity that the *Cell* continued to bring Upjohn.

The *Illustrated London News* told its readers that the *Cell* Mark 1 was being assembled in a BBC television studio. There, it would serve as its own set, from which the BBC would broadcast two "Science Internationals" dealing with "The Origin of Life." (Figure 55). The first, "What is Life?" (December 1 1959), explained the nature of living cells. A week later, "The Last Scourge" explored cancer research. A professor from the University of Edinburgh chaired both episodes: British, American, French and Russian scientists took part.

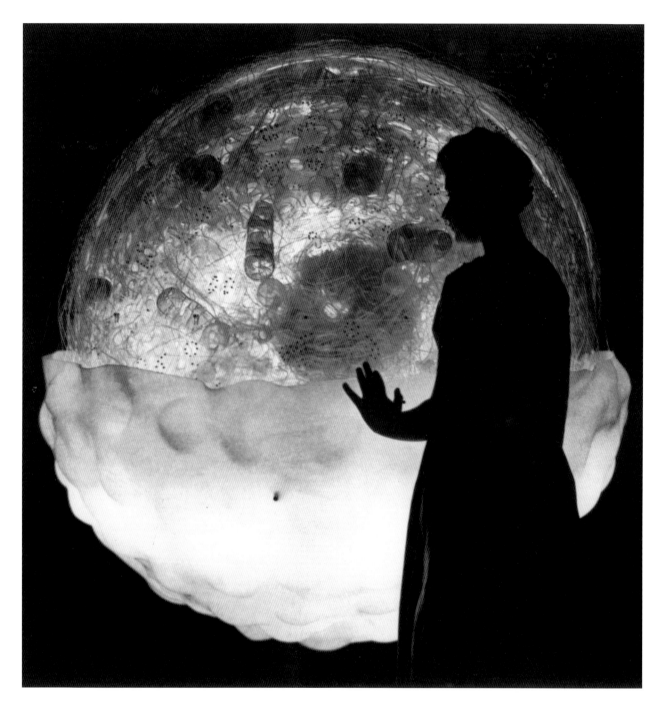

Figure 56
The full-sized *Cell* was too large to go everywhere, so Burtin's team built a
smaller model, which designer Conny Raitzky calls the "six foot *Cell*." In 1958,
Ezra Stoller posed Carol Burtin with it to show scale. Several publications ran
this image. The *Illustrated London News* gave it a full page in 1959 above text
promoting the BBC Science Specials. Photo by Ezra Stoller © Esto.

It was no error that the magazine ran the photo of Mark II while promoting programs featuring its big brother. The staid *Illustrated London News* was slow to move to color: the black-and-white portrait-format Mark II suited the publication better than the landscape-format Mark I. Here, and elsewhere, the smaller Mark II won the Upjohn *Cell* additional exposure.

The BBC worked hard to make these programs. Producer Aubrey Singer filmed expert guests ahead of time. The live-to-air programs featured studio-based hosts, seated in the *Cell*, and these filmed interviews.

While in London for the BBC broadcasts Burtin began drafting a presentation. He was proposing to build a large-scale model of a uranium atom for the foyer of Union Carbide's new corporate headquarters in New York. This was no back-of-the-envelope draft. His preliminary notes are written on hotel stationery from The Dorchester, Park Lane.

In the week between the two BBC programs, the Film Unit of Shell Oil came to the studio and filmed the *Cell*, dedicating their color film to the Royal Society's 300th anniversary. The model then visited the University of Edinburgh, and was still on the move three years later, when Burtin's friend Willem Sandberg assisted the *Cell*'s exhibition in Amsterdam.

Did the client get its money's worth? Upjohn thought so. It funded four more large-scale three-dimensional designs. More than ten million people walked through the *Cell* in just three cities, New York, Chicago and San Francisco. Many more came to marvel. Visitors left with pieces of Upjohn literature (Figure 57).

Press coverage was copious and generous. As Klauber told Remington: "We made front pages of newspapers all around the country." Editors found Stoller's photographs hard to resist. Between eleven and fifteen million Britons watched part of each BBC program. "This historic telecast as well as films made on that occasion were viewed around the world by more than 40 million people." Upjohn estimated "its publicity value alone, aside from its impact on science communication," at $10 million in 1959 money, a return on investment of 28.6 to one.[20]

Pay-off kept coming. "Schools and universities asked permission to build cell models of their own from our drawings and photographs, proving how profoundly public imagination was stirred by the 'breakthrough' of a presentation concept."[21]

> The primary value of such models, as well as graphic design work preceding and following them, was they reduced the time necessary for the study and understanding of a science problem. … One physician after wandering through the structure of a basic cell, stated that "it reduces six months of detailed study to six minutes of visual and physical exercise." It made him and his students again curious to re-study the original cell under the microscope, but this time on the basis of a more dynamic understanding of the total, generalized, image.[22]

Burtin is referring to the *Cell*, while supporting his thesis that good design can explain the inexplicable; that it can make the most complex scenarios crystal clear. Good design cut air gunnery training times from twelve weeks to six. And the walk-through *Cell*? From six months to six minutes, apparently.

Textbook publishers used Stoller's photographs, transmitting the iconic *Cell* as "science communication" to young people. Born in 1972, biology graduate Jon W. Benjamin worked in a laboratory for five years before returning to the Rochester Institute of Technology (RIT) to get a graduate design degree. In 2000, Benjamin wrote:

> [Will Burtin's *Cell*] … had a tremendous effect on my attitude and knowledge. I remember it clearly. I was in fifth grade science class struggling to understand the

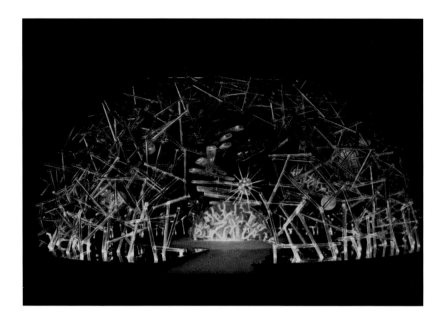

Figure 57 (left)
Take-home brochures for the Upjohn *Cell* varied in size and content: a small format brochure for its 1958 launch at the AMA convention in San Francisco; a larger version for the Museum of Science and Industry (Chicago, 1959).

Figure 58 (below left)
Upjohn featured the *Cell* in a two-page *Scientific American* spread (September 1958), extending its success at the AMA convention. Descriptive text promoted Upjohn's cutting-edge research: "Summarizing and coordinating current knowledge is the first step in creative thinking such as is required in supplying up to date pharmaceutical preparations … ."
Used by permission of Pfizer Inc.

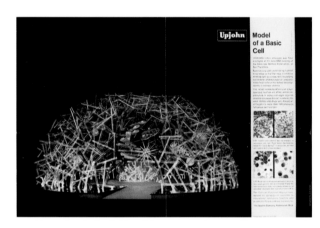

basic ideas being presented to me. But when I turned to the page in our text that displayed Burtin's *Cell* I became extremely intrigued, … I thought, how interesting and fun science could be if there were more of these models! … Finally I entered RIT as a graduate graphic design student and rediscovered Will Burtin's work. Upon seeing the image of the Upjohn *Cell* in *A History of Graphic Design*[23] my search seemed to have come full circle. … Design can and does affect people's attitudes, knowledge or behaviour. Sometimes as in my case, design can profoundly affect people. Will Burtin and his work has profoundly affected me, my career and my perception of the living world.[24]

Benjamin reached Grade 5 in 1982. Twenty-four years after the *Cell* was unveiled to America's doctors it was still impressive and impressing. Benjamin's comment would have pleased Burtin, for whom design was the educational tool that made complex subjects crystal clear. He taught for most of his working life, accepting without question that a designer was a teacher. In his mind, those roles were interchangeable. He lived a career of "information design" decades before that phrase was born. The Upjohn *Cell* is among the best exemplars of his thinking, and his craft.

6

KALAMAZOO WOWS GERMANY: HELVETICA FINDS NEW YORK

Will Burtin, Inc. prospered in the 1950s. IBM commissioned the studio to develop the format for its *Journal* from scratch. Betti Broadwater (later, Broadwater Haft) worked with Burtin from 1956 to 1958. In March 2006 she recalled:

> [We developed] the format and, in the beginning, the production for the early issues and the experiments to make the content accessible in terms of image as well as in words and numbers.[1]

Making the content "accessible" demanded audience-testing not unlike that required by Burtin's gunnery manuals a decade before. But, whereas the Air Forces' manuals were designed to be studied by poorly educated recruits, IBM's readers occupied the opposite end of the spectrum.

During his time with the OSS, Burtin had made valuable contacts in the intelligence community. In 1953, a federal government Reorganization Plan established the U.S. Information Agency, staffed in part by OSS veterans. The USIA became a steady client. In 1957, it commissioned a traveling exhibition to tour Great Britain, then Germany:

The city of Kalamazoo was selected by the United States Information Agency as the subject of a traveling exposition depicting a representative Midwestern American community in growth and change. The purpose of this exposition, *Kalamazoo – and how it grew*, which toured Great Britain from December 1957, through August 1958, was to give our British friends a better idea of what the everyday life in our country is like apart from the impressions which so many of them get from our movies, television programs, wealthy tourists and military personnel.[2]

It was no accident that the city selected to give the British a taste of "representative" America was Kalamazoo, Michigan, home of Upjohn, Burtin's major client. *Kalamazoo – and How It Grew!* (Figure 59) took shape as a set of displays explaining: town history, "from log cabin to bustling city"; agriculture; paper-making; city management; drug manufacture in a "spacious factory" (Upjohn's); healthcare and U.S.-style insurance.

Betti Broadwater coordinated aspects of the Kalamazoo exhibition. She recalled:

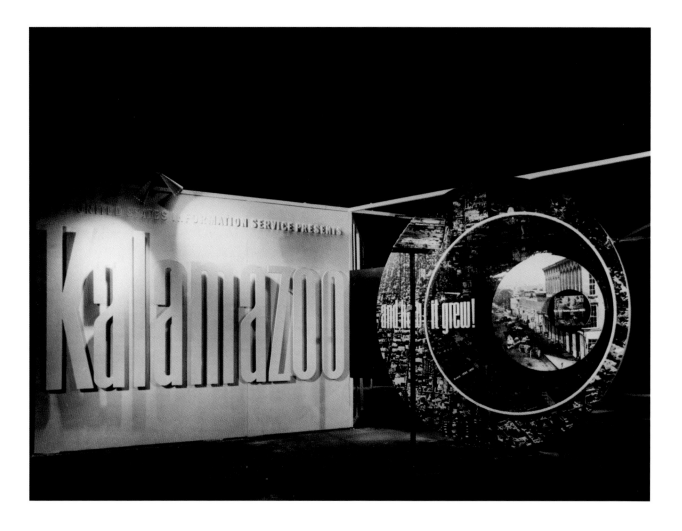

Figure 59
The USIA commissioned Burtin to create a touring exhibition showing life in a "typical" mid-sized American town. Several future stars of American photography documented everyday activities in 15 representative families, for a multi-media exhibition touring eight British cities (1957–58), and Berlin (1958).

Photography was an essential tool. I brought in three friends from the Limelight Coffee House and Photography Gallery, Jay Maisel, Garry Winogrand and Lee Friedlander. Garry not only won over Will but apparently charmed Kalamazoo natives with his New York ways into revealing themselves in a most productive fashion.[3]

These future stars of American photography joined Ezra Stoller in recording everyday activities in Kalamazoo. Apart from the photos selected for the project, much of this "Kalamazoo archive" remains unpublished.

Attendance was excellent, thanks to efficient press campaigns and a city-by-city "Kalamazoo limerick" competition. Information Officer David Macleod reported:

The general reaction in most places was one of pleasant enlightenment. Interest centered around the individual and his life and most of the questions concerned

American family, life, working conditions … cost and standard of living, social welfare, health and hospital conditions … .

In 1958, the USIA sponsored a German version for the West Berlin Industrial Fair. Here, Burtin had to redesign an unsuitable building as well as his exhibit. *Industrial Design* magazine was favorably impressed. Under the headline "Ribbon ties show together," its reporter wrote:

> One of the most satisfying ways for exhibition designers to integrate form and content in a show is to use some of the subject matter as the vehicle for its own presentation. Graphics designer Will Burtin … has done it by using a ribbon of aluminum that looks like an unrolled roll of newsprint. The device has a dual function: it serves as a symbol of paper making (Kalamazoo's biggest industry), and it gives unity and form to an awkward space.[4]

The space was awkward indeed. A long, curving corridor led into the narrow end, on the second floor, of a two-story hall. For lack of space, the exhibit had to start in the corridor, where twelve interconnected revolving discs showed life in Kalamazoo during each hour of an average day. Nothing daunted, Burtin linked these first displays to others in the main space by running an unrolling aluminum ribbon along the corridor until, where the corridor joined the hall,

> the ribbon turns on its side and loops and swirls through the high room. Visitors walk along the balcony to a staircase, where they descend to the main floor.

When visitors emerged from the corridor to look down over the length of the hall, the purpose of the unrolling aluminum ribbon suddenly struck them. The bright ribbon represented raw paper being processed in the mill. "Although the ribbon display was not planned for this purpose, it is well adapted to the needs of a traveling show," *Industrial Design* reported. Burtin had improvised the ribbon that "ties show together" to solve a crisis.

Kalamazoo, ein Mittelstadt im Mittelwesten[5] drew 40,000 visitors a day, and 430,000 in its first two-week run. To meet the demand, the USIA reopened it, twice, and asked Burtin to create a traveling version that toured America Houses throughout West Germany. When it closed in Berlin, U.S. Foreign Service Exhibits Officer Gerhard Drechsler wrote to Burtin:

> I wish you could have seen the interest which the exhibit aroused among the groups of East Zone refugees. It was a keen, active, intelligent and wholly sympathetic interest. These people were without a doubt our most appreciative audience.[6]

In a divided city in a divided country, the Kalamazoo exhibition was effective propaganda. The exhibition was not without incident. Western Michigan University had provided two large hams for the kitchen display. Everyone coveted these, the local staff no less than visitors. Hams the size of violin cases were unattainable by most Germans in 1958. The staffers jealously guarded the hams to eat at their wrap party. Fortunately, Drechsler reported, before they got the chance,

> By some stroke of luck [we] … happened to look at the shipping notice to find they were not to be eaten but to be destroyed by fire [because they contained] a very high amount of poisonous preservative … . What a climax to the exhibit this would have been! … we also thought of using the hams as give-away to the 400,000th visitor who happened to be, by personal selection, a very attractive young girl out of the East Sector. Here again fate robbed the head-lines but saved us.[7]

Burtin replied from New York,

> It would have been more than unfortunate to have the name "Kalamazoo" forever associated with mass murder.[8]

Kalamazoo drew crowds in Berlin and a national television audience which included several excited fans in Cologne: Burtin's sisters, Rosa and Leni, happened

Figure 60
Burtin with his model for *Kalamazoo — and how it grew* (1957).

to be watching the television news with their families when economics minister Ludwig Erhard appeared on the screen. The hero of West Germany's post-war economic recovery was being guided through the Kalamazoo exhibit in distant Berlin by the familiar figure of 15-year-old Carol Burtin.

From Burtin's point of view, the best fan of all was Donald Gilmore, CEO of Upjohn with two family ties to the company's founder. Gilmore was so impressed by the Kalamazoo exhibition that he became one of several

corporate officers "who supported Will from the days of the Berlin exhibit."[9] Since Gilmore remained Upjohn's CEO until he was past 70, his tenure represented a lot of support.

In the summer of 1958, Will and Hilda Burtin flew to Zurich. Europe was still struggling to rebuild, but the neutral Swiss, untrammeled by war, continued to explore concepts bequeathed by De Stijl and the Bauhaus. Basle and Zurich were progressive design centers in the mid-1950s – the movement came to be

Figure 61
Will Burtin was among a select group of American graphic designers who
championed Helvetica, the new sans-serif font, in the early 1960s. Its large
x-height (in which the lower-case area occupies a greater proportion of the
type slug than usual) makes it very legible. Yet its construction permits tight
letter spacing, making it popular with designers. Max Miedinger and Edouard
Hofmann based Helvetica on Akzidenz Grotesque, popular at the turn of the
twentieth century.

known as International Typographic Style. Designer Theo Ballmer and architect, painter and sculptor Max Bill bridged the gap between pre-war, and new, influences; while designer Josef Mueller-Brockmann was a leading proponent and innovator. From Bill, Mueller-Brockmann and others, the Burtins discovered Swiss innovation first-hand.[10] The previous year, 1957, designers Max Miedinger and Edouard Hofmann had released a new sans-serif font, Haas-Grotesk, at the Haas Type Foundry, near Zurich. In just one year, Haas-Grotesk had taken Swiss typography by storm. It would soon dominate international typography under its better-known name, Helvetica (Figure 61).

Sans-serif fonts were not new. They had been favored for posters since the 1920s. Burtin's sample collection contained work printed in Zurich, dated 1953, that a layman might mistake for Helvetica. Perhaps it was the leverage provided by the dominant Swiss-centric International Typographic Style that launched Helvetica to global glory starting from the late 1950s. Burtin had declared his preference for sans-serif fonts as early as his 1941 supplement for *A/D* magazine, and perhaps earlier. During the summer of 1958, in Zurich, seeing work by Bill, Mueller-Brockmann, Ernst Keller, Armin Hofmann and others, Burtin determined to take sans-serif to a larger world. He was already campaigning for the "clarity" of Swiss Style, having invited three Swiss designers to address Aspen in 1956.

When the Burtins returned to New York in the fall of 1958, they imported Helvetica with them. Carol Burtin Fripp recalls her father's unwavering opinion: "Helvetica succeeds in conveying the message because it is so plain that there is nothing but the message to see. In this respect, the medium serves the message." In time, the myth grew that Burtin used only Helvetica. He championed it, certainly; but he used serif fonts when he considered them appropriate.

Typography was evolving in North America, too. On April 18 1959, the Type Directors Club of New York

held a one-day meeting at the Hotel Biltmore. That event, *Typography–U.S.A. 1959*, enjoys a cachet in the annals of North American typography.[11] Speaking as program chairman about *die neue Typographie*, Burtin told delegates that, if typographers were to serve the quickening pace of new knowledge, it was essential that they should present information clearly, for people to grasp quickly and easily.

> I like to think that typography in the U.S.A. has one of the finest opportunities that ever existed to contribute in a vital way to the building of this new harmony of art and science and life.[12]

Not everyone in his audience was enchanted by International Typographic Style. Among the thirteen leading art directors and typographers who addressed the forum, William Golden took issue with it. The down-to-earth Golden told the forum that: "If there is such a thing as a 'New American Typography' surely it speaks with a foreign accent."[13]

One imagines Burtin, who had opened the forum in his sepulchral Germanic tones, taking notice. Golden continued:

> And it probably talks too much. … Have we imported the European propensity for surrounding even the simplest actions with a gestalt? … Designers don't seem to be lucid writers or speakers on the subject of design.

> I have been frequently stimulated by the work of most of the people on this panel, but only rarely by what they have said about it.[14]

It may be that Burtin, who could be verbose – he bestowed on grand occasions more and grander words – registered this as a rebuke to others. It would not have occurred to him that Golden's comment might bear on himself. Unfortunately, Burtin's speech that day was not one of the ones his daughter edited for him, a process that produced marked improvement at the cost of two frayed

tempers. Whether or not his friend Golden was chiding
him on this occasion, there is no doubt that a Burtin
speech could put a few people to sleep.

An anonymous letter survives from that day. Carol
Burtin Fripp's family knows it as "the note from the
four guys in the eighteenth row." It is typed neatly on
letterhead printed for the occasion. The vertically
stacked header reads: "April 18, 1959 / Hotel Biltmore /
New York City / Sponsored by / The Type Directors
Club / of New York." Beneath this, the letter on a half
sheet of ragged-edged letter-quality stock reads:

```
Dear Will:

This comes from four guys who sat in the
18th row during the forum session. First,
we are friends who appreciate your work
for the TDC; second, we are aware of your
talent as designer. But may we help you --
and future meetings which you chair -- by
saying that, to put it plainly on the
line, you talk too long. You don't have to
be eternal to be immortal, as the man
said. Your audience will get much more
from you if you say more briefly -- and
more orderly -- what you have to say.
Yours, for a better meeting in the future
and for a better Will Burtin who knows
when to stop... .

Four Friends in the 18th Row
    who wish you well
```

We can exclude Bill Golden as an author: he was
among the panel on the podium. Anyway, the "four
friends" wished Burtin well, and he thrived. That year,
Pratt Institute appointed him professor of design and
coordinator of visual design. As for the "four guys"
note, they spoke the plain truth. The original is framed,
a curious sort of family treasure, beside Carol Burtin
Fripp's bed.

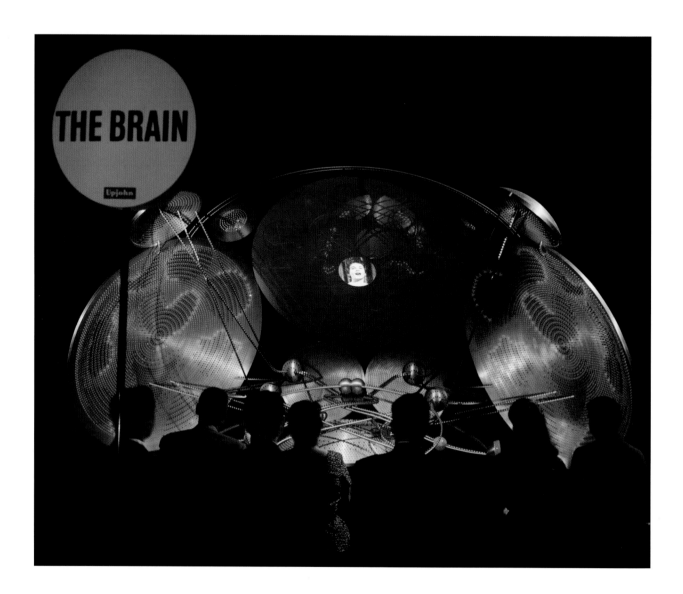

Figure 62
The Upjohn *Brain*, a working schematic in three dimensions. Where the *Cell*
modeled a physical object, the *Brain* introduced the concept of time—the time
messages take to thread neural pathways. Red lights represent visual stimuli;
green, auditory; white, muscle function. Photo by Ezra Stoller © Esto.
Used by permission of Pfizer Inc.

THE BURTIN *BRAIN*

MIAMI BEACH, JUNE 13 -- AN IMPRESSIVE
ELECTRIFIED MODEL OF HOW THE HUMAN BRAIN
WORKS WAS SHOWN HERE FOR THE FIRST TIME
TODAY.

THE MODEL, CONSTRUCTED FOR THE UPJOHN
COMPANY, PHARMACEUTICAL MANUFACTURERS,
KALAMAZOO, MICHIGAN, WAS SHOWN TO
PHYSICIANS AT THE AMERICAN MEDICAL
ASSOCIATION'S ANNUAL MEETING HERE.

This press release crossed America, announcing the
birth of the Upjohn *Brain* in 1960. To ensure that
editors took notice, the text reminded them of the
sensation Upjohn had given them two years before:

THE BRAIN MODEL WAS DESIGNED BY WILL
BURTIN, UPJOHN DESIGN CONSULTANT, WHO ALSO
DESIGNED THE UPJOHN COMPANY'S MODEL OF A
BASIC CELL A MILLION TIMES ENLARGED, WHICH
WAS SHOWN AT AMA'S 1958 MEETING AND HAS
ATTRACTED INTERNATIONAL ATTENTION. BOTH
MODELS WERE CONSTRUCTED BY THE DISPLAYERS,
INC. OF NEW YORK. MR. BURTIN DESCRIBED THE
NEW PROJECT AS A "TIME AND SPACE
DEMONSTRATION OF PRINCIPLES ON WHICH
CONSCIOUSNESS IS BASED."

From a design point of view, the key word in the
previous sentence is "time." Two months before the

Figure 63
The Burtin archive yielded this preliminary sketch for the *Brain*. To a
remarkable degree it resembles the product released three years later. Burtin
sketched and wrote most things on yellow, legal-sized lined pads.

press release went out, Burtin wrote, "The early design
phase of the brain project (Figure 63) preceded the
design of the *Cell* exhibit."[1] Why did the *Cell* come first?

As complex and magnificent as it was, the *Cell* had been restricted to depicting a physical structure. A massive, scaled-up sculpture of a static object, the *Cell* transformed two-dimensional electron micrographs into a three-dimensional sculptural interpretation of them. It was a true model.

But the *Brain* had to simulate mental function, thus reproducing cause and effect and therefore the passage of time. To achieve that, design and build teams had to take another logarithmic leap, out of three dimensions, into four. They were leaping from space into time.

Burtin had simulated the passage of time years earlier, managing the trick in gunnery manuals – vectored responses against moving attacks – in just two dimensions. Now he had to learn how to simulate the reception and transport of nervous stimuli, move them along neural pathways, and show them being processed before generating nervous reactions.

As Roger Remington points out, "Information developed in the 1950s, on how the brain works, then was available only in specialized publications that made difficult reading, even for the physician."[2] Burtin was designing his *Brain* exhibit to simulate very recent research findings. At that time, only a handful of researchers understood the full sequential process: Drs. Wilder Penfield and Herbert Jasper, of the Montreal Neurological Institute at McGill University; and Dr. H.W. Magoun, professor of anatomy at the University of California. In 1960, with the *Brain* nearing completion, Burtin wrote that the time element "was stressed in the papers by Penfield, Jasper and Magoun over and over again."[3] All three became consultants.

In order to represent time accurately, Burtin rapidly abandoned – or never considered – the possibility that the Upjohn *Brain* would resemble the human brain itself. The *Cell* resembled what it represented. But it was more important for the *Brain* to demonstrate mental function than to resemble the actual organ.

Burtin wrote: "In studying the anatomy of the brain some years back, while working on a lead article of '*Scope*' with Dr. Macleod, I found that the concern over anatomical details prevented or made very difficult an understanding of operational principles on which consciousness – the essential product of the brain – is based.'[4] For that reason the present authors refrain from calling the Upjohn *Brain* a model. Better to use Burtin's term, 'exhibit sculpture'; or Remington's, 'a schematic of a functioning brain'' (Figure 63).[5]

Burtin, with Upjohn's Dr. Macleod, assembled their first mock-up for a possible *Brain* exhibit in the summer of 1957. Having decided that a *Brain* exhibit did not have to look like a brain, they went to a hardware store to buy supplies. When Upjohn unveiled its *Brain* exhibit, on June 13 1960, the final product still bore some resemblance to objects they had purchased three years before: fine wire, a kitchen colander and two rubber balls which they cut in half to act as ears and eyes.

Ears and eyes. The *Brain*-builders decided that, from every major point of view – cost, ease of comprehension and available technology – their exhibit sculpture would represent just two senses, sight and sound. The audio-visual experience that Burtin chose to create for his *Brain* to receive, perceive, process and recall was "a moment at a concert." That is also the name of the 24-page, self-cover booklet distributed to physician-delegates at the AMA's Miami Beach convention. Meanwhile, teletype machines were hammering a condensed explanation of Upjohn's *Brain* onto tear-sheets in newsrooms:

```
BY EMPLOYING MOST ADVANCED VISUAL
TECHNIQUES, THIS EDUCATIONAL DEVICE
CORRELATES RELEVANT SCIENTIFIC DATA ON THE
BRAIN'S FUNCTION THAT HAS EMERGED LARGELY
IN THE PAST DECADE. A SYSTEM OF MOVING
LIGHTS AND FLASHING IMAGES SHOWS:
```

- HOW THE BRAIN RECEIVES INFORMATION.
- HOW IT CORRELATES THIS INFORMATION.
- HOW IT EVALUATES IT; AND
- HOW IT RESPONDS TO THE INFORMATION.

The *Brain*'s demonstration started with the projected, filmed image of an opera singer as she began to sing.[6] The audience seated in front of the exhibit saw her face while hearing her voice in an ear-piece. Then the working schematic – the *Brain* – began to react, coming alive to show the audience exactly how a real human brain would process the sight and sound. Remington, who has made a fine study of the Upjohn *Brain*'s "physiology," writes:

> Inputs were received through the eyes, symbolized by two saucer-like structures, and the ears, [placed] to the outside and below. These inputs then transferred through elaborate circuitry to various centers of the *Brain* such as the midbrain (dome-like structure at the bottom), the visual cortices (top, left and right), and memory cortices (pair of large discs on left and right). The experience of seeing and hearing was registered on the "consciousness screen" at the center. Although this screen is imaginary, it symbolizes the brain's most striking characteristic. Only in the human being does such a "screen" project past experiences as well as estimates of future experiences. Thus humans are able to form thoughts and judgments. The use of this central consciousness screen was necessary to assure a logical and clear relationship between the mechanical process and the representational nature of thinking.

Regarding Burtin's "consciousness screen": Was it "necessary" in 1960? Yes. Was it "imaginary," as narration and brochures described it? With the wisdom of hindsight, not quite. As a designer's device, the consciousness screen was inspired. Burtin would not live to discover this, nor would many of the doctors who experienced the Upjohn *Brain* in 1960: but in fact to see the *Brain*'s consciousness screen light up in response to audio-visual inputs was to enter a time

machine and be carried into our own electronic revolution, and forward several decades through time. Burtin's huge exhibit sculpture was projecting visual abstracts onto its consciousness screen that bore an uncanny resemblance to scans a modern MRI creates when it probes a stimulated brain.

> Red lights were used for visual sensations, green lights for auditory and white lights for muscle functions. It took nine minutes to demonstrate the experience of a concert which, in reality, lasts only a fraction of a second. Up to fifty persons [later, one hundred] with headphones were able to participate in each demonstration. A narrator first oriented the viewers by saying: "You are standing in a hypothetical forehead, looking into a much simplified brain ." [7]

Here, the narrative script takes over.[8] A surviving typescript shows where Burtin added pencilled numerals followed by opening parentheses to show cue points where the master control tape, or one of the *Brain*'s many electro-mechanical relays, triggered the next event:

> 4[If those of you who are seated will please look behind you, the image of a singer will appear and you can hear her voice. [Pause]

> Your brain is paying attention now. You are concentrating. First consider how you see. Impulses shown by red lights leave the eyes and arrive at these relay stations, which return signals – shown by white lights – to the iris of each eye. 5[The signals reach each iris but cause them to open too much. A second impulse returns to readjust them. 6[This closes each iris too much, and a third impulse traveling along the same path, 7[returns to adjust them correctly to the intensity of the light. [Pause]

Thus, the Upjohn *Brain* incorporated not only audio-visual perceptions and reactions but also neural feedback loops (Cues 6 and 7). At 24 feet across and 12 feet high, the sensory impact on the audience

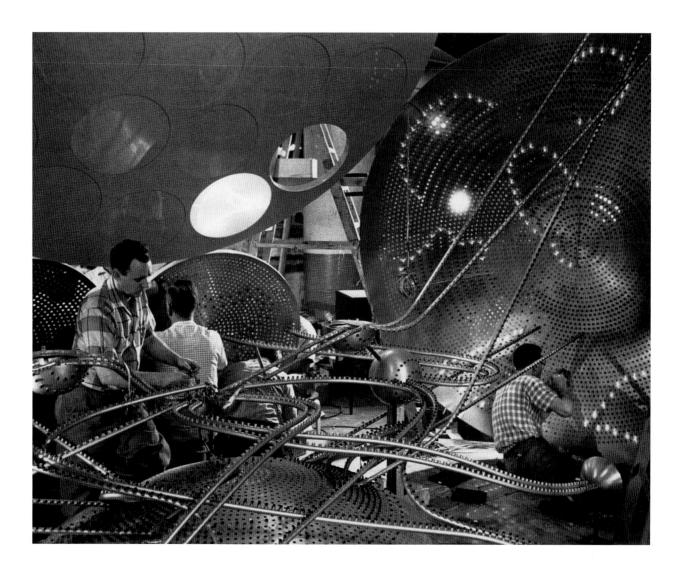

Figure 64
Building the *Brain*. Its reliability was a tribute to craftsmen at The Displayers, Inc. and the genius of electrical engineer Martin Salz. Photograph by Ezra Stoller © Esto.

(seated in the 'forehead') was intense. The nation's teletypes kept hammering out superlatives:

BRAIN CENTERS ARE REPRESENTED BY CONCAVE
ALUMINUM DISCS STUDDED WITH ELECTRIC
LIGHTS. THREE OF THESE MEASURE 9 FEET,
3 INCHES IN DIAMETER AND ARE BELIEVED TO
BE THE LARGEST ALUMINUM SPINNINGS EVER
MADE IN THE U.S.

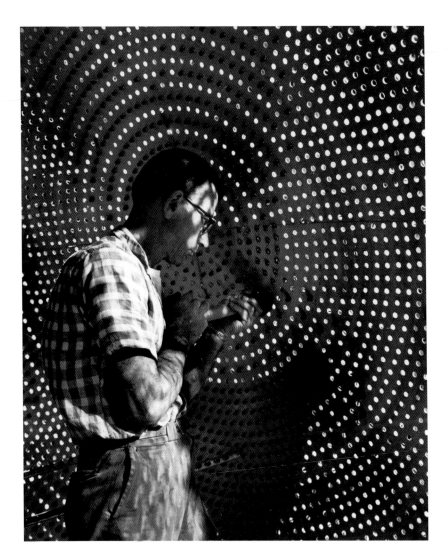

Figure 65
Drilling the "consciousness screen."
A nine-minute demonstration represented
sensations one might experience in a millisecond.
Photo by Jerry Cooke.

Remington takes up the tale:

Among the components were [Figures 64, 65 and 66]
38 miles of electrical wiring, 30,000 tiny electric lights,
330 feet of aluminum tubing and ten aluminum discs. …
There were 70,000 electrical connections, 25 transformers
and 70 relays in the electrical system. Twelve fractional
horsepower motors operated the exhibit. They operated
controllers that fed the coded messages along the tubes
and produced colored light patterns on the discs.
Some controllers had more than 200 contact-point
receiving wires.[9]

The Displayers, Inc. used state-of-the-art telephone
switching equipment, especially for the large
controllers. Control by computer was not even
considered. Remington notes that, "In early 1960, the
transistor was only four years old." The feeble-brained
computers of that era took up whole rooms and needed
their own air conditioners to cool hot vacuum tubes.
"There were no solid state components in the exhibit.
All of the *Brain*'s electrical functions were electro-
mechanical, which made the effect of the exhibit even
more impressive."[10]

Figure 66
Detail in the *Brain*. Photograph by Ezra Stoller © Esto.

Impressive indeed. Many who saw Upjohn's *Brain* in Miami Beach were impressed, and by more than the amazing technical accomplishment. One physician-delegate noted that it was "fascinating, and so well conceived that it makes neuro-anatomy and physiology comprehensible."

Figure 67
Narration introduced visitors: "You are standing in a hypothetical forehead, looking into a much simplified brain ..." Photo © d'olivera.

Figure 68
The *Brain* toured the U.S. in 1960, Europe in 1961. Here, exhibition guide Carol Burtin chats in Turin with Adlai Stevenson (former governor of Illinois and two-time Democratic presidential candidate), and Fiat boss Gianni Agnelli (right). Carol confided her ambition, "To be a diplomat," to Stevenson, who had recently resigned as U.S. ambassador to the U.N. over the Bay of Pigs invasion. While a photographer was taking this shot for the U.S. Department of Commerce, Stevenson was warning Carol against a career in diplomacy.

This contemporary comment, and others like it, implicitly takes into account a series of graphic displays that stood in a semicircle behind the seated audience. Stoller's photographs of the massive, working *Brain* exclude them. Nevertheless, they made an impressive contribution. Some of the diagrams and schematics survive in the booklet (and mini-textbook for doctors), called *A Moment at a Concert*.

BBC producer Aubrey Singer was planning the sort of coverage he had given the *Cell* two years before, but the frequency at which the tiny strands of lights went on and off was not compatible with the 25 frames per second rate of British television transmission. The combination set up a Keystone Effect (as when wheels appear to rotate backwards in movies). At 25 f.p.s., the light strings appeared to transmit messages erratically. The *Brain* failed its British screen test.

Fortunately, Upjohn's *Brain* was compatible with North America's 24 f.p.s. transmission rate. Millions of viewers watched its first national television appearance on NBC's *Today Show*, hosted by Dave Garroway.

After its debut in Miami Beach (Figure 67), the *Brain* went on tour: in 1960, to New York and Chicago; in 1961, to stops in Germany, then south to Turin; in 1962, to Amsterdam (the Stedelijk Museum), London, Paris and Brussels. In Amsterdam it was exhibited with its companion, the *Cell*. It returned to London. A duplicate was made for Europe.[11]

The U.S. Information Agency sponsored the *Brain*'s two months in Turin. 1961 marked the centenary of Italian unification, and the agency chose the *Brain* to represent U.S. scientific achievement in the American Pavilion at Italia '61. The Italians got more than the Upjohn *Brain*; they also got the designer's daughter. Fresh from her first year at Barnard College, Carol Burtin learned Italian in two intensive weeks in June, and spent July and August working as a guide to the *Brain* in Turin, augmenting the pre-recorded Italian narration. "Whole villages came into town to see the exhibits," she says. "People were often escorted around by their priests. I still remember how the commentary starts," she adds, switching to Italian: '*Il cervello umano lavora sempre, anche durante il sono …*' (The human brain is always working, even during sleep)."

Celebrities visited: Fiat Motors boss Gianni Agnelli, with his guest Governor Adlai Stevenson, twice-

Figure 69
The *Brain* at the Stedelijk Museum, Amsterdam, 1962. Photo © d'olivera.

nominated as the Democratic presidential challenger against Eisenhower (Figure 68); the Olympic Games' Avery Brundage; President Kennedy's youngest brother Edward. Meadowlark Lemon and the Harlem Globetrotters were delighted to learn that Carol Burtin had been born in Harlem.

The *Brain* exhibit that toured Europe (Figure 69) was a duplicate, made by a German firm. Mechanically, it was less robust. The Displayers, Inc.'s electrical engineer, Martin Salz, flew from New York with Conny Raitzky to set it up, but the quality was not the same. By the time it reached Turin, the *Brain*'s controllers needed an overhaul. A father and son engineering team had kept it running in Germany and were doing the same in Turin. "Michelangelo and Ugo Lo Pipero knew the *Brain* inside out," Carol recalls. Nevertheless, her ability to provide backup commentary – "*Il cervello umano lavora …*" – was essential when the controllers went awry.

Figure 70
Burtin designed this promotional poster for the *Brain* in 1960. Bright colors and abstract elements catch the eye while symbolism introduces forms that visitors will see in the exhibit. Used by permission of Pfizer Inc.

Looking back at his project, Burtin wrote in 1964 (Figure 70), "The most profound experience of working on 'the *Brain*' was the idea that the problem of how we think about thinking had become a design problem as well. In tracing the logic by which awareness of reality and dream is established, I felt often as if I were looking into the reasoning of creation itself."

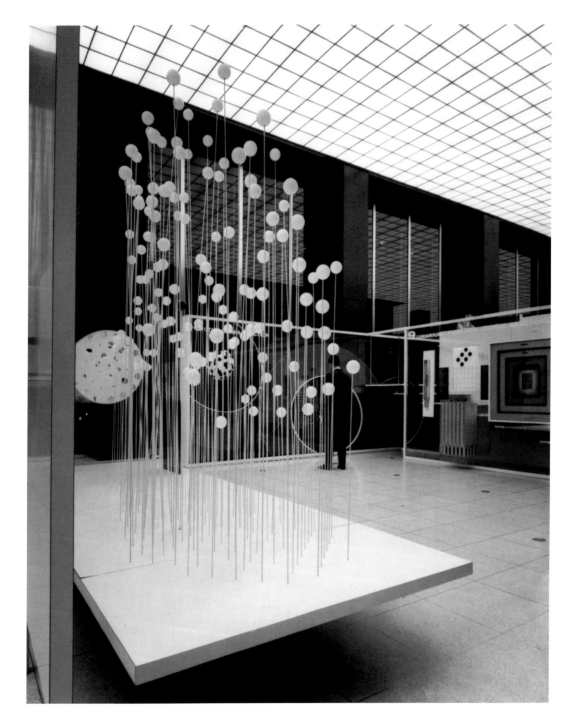

Figure 71
Union Carbide commissioned *Atomic Energy in Action* for the cavernous lobby of its new head office. The building opened with the exhibit in January 1961. Burtin's theme: man's changing concepts of the atom through 2,500 years. Roy Tillotson, Manager of Art, Design and Photography for Union Carbide, later wrote: "The accuracy of the information and the resulting disciplined beauty strongly impressed many thousands of visitors from all parts of the world ..." Photograph by Ezra Stoller © Esto.

8

CHANGE, MOVING ON AND THE UNION CARBIDE *ATOM*

Luckily the timing of the AMA's convention required the Upjohn *Brain* to be ready by mid-June. It gave the Burtins more time that summer to devote to Hilda's failing health. She was admitted to hospital in the summer, and again in the fall.

Carol was due to start at McGill University that September, a choice influenced by Burtin's work with Penfield and Jasper at the Montreal Neurological Institute. Hilda had doubts about McGill. She worried that her daughter might marry a student from the British Commonwealth and disappear to New Zealand or Australia. In the event, Hilda's decline determined the issue. To stay near her mother, Carol applied, late, to Barnard College on compassionate grounds and was accepted.

Hilda Burtin died of cancer, age 50, on October 10 1960. Will, and Celia Mitchell,[1] were with her when she died. October 10 was also Carol Burtin's eighteenth birthday and her father was determined that Carol should never know that her mother died that day. He drove, alone, to Rockland County, stopping at the Levy house on South Mountain Road. There, he arranged for Edgar Levy to phone the Burtin house in the early hours of the following morning, as if the hospital were calling to break the news.

In the small hours of October 11 , Carol heard the phone ring and heard her father take the call before he came to her room to tell her that her mother had died. Years would pass before Carol saw a copy of her mother's death certificate, only to discover that Burtin concealed the date of Hilda's death as long as he lived.

In the months after Hilda's death, Burtin increased his already heavy workload. Mourning took the form of work: it was his balm, his therapy. However, his apparent attitude drew criticism, especially from some who had been closer to Hilda than to her more austere husband. Howard Mont, who joined Will Burtin, Inc. months later, never having met Hilda, was more objective: "Will didn't give himself time because he didn't have any time. There was no time."[2]

In the fall of 1960, Will Burtin, Inc. was racing to complete an assignment for Union Carbide (Figure 71), which was about to move into its new corporate tower, five years in the making by architects Skidmore, Owings & Merrill (SOM).

This period marked a zenith, both of business self-confidence and of the promise heralding the new, atomic age. It was the time of "atoms for peace"; of pundits predicting that nuclear energy would cost less

than water; of commercials telling people to "live electrically." Union Carbide had launched a major advertising campaign in 1959 under the slogan, "probing the atom … for you." The company was enriching uranium to make nuclear fuel, using two large plants at the Oak Ridge federal facility.

A principal architect for the Union Carbide building, SOM's Gordon Bunshaft, knew Burtin well. With Bunshaft's support, Union Carbide commissioned Burtin to create a large-scale model of a Uranium-92 atom for the corporate lobby. The company's massive new building at 270 Park Avenue took up the full block, from 47th to 48th Streets, and from Park to Madison Avenue. Everything about Burtin's exhibit, especially its central feature, a working model of a uranium atom, had to be large. Anything less would have looked puny in that vast, hollow vault.[3]

The client called the exhibit *Atomic Energy in Action*, but design historians refer to it as "the Uranium Atom," or "the Atom." As with other Burtin exhibits, visitors moved through stages, each exhibit adding a layer of background and information. This included an interactive, simulated "chain reaction": a visitor pulled out a control rod, irradiating a nuclear pile that grew brighter as the rod withdrew; a soft hum grew louder and a Geiger counter clicked more urgently as its needle moved up the scale. The exhibit as a whole was designed to explain the physics of nuclear energy and the process by which that physics was harnessed.

At almost three meters across, the final stage of the *Atom* – the model itself – was enormous. A dense cluster of protons and neutrons formed its bright, glowing nucleus. Around this, Burtin simulated a uranium atom's cloud of 92 electrons, in perpetual orbit, circling their core. Ezra Stoller's time-lapse photograph suggests a mystical globular cluster swathed in bright, swirling pinpricks, each electron etching its contrail of light.

Burtin hired designer Howard Mont during the dark winter months between Hilda Burtin's death and the installation of the *Atom*. Fresh out of Pratt Institute, Mont's first task was working with a construction crew to remove an enormous plate glass window that had just been installed between Union Carbide's lobby and Park Avenue.

"The 'Atomic Energy' for Union Carbide was literally being installed when I got there," said Mont, describing his first days on the job. "The show, and the building, were opening together. The big piece that drew all the attention to the event, besides the details of the science, was a very thick piece of plastic that was almost 2.74m (9 ft) across." Speaking 44 years later, Mont described the central plastic globe with awe. "It was cast in a single block. The Rohm and Haas Company[4] cast this unbelievable thing, clear, crystal clear. It had that swirl of the atom etched onto it, because that was the first time they were able to photograph that sort of thing."

"It was a monster of a piece, and the only way they could get it into the building was to get a cherry-picker, take the window out, and shove the *Atom* in. And that meant taking out a brand new window, because the building itself was brand new."

"The actual *Atom* was a photograph itself, etched onto the block. And the block moved. Will Burtin never did a static show of anything. It always had something moving in and out of space. Whether it was the wall or the way the material was mounted, nothing was ever flat."[5]

The block that Mont remembers so well was a blue, vacuum-formed, Plexiglas sphere. Remarkably, it was seamless. This was lowered over the other components, which were propelled from below and supplied with electricity through a hole in the base. Tiny, bright lights at the outer ends of thin, flexible steel rods simulated the 92 electrons. The rods, painted the same color as the glow of nuclear light, were barely visible, so it was

Figure 72
Ezra Stoller's extraordinary photograph traps the kinetic energy of electrons whirling around protons in the giant atom's core. Stoller used time-lapse to create the effect that visitors observed: their retinas retained the bright images just long enough to convey the effect of 92 electrons rotating rapidly in three dimensions.

the tiny lights – the electrons – that held one's attention while the electron cloud rotated around the core. The 'electrons' really did seem detached. The little lights were bright enough, and moved fast enough, to leave after-images on an observer's retina, giving the impression of contrails left in the wake of whirling particles (Figure 72).

Union Carbide planned to display *Atomic Energy in Action* for just six months. The exhibit was intended as a corporate house-warming, welcoming people to the new lobby where they could see and read about uranium, the fuel of the future. This very public exhibit in Midtown Manhattan effectively staked Union

Will Burtin: The new sciences present new challenges to design

Two and three-dimensional means of design are disciplined by needs for easy understanding and beauty

Time-lapse photo of a uranium atom model showing trails of electrons forming spheres around the nucleus (from the exhibition of the Union Carbide Corporation "Atom in Action" designed by Will Burtin)

Figure 73
In 1962, Burtin was asked to contribute to *Comment 200*, an occasional joint publication from four national printing firms. This "special issue" presented work by Burtin, Lester Beall, Leo Lionni, Arthur Paul and Henry Wolf –"foremost art directors and design consultants." Burtin ran Stoller's photo of the uranium atom, writing: "The new sciences present new challenges to design. Two- and three-dimensional means of design are disciplined by needs for easy understanding and beauty."

Carbide's claim to be a leader in the bright new promise of nuclear power. From the client's point of view, the *Atom* was a big success. The allotted six months came and went, but the *Atom* adorned Union Carbide's lobby for five years, until the company sold the building. At one point it served as a movie set.

Will and Hilda Burtin had known Cipe Pineles and William Golden since the Burtins' first summer in New York. In 1951, when the Goldens returned to their apartment with their infant son, Thomas, the Burtins

were waiting to greet them: Carol recalls holding a large, white teddy bear. The families practised design and argued about it together. Golden and Burtin might differ on Helvetica, but on much they agreed. Years before, one of the last things the Burtins stuffed into a small suitcase when they fled Germany was a specimen sheet of the type Firmin Didot. When Bill Golden was developing his new identity for CBS he asked Burtin if he would suggest a typeface. Burtin loaned him that specimen sheet – and the logotype "CBS" is still written in Firmin Didot.[6]

None of the four people had had an easy path in life, nor a straight track to success. Nonetheless, they had succeeded. In American terms, they were New Deal Democrats in a social circle of New Deal Democrats. The South Mountain Road community tried to support those who were blacklisted during the House Un-American Activities' witch hunts. For his part, Bill Golden had risked his job as art director at CBS by refusing management orders to stop giving work to HUAC targets, such as Ben Shahn. Cipe Pineles, an art director at Condé Nast, had done the same.

Now Hilda Burtin was dead. And Bill Golden had died of a heart attack a year earlier, on October 23 1959.

In January 1961, Will Burtin married Cipe Pineles (Figure 74) in the living room of the Goldens' grand, *ante-bellum* manse in Stony Point, two miles north of the ridge that gave its name to South Mountain Road. Will and Carol Burtin moved in with Cipe, nine-year-old Tom Golden and their housekeeper, Roslyn Rose. The house on South Mountain Road was too much "Hilda's home": it stirred memories that were too fresh and raw. Will could neither continue to live in it nor sell it. For the rest of his life it was leased.

Jim Fitch had designed 475 South Mountain Road in a Frank Lloyd Wright style, integrating the house with nature, setting it back in the rocks and trees on its hill. Viewed from the road below, the house seems to hide in plain sight.

By contrast, the Goldens' home in Stony Point was built to assert a mid-Victorian fortune made in the Haverstraw brick trade. Its dark slate mansard roof still lowers over tall, shuttered Dutch casements, making the house the perfect model for cartoonist Charles Addams, who introduced its lines to the nation as the spectral mansion of his Addams Family. No plaque announces "Gloria Swanson stayed here," but she did, briefly. Later, theatrical producer Lemuel Ayers entertained his entourage in the house. In 1948, Ayers

signed papers in the dining room launching the musical *Kiss Me Kate*. The following year he celebrated winning two Tony Awards in what would become the Goldens' living rooms.

In short, Will and Carol Burtin were moving from a Modernist home marked only by their own brief tenure to a house that mingled a century of lives and lives' tales. For Burtin, re-marriage and remove eased the pain of moving on.

Cipe Pineles, too, had endured a terrible year. Months after Bill Golden died, management shuffles put her out of a job. After 25 years with Condé Nast, she was out on her own – but she had friends, an address book full of impressive contacts, a job teaching magazine design at Parsons and a growing supply of freelance work including, before long, the recently-opened Lincoln Center.

When the Burtins moved into the Golden house in Stony Point, Cipe Pineles moved her artist's materials into Will Burtin, Inc. on 58th Street.

Will Burtin and Cipe Pineles were completely unalike. Both demanded (Figure 75) much of themselves and of others; but where he could be pedantic and solitary, she was a free spirit and gregarious. The parties she threw at her Stony Point home may have rivaled the previous occupant's. Her first, self-assigned, task in Burtin's office was editing and designing *The Visual Craft of William Golden*,[7] a book celebrating her late husband's work. Burtin assigned Howard Mont, fresh from installing the *Atom*, to work with her. Mont lowers his voice with its New York accent into an odd but not altogether unconvincing imitation of Will Burtin: "Oh Howard, I think you'll have a lot of fun if you work with Cipe." And so he did.

Figure 74
Illustrator Joe Kaufman made tiny papier maché figures to mark the marriage of Cipe Pineles Golden and Will Burtin in January 1961. Time has taken its toll on Will and Carol Burtin, Tom Golden and Cipe. Only Cipe (6.2 cm high) retains both arms. Photo: R. Roger Remington.

To the suggestion that he probably had more fun working with Cipe than with Will, Mont replied, "No. Will was such a fine designer, so creative and so precise, with his German Bauhaus training and everything else. Cipe was flamboyant, and it was beautiful to watch them work together and interact."

Mont had plenty of time to watch them interact. He worked with them both at Will Burtin, Inc. for the next seven years.

Figure 75
Cipe Pineles drew herself trailing Will Burtin as he strode through London. She enclosed this with a letter to a friend in the U.S.

9

METABOLISM TAKES PHYSICAL FORM: ACHIEVING CREATIVE CONTROL

Will and Carol Burtin's move to Cipe Pineles's house in Stony Point surrounded Burtin with work by many artists and illustrators whom Golden and Pineles had commissioned through more than twenty years.[1] The house was full of Pineles's light, often whimsical touch in illustration and calligraphy, too. And her style was now infiltrating Will Burtin, Inc.'s Manhattan office.

This did not reduce Burtin's passion for sans-serif, or his rigor when it came to clear presentation, but it opened him to a broader, more free-spirited, American pallet. It may be significant that the first project Pineles assembled in Burtin's office, with his "oversight" as she smilingly put it, and Howard Mont's assistance, shows not one trace of sans-serif – except on the title page and the spine, where sans-serif forms the title, and only the title. In other respects, *The Visual Craft of William Golden* has Burtin's "geometry" stamped upon it. The book also contains his tribute, entitled "The passionate eye," which plays on the fact that Golden created the CBS "eye" logo. Burtin wrote of Golden:

His eye is unerring. His designs hit the bull's eye of a target with that deceptive ease which only the strong can command. ... There is a mental dexterity and an absolute mastery of subtle details ... There are many medals, awards, magazine articles, letters, speeches, reprints of work. Unmoved by laudatory exclamations every new job reflects his deeper insight into the fabric of human communication and motivation.[2]

Having known Burtin and Pineles as a couple for more than ten years, one of the present authors (Fripp) sat through many debates over points, picas, Burtins and serifs that took place on the drive to and from Stony Point, in the kitchen or at their dinner table. Their curious argumentative-collaborative relationship was surely why Mont interjected, at sundry points in an interview, such comments as, "And I just loved the man, and I just loved working with Cipe and I loved the dichotomy between the two of them. Just beautiful." Beautiful, and productive. Family meals for the next eleven years were animated affairs, with Pineles and Burtin debating fine points of design.

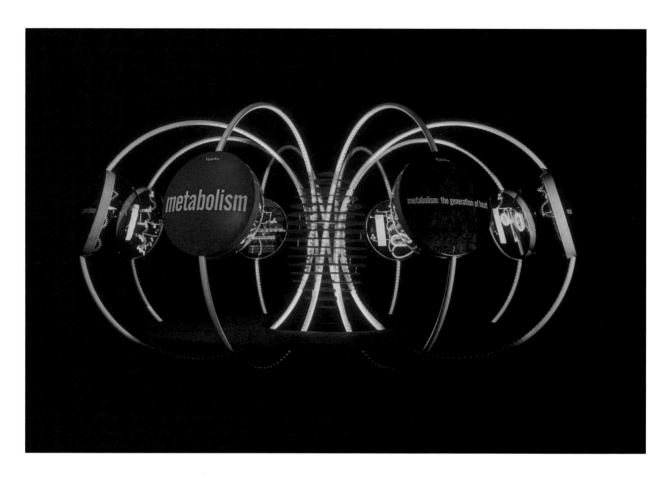

Figure 76
Metabolism—the cycle of life exhibition. Burtin's first electronic 'exhibit sculpture' showed key biochemical reactions. The central element represents a mitochondrion, a cell's power station. Moving light strands animate spirals connecting it with surrounding hemispheres. Each represents a metabolic reaction empowered by the mitochondrion.
Used by permission of Pfizer Inc.

In 1960, the press release announcing the birth of the Upjohn *Brain* had referred to an impressive "electrified model." In 1963, just three years later, the press kit announcing *Metabolism, the Process of Life* described an "electronically-controlled exhibit." More than language had changed. The world was entering the electronic age.

Metabolism was Burtin's third, large-scale scientific model for Upjohn (Figure 76). Its electronically-controlled graphic displays demonstrated critical, life-sustaining, biochemical reactions. Five years earlier, the *Cell* – a graphic in three dimensions – had won enormous attention by showing the public a thing never before seen, the form and structure of a human cell. Among the organelles represented in Burtin's *Cell* were mitochondria, modeled in clear plastic.

By moving from an exhibition about the *Cell* to one about *Metabolism*, Burtin was zooming in. The *Cell* showed half of a human cell with its organelles. Now, in *Metabolism*, the mitochondrion itself became the star.

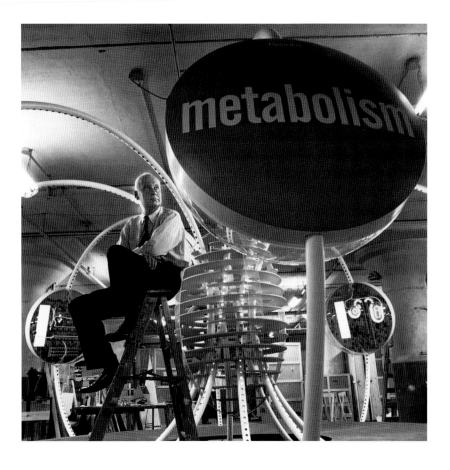

Figure 77
Burtin during construction of Upjohn's
Metabolism—the cycle of life which premiered
at the AMA convention in Atlantic City, 1963.
Photo © Robert Isear.
Used by permission of Pfizer Inc.

Biochemists had shown that mitochondria serve as tiny "batteries" that turn cell chemistry into energy, their other critical role being to house and support the enzyme systems that regulate and transform (metabolize) the body's organic chemistry.

The success of previous models encouraged Upjohn's sales force to demand a direct stake in *Metabolism*. Burtin had more stakeholders to please. Over his objections, the tone of the exhibition's brochure was geared less to laymen and more to the doctor-delegates attending the AMA's 1963 convention in Atlantic City. For the first time, a sales flyer was slipped into the brochure: it promotes Orinase® "for stimulating insulin release to meet metabolic needs when normal stimuli are unable to do so"; and Sigtab™, "metabolic systems wear out[.] vitamins are needed as well as proteins to regenerate them." Sales was now muscling into corporate branding.

To satisfy Burtin's new stakeholders, Upjohn's *Metabolism* exhibition (Figure 77) had to demonstrate not only the primary structure and function of a mitochondrion, but seven chemical reactions: the active transport of glucose; the synthesis of glycogen; the synthesis of fat; the synthesis of protein; the synthesis of insulin; muscle contraction; and the generation of heat.

Before Burtin could tackle these, his first challenge was to show a mitochondrion's basic structure. The second was to demonstrate these seven biochemical functions.

Once more, the design team drafted the best consultants: Albert Szent-Gyorgyi had won the Nobel Prize for discovering Vitamin C; Keith Porter of Rockefeller University had been instrumental in adapting electron microscopy to biological materials and 'literally helped start the modern era of cell biology.'[3] Burtin, Mont, Edgar Levy and Upjohn's Dr. Macleod were soon shuttling between them, attempting once again to reconcile sometimes differing interpretations of electron micrographs from several sources.[4] Mont said of his experience:

> It was breathtaking to work on those projects, because … when you were working on science you … had to make it graphically beautiful and be scientifically correct. So you were limited, your creativity had to be very sharp, your research had to be very sharp.

> Szent-Gyorgyi and Porter were working with each other from different points of view. I'd go to one and he'd describe a microscopic cross-section; and the other one would describe the way another piece goes. And I'd come back and say, 'Will, something is wrong. These two pieces aren't going together.' He'd say, 'There must be a mistake.' And I'd say, 'There's a mistake all right, but we didn't make it. We got all the information.' So I'd go back out to these guys, and it was beautiful to watch one of them go, 'Oh, so that's what [the other one] meant when he said so-and-so. I bet this is the way this thing should look.' And then the pieces went together.

> So, in essence, there were many things that Will's work opened up for basic science, by interpreting electron micrographs into a three-dimensional framework. We were reconciling two impressions of the same science that these guys had been seeing from two points of view. They needed to come together and see it in 3-D to envisage the complete three-dimensional object.

By 1963, Burtin's team had performed this feat several times, presenting eminent researchers with three-dimensional visual solutions to scientific challenges. Computer science caught up in the early 1990s, with a technique called the computer-assisted virtual environment (CAVE). CAVE is commonly used to discover how virtual molecules (such as experimental prescription drugs) combine with or reject each other. How Burtin would have loved to enter a CAVE-space to "dock" some modern virtual molecules – molecules such as glucose or glycogen that his own virtual mitochondrion had metabolized thirty years before!

In the end, the scientists and designers collaborated to make science visible.[5] A mitochondrion is an elongated, potato-shaped organelle containing a series of thin, platform-like membranes called cristae, each of which runs transversely, part-way across the long axis. Enzyme systems affix themselves to a mitochondrion's internal walls or cristae in specific sequences. This directs the correct sequence of chemical events while speeding up each metabolic reaction.

In practical terms, Burtin solved his first problem – showing structure – by designing a large-scale mitochondrion with its long axis rising vertically from the center of his model. Its array of horizontal, vertically-stacked cristae glowed red.

Next, he had to demonstrate the organelle's multiple functions. He solved this by dividing his model into components, each dedicated to a single metabolic reaction. Around the glowing stack of cristae, eight equidistant Plexiglas hemispheres shone with electronically-controlled static elements. Each hemisphere demonstrated one of the metabolic reactions mentioned above.

The eight hemispheres were interconnected, because Burtin had to show the biochemical sequences linking the eight metabolic reactions. But, in the exhibition, as in life, the links between reactions were not direct.

Figure 78
A scale model for Eastman Kodak's pavilion at the New York World's Fair, 1964–65. Among the largest
Fair buildings, Kodak housed two theatres, twenty-six exhibit sections and, on Burtin's eventual
'cloud-tops' roof, backdrops where visitors took pictures. Burtin called this "a total design challenge and
a totally integrated communications environment." He wrote, in *Visual Aspects of Science*, "A magic
carpet was shaped and constructed as a flowing, continuous and primarily white, protective shell.
Through circular holes in the carpet one saw a light and color sculpture, a 'Fountain of Life,' a garden
maze and a photographic playground … ." Photograph by Ezra Stoller © Esto.

A light-studded stainless steel strand supported what
we might arbitrarily designate as the "first" hemisphere.
This strand then rose in an arc before plunging down
through the glowing cristae in the central mito-
chondrion. Here the strand disappeared under the
flooring, rising again to connect a second hemisphere
before arcing over and plunging down through the
central mitochondrion once more, and so on. The light-
studded strand thus formed an endless, giant coil which
passed through the central mitochondrion eight times
as it looped up and down around the model's full 360°.
Eventually the endless strand linked the mitochondrion
to all eight hemispheres and their metabolic displays.

Each hemisphere demonstrates one important, life-
assuring function such as the metabolism of fat formation
… etc. Chains of electric lights move from one substance
to another, combining them and changing them in this
process until the final substance emerges, which serves
as the starting material of the next hemisphere
demonstration … .

This method of cycling lights, and of the action of light in
each hemisphere, demonstrates visually the basic
meaning of metabolism – the cycle of energy production
and of energy use out of which new energy develops … .
The structure, designed by Will Burtin, is the first visual
demonstration of metabolism.[6]

The companion brochure ensured that no one who saw the hemispheres cycling through their electronic reactions could forget the display. Each left-hand page reproduces the display graphics for one of the hemispheres, suitably modified for the medium of print.

The appearance of this third major model for Upjohn attracted sponsors, including the USIA, for a traveling exhibition featuring Burtin's earlier work. The *Visual Aspects of Science* exhibit included the refurbished *Brain*, which toured cities, including Amsterdam, London, Paris and Brussels. Meanwhile, the Royal College of Art, in London, hosted an exhibition of Burtin designs.

In the spring of 1962, Will Burtin, Inc. won a major project from Eastman Kodak (Figure 78). Kodak wanted a visible presence at the New York World's Fair in 1964–5, but the company did not want an exhibit, at least, not at first. According to Mont, "They wanted their building to be the exhibit." The client got its major presence – the Kodak pavilion was much talked about and photographed – but not before Burtin survived the most difficult client–designer relationship of his career.

He was lucky to win the contract. Kodak wanted a film to be shown in its projected pavilion, so Burtin introduced Saul Bass to the full board of directors, and the two men made a joint presentation. Burtin also invited Lou Dorfsman of CBS, a friend and colleague of the late William Golden, to attend as a technical consultant. According to Dorfsman, Burtin made "an extremely elegant presentation," a verdict supported by Conny Raitzky: "Will's talk was tremendously impressive, covering all the bases. I expected everyone to applaud."[7] No one applauded. Burtin's "elegant presentation" omitted nothing, and that was the problem. Bass and Dorfsman watched the listeners' eyelids droop until Bass sprang to his feet and told the directors how profitable his film would be.[8] The board sat up. Four decades later Dorfsman reported, "In the final analysis they bought in. Probably Bass won the day."[9]

Burtin's team would eventually design a unique roof for the Kodak pavilion. Molded, rather than poured, to suggest the upper surface of fluffy cloud tops among which adults could walk and children could safely play, Kodak's roof resembled the dazzling surface of a bubble-bath. Burtin planned the pavilion to be low, so that its roof, molded in bright white concrete, would stand out as a landmark. Kodak's cloud-tops were a much-reviewed visual magnet for visitors to the Fair.[10]

There would be much to see under the cloud-top roof. Bass's film, *The Searching Eye*, was popular. So was the multiple image slide display that Bass subcontracted to Sy Wexler, working in the latter's Hollywood studio. Forty years later, Wexler's son Howard described the display for Kodak that he had seen being readied in Hollywood: "There was a mix of stills and film. I remember going to see several tests of twenty to thirty carousel projectors throwing images against a wall. This was one of the first times multiple images were used to tell a story."[11] Installed in the Kodak pavilion, the many slide projectors took their change cues from signals encoded in the music and narration tape.

But before that came about, Burtin sparred with Kodak for nearly two years. They were already warring between April and July, 1962, when Burtin fired off a letter to his client's project executive, underlining the phrase *design control* in the header.

> I hardly need to emphasize to you, that I know something about exhibitions, how they develop, and about the dangers that develop from the absence of properly placed competence and responsibility.
>
> Am I right in deducing that by pointedly avoiding the assignment of design responsibility, the shapers of the contract indicate an intention to put into the exhibition any design they please ... ?

Figure 79
Burtin's model for the State of Illinois' World's Fair pavilion featured displays about Abraham Lincoln and a theatre showing Saul Bass's film about the state's favorite son.

Just as I have no intention or interest in interfering in Eastman management decisions and thoughts as to what should be shown and what not, I do not wish Eastman management to inhibit my professional function[12]

Burtin always fought for perfection, but the Kodak contract brought out the worst kind of obstinacy. He assigned Howard Mont to work with the architects and the concrete contractor, Lev Zetlin. Mont had a ringside seat.

"One of the things that I'd go back to Will with was: 'Will, we don't have any bathrooms in this place. We need them.' 'No, no. Don't be silly. We don't need them. Forget it.' So time goes on and finally Will's at one of the meetings and we talk about the bathrooms. And he finally says, 'OK, we'll do a bathroom down below. We're not going to touch what we already did.' In the end the bathroom cost more than the whole darn exhibit. That's the way Will spent time, and time, and time, and money, and why things dragged on."[13]

Obstinacy wasn't all on one side. Kodak insisted on using a photographer at corporate headquarters, in Rochester. "So there I was," says Mont, "renting a large station wagon, dragging this model up to Kodak in Rochester to photograph. And it always looked like a model! Three times they tried, and it always just looked like a model. Finally Ezra Stoller photographed it and it looked like the actual place."

The New York World's Fair of 1964–5 was a showcase for Burtin's work. The State of Illinois commissioned a pavilion and a film about the state's famous son, Abraham Lincoln. The Hall of Science, a soaring gallery bathed in light passing through cobalt blue glass, featured Burtin's slide-based exhibition, *From Superstition to Science*. Designed to complement the Hall's deep blue lighting, the images led viewers from ancient healing practices to modern medical research. A third building on the site, the New York State Pavilion, hosted the Upjohn *Brain*.

Burtin crafted a careful response to the reverential tone taken by the State of Illinois regarding the theme in its pavilion, "Abraham Lincoln, the greatest American" (Figure 79). Burtin warned his client that Illinois would be placed in a "strongly competitive environment," surrounded by large, ambitious projects displaying "jazzy and sometimes unprincipled uses of colors, building shapes, sounds, motion devices and other forms of persuasion." Confronting this, he went on, "the success of the Illinois State Pavilion depends on a *unified* organization of all conceptual and visual data [emphasis in original]."[14]

Burtin was therefore appalled when Illinois agreed to display a Walt Disney-made mannequin of Abraham Lincoln reciting parts of the Gettysburg Address. That, of course, was not how he phrased his reservations in a carefully worded memo to his client and the design team:

Considering the strongly competitive atmosphere of the fair … the success of an Illinois State Pavilion cannot be left up to the Disney imitation no matter how ingenious it will be. The historic scale and manifestations of the living man and the many-sided aspects of Illinois set the *real* frame of reference within which the Disney creation can operate advantageously. This implies a harmonious relationship of all parts to each other, which is a problem of design.[15] [Emphasis in original]

Reading between the lines, Burtin was fighting off a major challenge. He had the signed contract, but now he had to compete with Disney. The powerful late-comer had found in Illinois a market for its talking mannequin: now Disney demanded control of the mannequin's environment – the pavilion interior – the kernel of Burtin's contract. Burtin held his ground, but had to accommodate the mannequin. Despite the furore, the pavilion with its central theater, showing a film made by Saul Bass, remained true to the designer's demand for "unified organization." Client–designer relations stayed firmly on track. Besides, Burtin had larger problems at the New York State Pavilion.

This was designed by Philip Johnson, for whom Burtin reserved a special loathing. In 1939, Johnson's pro-Nazi sympathies had taken him into Poland as a camp-follower with invading German troops. Fast forward to 1964. Burtin's Upjohn *Brain* exhibition was about to open in the Johnson-designed New York State Pavilion. The refurbished *Brain* needed low ambient light before its strings of mini-lights could demonstrate sequenced messages. But here it sat, a beached whale in a tropical sun, because Johnson insisted on even lighting throughout "his" building. Howard Mont takes up the tale:

Picture this. All these lights in this ceiling, maybe 20–25 feet high [6m–7.62m]. And Will comes in and says: "You must get all those lights out, Howard, because our lights won't reflect." Because the *Brain* had these strings of little lights connecting the functions. So I go and find the

switch. Then Philip Johnson comes in and all the lights go back on. Will goes, "I said turn them off," so I turn them off again. With Philip Johnson, there was going to be no way that his building would not be symmetrically lit. He was upset enough that we had these different kinds of exhibits in there that threw his structure off. Finally, everything was built and Will came in and said to turn the lights out. I went home, I got my BB-gun and shot the bulbs out. They had a lot of problems getting a cherry-picker in there between the exhibits to change bulbs before they opened for the press preview. So the *Brain* got its own little lights, and Will got his press preview in perfect lighting.

Mont concludes: "One story after another. I just loved the man."

Figure 80
Will Burtin Visual aspects of science (1963) positions its author without
punctuation between Burtin's name and his subject. His booklet discusses
his major visualization projects for four clients.

10

MAKING SCIENCE VISUAL

Despite incidents such as the one described by Lou Dorfsman, in which Saul Bass rescued Will Burtin's presentation to Kodak, Burtin could be an effective salesman. In 1963 he convinced four major clients to collaborate in a single exhibition. He wrote at the time, "I have been fortunate in finding clients who were similarly concerned to convey the meaning of new knowledge which scientists have gained."[1] The result: *Visual aspects of science* (Figure 80).

In the brochure, the maze of lines tracing the orbiting "electrons" in Ezra Stoller's intricate time-lapse *Atom* photo is die-stamped into its red front cover.[2] This opens to reveal translucent papers, textured card and photos by Stoller on 80 lb glazed stock. Finally, the back cover credits "Type setting, reproduction and printing by Fritz Busche, Dortmund, Western Germany."

Why was the brochure for this traveling exhibition printed in Germany? The title on the front cover may answer the question. It reads: *Will Burtin Visual aspects of science*. For this very personal project Burtin went back to his roots in German precision – with Helvetica throughout. To turn the pages of this brochure is to imagine Burtin deliberately revisiting a past life and career – perhaps that of Entwurfe Bürtin, Köln (Designs by Burtin, Cologne).

Visual aspects of science combined materials from Union Carbide's *Atom*, Upjohn's *Brain*, Upjohn's *Cell*, and print design projects for IBM. The brochure also gives a two-page spread to Stoller's photo of the model for the Kodak pavilion then being developed. Three clients wrote copy amounting to glowing references.[3]

Here is Bruce MacKenzie, IBM's Director of Scientific Information and editor of the IBM *Journal of Research and Development*, for which Will Burtin, Inc. designed a variety of graphic visualizations (Figure 81) and layouts explaining and sequencing technically complex subjects.

> Scientists and engineers can now visualize and test hunches … without the time-consuming and often impossible job of thinking through all logical possibilities and deciding on the best.

> Problem solving is creative visualization, the sequential ordering of partial images to form a coherent tableau. In all areas of science *we face the need for visual concepts, so that translations into mathematical models can be developed* by the scientists.

> In the designs of Will Burtin many scientific abstractions become visual forms which are easy to memorize. But beyond this, the significant effect of [his] visual devices, is that they give us an increased sensitivity toward the nature and the grandeur of new knowledge which an expanding science universe has introduced.[4] [Emphasis added]

Burtin was already working in both modes. For clients such as IBM he was creating graphical concepts on which scientists might indeed base mathematical models. Meanwhile he had developed the second mode, in which "scientific abstractions become visual forms," from first principles, i.e. with the Upjohn *Cell* in 1958, the *Brain* and the Union Carbide *Uranium Atom* in 1960. It would take another 25 years for computational science to achieve the same representational skills.

Visual aspects of science toured many cities, including Amsterdam, London, Paris and Brussels.[5] Its appearance in London was planned to coincide with an exhibition of Burtin's work hosted by the Royal College of Art. In Amsterdam, the exhibition coincided with a display of the walk-through Upjohn *Cell* (Mark 1), which was still earning kudos for its sponsor.[6]

With the Kodak pavilion just months from opening, Will Burtin, Inc. won a major commission from Chicago-based Brunswick Corporation (Figure 82). Brunswick's corporate headquarters had a large lobby (22.7 x 44.2 metres; 91 x 145 feet); both client and |architect, Bruce Graham of Skidmore, Owings & Merrill, had high hopes for it as exhibition space. Brunswick presented a special challenge. One international division and eight major U.S. divisions had to be represented; and the company's multiple product lines touched everything: bowling balls, defense equipment for the Pentagon, space-related products for NASA, health and science-related products, school and gymnasium furnishings and a wide range of sports equipment. Finally, a stand-alone division offered special manufacturing facilities. Industrial designer David Sutton recalled, "I went all over the country for the Brunswick job, researching the affiliates, what they had, and what information they needed to present it."

The design team took just minutes to realize that displaying Brunswick's full product range in one place at one time would create serious visual confusion, even giving a negative impression. Compounding the problem, three central blocks of elevators ran parallel to the narrower dimension of the building, cutting available space into long strips around its margins.

Asked how the designers solved the problem of displaying such a wide product range, Sutton replied, "With big plastic spheres. Each sphere was a little capsule with one sort of product, from bowling balls to the space age. That was our solution."

As well, the designers took advantage of the broken space to design what were, in effect, two exhibitions. Though separated by the full width of the building and its elevator blocks, they had a single unified look. All the elements were displayed in matching white cut-away spheres, giving an overall impression of remarkable homogeneity, even unity. Time was also a factor in separating the displays: the spheres rotated towards (and away from) viewers at timed intervals, so that the total exhibition presented Brunswick offerings in carefully timed, product-related sequences. No one, no matter where they stood, could see the whole thing at once – until the timing mechanism deliberately revealed the full range. This solution gave the client another advantage: passers-by had to stop and walk back and forth along the block in order to see the total package unfold behind the lobby's plate-glass windows. Meanwhile they saw Brunswick's corporate logo and teasers such as "defense and space", "education" and "health and science" stenciled on the backs of those spheres that were turned away.

As an inducement for people to enter the lobby and look more closely, the "Corporate" display ended with a larger, walk-through "World" sphere, featuring sound and light demonstrations.

> The Brunswick corporate exhibit (East lobby area, North Dearborn Street) should create a positive and enjoyable feeling of moving lights, colors, turning spheres, dynamic shapes in space and unusual visual

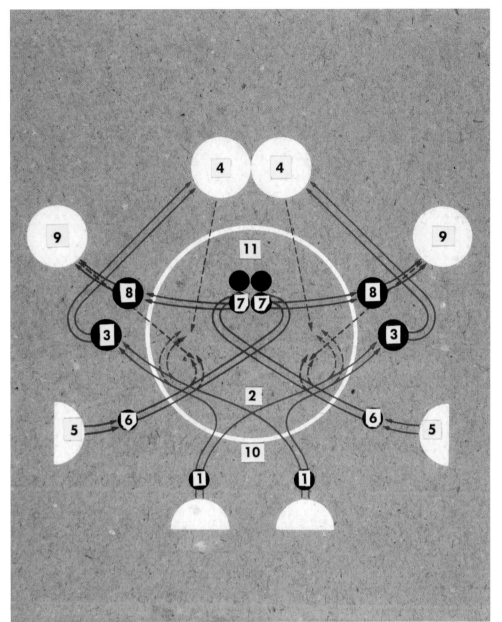

Figure 81
Will Burtin Visual aspects of science includes notes by Union Carbide's Roy Tillotson, Upjohn's Dr. Macleod, and IBM's Bruce MacKenzie which amount to glowing references. Remington comments that this booklet was a sophisticated résumé on three levels: documenting Burtin's "mature" work; providing rationale for innovative projects interpreting science; and "as a superb print scaffold for attracting new clients and projects."

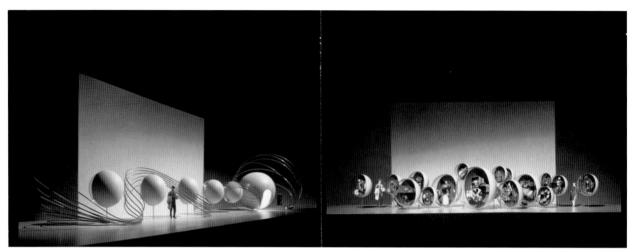

Figure 82
Brunswick Corporation was an early corporate conglomerate. Starting from sports equipment, by 1965 it was "a world leader in health, education and defense," hence the name of Burtin's exhibition for its new lobby, *The many worlds of Brunswick*. To display Brunswick's whole range at once would have been confusing. Burtin placed products from each division in "corporate spheres" in a "product ballet." Spheres for recreation, health, science, education, defense and industry rotated at intervals to face visitors whether in the lobby or the street and then turned away. Photograph by Ezra Stoller © Esto.

presentations of the featured subjects ... While motion and colors are important during the day, at night the moving light play should come into its own – transforming the entire exhibit floor into an arena of visual activity and beauty.[7]

Another device unified diversity. Burtin ran six swirling rods of stainless steel through and along the line of the six white spheres – five rotating display units with the larger, walk-through "World" that made up the "Corporate" exhibition. The effect reminds one of the steel ribbon he used to unify the Kalamazoo exhibit at the Marshall Haus in Berlin.

It took over a year to develop and build the Brunswick lobby exhibitions. It is an understatement to say it presented a challenge for Burtin's small, busy studio. Sutton left to work for Rudy de Harak on contracts for Expo '67 in Montreal before Brunswick was completed, but Howard Mont stayed on:

"The Brunswick exhibit was a tough one. Will really pushed me hard on that. Go try to design on paper and three-dimensionally inside a sphere where everything foreshortens, all over the place. And everything had to move. We had moving parts in these spheres, and the spheres themselves moved, and Will wanted these four foot [121.9cm] and five foot [152.4cm] diameter spheres to be held up on a two-inch [5.1cm] pipe. We buried

the mechanisms in the floor, and worked on that, and it was phenomenal what went on there, and the expense!"[8]

Mont was referring to more than the "Corporate" exhibition. At the opposite end of the lobby the "Products" section came to grips with the large and diverse array of "products, facilities and services of the Brunswick Corporation."

> The Court side of the Brunswick building's ground floor is exposed to pedestrian traffic flow primarily, which allows more inspection time for exhibit. Theme of exhibit: The many worlds of Brunswick.

On "the Court side," no fewer than 17 white spheres rotated. Here, they might turn in unison. At one moment a passer-by saw a building-wide array of white spheres between 121.9cm (4 ft) and 304.8cm (10 ft) in diameter. At this point the whole display looked like enormous white bubbles in a giant bubble-bath. Then, the array turned, in unison, to treat viewers to the full range of Brunswick's activities. It was impossible to grasp the full range in one cycle, so passers-by had to stop and wait while the mechanism turned the spheres through several intermediate positions before presenting themselves again.

Burtin's three-dimensional designs were revolutionary and effective precisely because he had no sense of technical or physical restriction. His attitude was that if he could imagine a concept, it must be possible to build it.

Nor did Burtin willingly acknowledge that severe time pressure might limit his range of activities. "He was a one-man show doing a tremendous amount of work," says Mont. "What we [Burtin's employees] didn't realize was how much writing he was doing behind the scenes, so it wasn't just his office he was trying to run."

Indeed, during this period Burtin spent almost two years designing a conference, cajoling speakers, finding sponsors and arranging a venue to bring together a "World Congress on New Challenges to Human Communications." This event is usually called *Vision 65*.

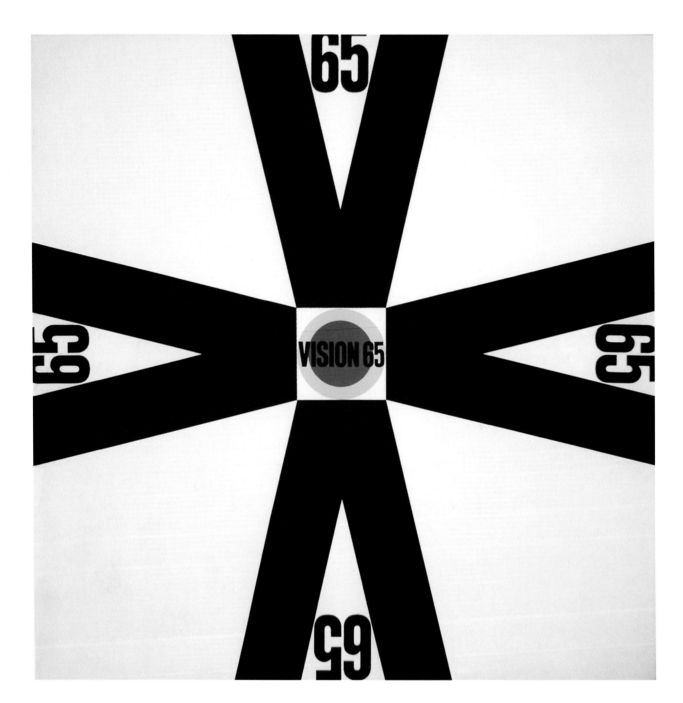

Figure 83
Burtin's lifelong commitment to education peaked in the 1960s
when he organized and chaired two international conferences.
Futurist Buckminster Fuller invited *Vision 65* to his home campus.

THE *VISION* CONFERENCES

Burtin made far-reaching preparations for his *Vision 65* conference. In 1956 he had invited three Swiss designers to address Aspen.[1] Visiting Zurich in 1964, he recruited Max Bill and Josef Mueller-Brockmann to address *Vision 65* the following year. Burtin and his program committee took two years to gather an A-list of prominent writers, designers and communicators in audio-visual fields.

In October 1965, 27 speakers addressed 490 delegates at the campus of Southern Illinois University, in Carbondale. Although SIU was far from the nearest major airport, St. Louis, *Vision 65* was a seminal event in communications studies. The conference 'concerned itself with the broad emergent problem areas of communications and the challenges posed by techno-logical and social development'[2]
(Figures 83 and 84).

Burtin's friend Aaron Burns, director of the International Center for the Typographic Arts, ensured that ICTA was the major sponsor. SIU hosted *Vision 65* in large part because a faculty member, futurist R. Buckminster Fuller, was an early, enthusiastic supporter.

Burtin organized, recruited speakers for, and chaired two Vision conferences: *Vision 65*, at SIU; and *Vision 67* (Figure 85), at New York University.[3]

The rising concentration and power of mass communications in the 1960s worried Burtin.

He and Hilda had fled Nazi Germany to escape fanatics driven by propaganda. Indeed, they fled rather than design that propaganda! As a communicator, Burtin himself had charted the paths of science and technology through war and peace: now he watched the growing power of what President Eisenhower famously called 'the military-industrial complex.' In the 1950s that complex was content to build its power-base in industry. By the 1960s it was striving to control opinion

> at a time in history when fundamental social, intellectual and technological developments reshape the substance and meaning of reality. Every facet of our lives is affected and every value requestioned, as a steadily mounting pressure on the individual and on society is recognized.[4]

Burtin knew how easily political or commercial pressures could "reshape the substance and meaning of reality." Nearly three decades after fleeing Germany he was still hypersensitive to the fact that mass communications were vulnerable to abuse. He told delegates to *Vision 65* that the rise of electronic communications was moving so fast that "communications professional ... are baffled and even frightened by [the impact of electronics] on the present and their portent for tomorrow."[5]

Whilst addressing *Vision 67*, writer Umberto Eco was more blunt:

> Not long ago, if you wanted to seize political power all

Vision 65 World Congress on
New Challenges to Human
Communications

Sponsored by Vision 65 was
the International Center the inaugural congress
for the Typographic Arts of ICCAS,
in cooperation with the International Center
Southern Illinois University for Communication Arts
Carbondale, Illinois and Sciences,
October 21 to 23, 1965 founded by ICTA

Rochester Institute of Technology web pages list all presenters at Burtin's *Vision* conferences. Try the generic search term <"Will Burtin"RIT>.

Figure 84
Papers presented at *Vision 65* compiled in a book.

Figure 85
Two years after *Vision 65*, Burtin organized and chaired *Vision 67*
at New York University.

you had to do was control the police and the army. Today only fascistic generals in under-developed countries still use tanks in a *coup d'état*. As soon as a country reaches a high level of industrialization, the political scene changes completely. The day after Khruschev fell the editors of *Pravda, Izvestia* and the managers of the state radio-tv networks were fired; not one change in the army. Today a country belongs to whoever controls communications.[6]

A pall of unease gripped the mid-1960s. The nuclear arms race was causing fear; the Cold War was turning hot in Vietnam; and rapid electronic advances in many fields "have shaken a confident belief in the feasibility of human control over made-made conditions,"[7] according to Burtin. He was selecting speakers for *Vision 65* while the world was absorbing the movie, *Dr. Strangelove or: How I Learned to Stop Worrying and Love the Bomb.*

The somber world view led Marshall McLuhan to open his speech with greetings from Canada, "the country of the DEW line, or early warning system." His talk went some way to explain Burtin's comment that "communications professional … are baffled and even frightened by [the impact of electronics]."

That fear, McLuhan explained, was due to the fact that we had entered a "new and potent environment," and that

> really total and saturating environments are invisible. The ones that we notice are … insignificant compared to the ones we don't see. … In the case of environments that are created by new technologies, while they are invisible in themselves, they do make visible the old environments.[8]

In short, McLuhan told delegates, we are baffled because we are driving into uncertainty. He listed technological transition points, starting from ancient Greece. Small wonder we are fearful, he suggested. We cannot appraise the state we are in, but rather the state we have passed through. We drive full speed ahead with our eyes on the rear-view mirror.

Conference transcripts give a clear picture of considered concerns and forecasts predicted by nearly sixty leading communicators looking towards the end of the twentieth century. Taken together, the *Vision* conference lectures project an imperative for both communicators and the public at large: that people should both integrate in society, and rebel within it. Here is Willem Sandberg, addressing *Vision 65* in a form closer to blank verse than prose:

> children when young / start scribbling: / registrate movement with pencil / often without looking … / suddenly, with puberty / inspiration stops / they start to copy / nature or a postcard / the moment has come / to integrate in society / to adapt / the majority remains at this stage as adults / follows tradition / society is based on these / the few, the inventors / in science and arts / the real leaders / create new traditions / to keep society going / we need a large percentage of integrated followers of tradition / and a small minority of creators.

Followers, and creators. Society needs both. But "creators" must deliver communications to the "integrated followers" with integrity if society is not to suffer. Sandberg was a creator. He understood the power of communications as well as any presenter at the *Vision* conferences. Perhaps better. At *Vision 67*, the mild-mannered former director of the Amsterdam City Museums revealed his past as a resistance fighter operating under the name van den Bosch. Sandberg described

> faking papers for the prosecuted to change their identity [as the] least original and most useful typographical job I ever executed – the waffen SS wrote the best critic [*sic*] I ever received: 'the identity cards of the last edition were so well copied … that the [specialist] could not recognize them as fakes.' Artists proved efficient for dangerous jobs / as they were less attached to material values / than the more comfortable citizens / and were more involved in humanity / all were prepared to die every day / the majority was shot. … Then came may 5, 1945 / on this bright springday / the two year existence of van den

bosch ended / he sat down at his desk in the stedelijk / and was again sandberg.

The Book of Ecclesiastes might have said that there is a time to integrate and a time to rebel. Burtin's agendas for his *Vision* conferences asked: When does one conform to prevailing wisdom, and when does one rebel? Geneticist Carl Lindegren told *Vision 65* that scientists had to fight the heavy hands of establishment science and peer review that forced scientific research into directions approved by the conventional and commercial wisdoms of the day. Information technology specialist Isaac L. Auerbach warned delegates to *Vision 67* against the growing ability of computers to invade personal privacy. Auerbach advocated a constitutional amendment,

> providing that *no person may be deprived of his privacy without due process of law.* And I would urge that the constitutional definition of privacy specify that each person has a *property right* in information about himself. … Our concern for the speed and scope of our technological progress must be matched by an equal concern for its judicial control.[9] [Emphasis in original]

Three decades would pass before the raw power of data mining forced governments in many industrialized countries to pass laws regulating electronic storage and dissemination of personal data.

Burtin himself worried that "the relationship between the communication of knowledge on which judgment and response depend, and the ever-increasing volume of communicated materials (i.e. advertising) … has become so disproportionate that serious concern exists now about the effects of such unceasing pressure on the individual." He still feared the power of the "Big Lie," whether in politics or advertising.

The Dutch designer Wim Crouwel was having none of it. He reminded his audience that advertising design started with creative fine artists such as Henri de Toulouse-Lautrec; but, Crouwel conceded, a graphic designer "is surrounded by all sorts of debris which at times almost threatens to inundate him."[10]

Such inundation posed a threat to the public because, said Burtin, "the communication of new knowledge is needed desperately on almost every individual and national level." But the rising tide of noise was drowning the still, small voice of valuable information.

Herbert Spencer was more sanguine, pointing out that "the capacity of our society to absorb and utilize what is [printed]" is limited, and that most readers choose to read just five percent of the printed words before them. "The task of increasing the efficiency of the printed word must now be examined in the wider context of the efficiency of the visible word in all media … ."[11]

Broadly, the tone of speakers at both events was hopeful that communicators would be more flexible, more artful (in a literal sense) in designing messages that people would want to assimilate. And they should do so while resisting commercial and political pressures.

Burtin, as program chairman, set the scene for both conferences in his introduction to the first:

> The social responsibility and new perspective of the communication professions should now be seen in utilizing its arts and sciences for a faster, simpler and future-conscious conveyance of knowledge first, and for an environment of decency and beauty as well.[12]

The concluding paragraph of Burtin's introduction to *Vision 65* contains a sentence that is underlined in the original: "What we think and design today is the record of history tomorrow."

Figure 86
Detail from exhibit for Upjohn, Burtin's exhibits produce a clear, physical
grasp of the significance of biological order. Used by permission of Pfizer Inc.

12

DESIGN EXPLAINS GENETICS

George Klauber wrote of Will Burtin that he "championed the reactivation of the American Institute of Graphic Arts ... and designed the first 'Printing for Commerce' exhibition – the precursor of the whole roster of shows which the AIGA puts on annually."[1] In 1966, the AIGA celebrated *Fifty Years of Graphic Arts in America* with an exhibition and a commemorative book.[2] Eighteen years earlier, design student Rudolph de Harak had heard Burtin present *Integration* at the Art Center School in Los Angeles. Now, as chairman of the AIGA project, de Harak invited Burtin to write the editorial introduction to *Fifty Years of Graphic Arts in America*.

The book features comments and illustrations by more than fifty leading members of AIGA. Most of their written contributions are fairly bland. Not Burtin's. Superimposed on Ezra Stoller's time-lapse shot of electrons orbiting the Uranium-235 model, Burtin's copy broaches Manichean duality (Figure 87):

> The technological-social consequences of applied sciences affect everybody by what we do with them and what they do to our future. Potential aspects of nuclear power permit only two human choices: To improve morally or to perish. From now on all deeds and thoughts cannot avoid evaluation as to which of the two they favor. Ours then is an age of great peril but of even greater creative opportunities[3]

The last fifty years brought a continuous acceleration in the growth of scientific knowledge. The technological-social consequences of applied sciences affect everybody by what we do with them and what they do to our future. Potential aspects of nuclear power permit only two human choices: To improve morally or to perish. From now on all deeds and thoughts cannot avoid evaluation as to which of the two they favor. Ours then is an age of great peril but of even greater creative opportunities. Communications have a vital function in this transformation of values. Visual communication design—including advertising—must assist in the continuous education for improvement. The creative arts can only benefit from embracing the new manifestations and profound human meanings of scientific insight, which they need for the comprehensive construction of a world culture.

Figure 87
In 1966, 50 designers contributed a page to the commemorative book, *Fifty Years of Graphic Arts in America*. For his page, Burtin overprinted Ezra Stoller's photograph of the *Atom*. He also wrote the book's introduction.

Burtin's philosophy was essentially humanist. He reasoned that only an informed public could steer humanity clear of the traps it set itself; and designers – even more than writers, whose copy frequently went unread – had a clear duty to inform, and to do so clearly.

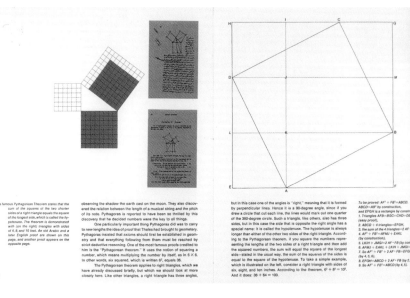

Figure 88
Will Burtin, Inc. designed *Story of Mathematics for Young People* for the Pantheon Books division of Random House (1966). The back cover states: "The mathematical basis for the beauty of the physical world has inspired the union of text and illustration in this book."
From *The Pantheon Story of Mathematics for Young People* by James T. Rogers, copyright © 1966 by James T. Rogers. Used by permission of Random House Children's Books, a division of Random House, Inc. World Portrait Globe printed with permission from Rand McNally.

In this period he wrote an essay on making science visible, for a book edited by Gyorgy Kepes.[4]

At Will Burtin, Inc., the business of a design office went on. Among the routine projects that still draw comment was a book design for *The Pantheon Story of Mathematics for Young People* (Figure 88), by James T. Rogers (1966).[5] An inspired editor at Random House teamed Rogers with Burtin. Rogers, a member of the Board of Editors for *Scientific American*, had been an artillery officer; Burtin had designed gunnery manuals describing aerial vectors in visual terms. If the two had had just one word in common, that word might have been "trajectory." The bright red-orange cover on Rogers's book carries over to its contents, where blocks of text complement orange and black two-color illustrations. The red-orange compensates (and effectively conceals) a budget restricting the book to two colors. Several features stand out: the designer receives as much credit as the author (in fact, Burtin gets more ink on the back flap); the spacial counter-poise between illustrations and text blocks is superbly balanced; and the entire book is set in Helvetica. In this large-format book the use of sans-serif throughout still has the power to surprise. The typography owes its success to the blocking and leading.

Girolamo Cardano (left), also known as Cardan, was able to reveal how to solve cubic equations because he learned the method from Niccolo Fontana (right), who is better known as Tartaglia. Cardan had promised to keep the solution secret.

Tartaglia applied mathematics to the technique of ballistics. This scheme for finding the angle at which to set a gun was published in an Italian book of 1562.

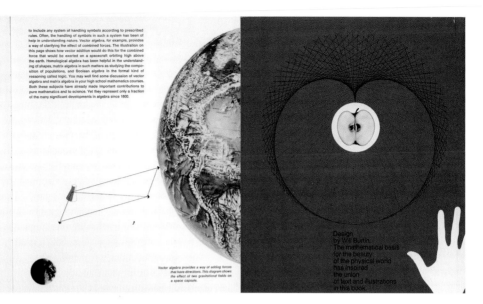

On that topic, Howard Mont had much to say. Forty years later he recalled the project vividly. "This was one of the major books that Will did. There was Standard font size and there was Helvetica. And Will didn't want to know from Standard, and Standard was on the machine and Helvetica wasn't. So Standard had to go!

"I still remember working around the clock with Bob Webster, not sleeping. And Will would come in and say, 'Howard, I'd like to take a point out there.' Then he'd walk away and I'd go, 'No way!' because I already had a dozen cuts on that board, and to take a point out I would have to take all those sheets and raise them that same point. So I took my triangle and made a cut line between the type so it looked like I did something. The next day all the boards were on the table and we were reviewing them. Will came to my board, and he said, 'Howard, I'd like to take another point off there.' That's how sharp the man's eye was. Then I had to take the board, flood it with rubber cement and move all twelve cuts!

"He trained all of us, including me who had no typography because I came from industrial design, how to see what a point was across the room. The stories like that were phenomenal."

Mont's story recalls George Klauber's: designers at *Fortune* coined the term "Burtins," as in "points, picas and Burtins," to describe the smallest discernible measure in type.

Will Burtin, Inc. was busy with another project, too. James Marston Fitch had a contract from the City of New York to improve urban esthetics, a task that included restoring city streetscapes and parks, including Central Park. Fitch, a pioneer and the leading practitioner of restoration architecture, asked Burtin to design new signage. Before long, new signs in Helvetica began to appear all over the city. (The fact that "Curb your dog" was the first to require the Burtin touch caused the maestro some chagrin!) Other cities followed New York's example. Arguably, urban signage did more to promote Helvetica in North America than good book design.[6]

```
FOR IMMEDIATE RELEASE
WILL BURTIN DESIGNS GIANT MODEL OF
"GENES IN ACTION"
```

The headline on this press release, dated May 17 1966,[7] announced the massive dynamic model and exhibition

that would greet delegates to the American Medical Association's convention, to be held in Chicago from June 26 to June 30. The Upjohn Company sent this release out six weeks early in response to an informal request by the AMA, which hoped to sign up more delegates. The incident speaks to the pulling power of Burtin's large models, which Upjohn always launched at the AMA.

The first paragraph of a good press release presents a tight kernel of key information intended to grab an editor's interest. And yet Upjohn's release chose to lead, not with Burtin's massive model, but with the model's designer:

> A designer who believes that the skills and insights of the artist must increasingly be used to communicate and interpret information from the frontiers of knowledge has designed a large-scale structure to illustrate infinitesimally small natural life processes that occur in the chromosome of a cell.

> Entitled "Genes in Action," the 18-ft. high and 30-ft. wide circular model was created by New York designer Will Burtin for the Upjohn Company of Kalamazoo, Michigan. For many years Upjohn has pioneered in the use of modern design in its graphic and three-dimensional communication projects related to medical research and to the development of new medicines.

Supporting the press release, a glossy mailer invited a select guest list to attend, that same day, an "informal preview (prior to the first public showing) of a science structure, designed by Will Burtin." The address, at Production Center Inc., 221 West 26 Street, was more appropriate for the invited opinion makers than the Displayers' fabrication shop where the massive model had been engineered and assembled during the previous year. Like Burtin's other models, *Genes in Action* was modular. Even so, given its size, the structure was neither simple not cheap to disassemble, transport and reassemble. Its "informal preview"

Midtown before being trucked to Chicago marked the importance that several stakeholders attached to the impact of this latest large model. The Upjohn Company did not commission Burtin's projects in isolation. The models, and the interest they aroused, reflected contemporary research priorities pursued by Upjohn's 400 scientists, and their competitors.

Burtin's previous models for Upjohn had introduced physicians and public alike to leading-edge discoveries in cell structure, brain physiology, and cellular metabolism. Fourteen years had passed since Watson, Crick and others had described the helical structure of Deoxyribonucleic acid (DNA). At Upjohn, Director of Special Projects Dr. Garrard Macleod decided to pull together the "rapid succession of discoveries" that followed the Nobel-winning research, and to invest those discoveries with a physical form. The brochure for Burtin's model states that "the time is ripe to present … *Genes in Action*." The exhibition and brochure were further billed as "a brief review of the relation of structure to function in the nucleic acids."

If *Genes in Action* (Figure 90) was the largest of Burtin's models for Upjohn, it was also the most tortuous for the design team to research. Consensus was elusive. In an earlier chapter George Klauber describes how Burtin had been forced to decide for himself on the physical form of his *Cell* model. Now, a similar phase of rapid expansion was gripping the young science of genetic research. Reputations had to be earned, grants and tenure had to be won, the conventional wisdoms laid down by senior researchers had to be duly observed, and peer review – a topic attacked by a geneticist at *Vision 65* – had to be appeased. Where Burtin's previous models had credited a handful of leading specialists, the *Genes in Action* brochure names seventeen. Many had different opinions.

The brochure (Figure 91) gives a lengthy and well-written overview of a complex subject, making few concessions to non-specialist readers.[9] Burtin designed

Figure 89
The central exhibit in *Genes in Action* (5.5m high x 9.2m wide) was two years in production. The element simulated the nucleus of a fruit fly. Sixty foot (18.2 m) aluminum tubes formed swirling patterns, representing DNA strands in the act of unwinding and replicating. Hence the studio's working title, *The chromosome puff*.
Photograph by Ezra Stoller © Esto.
Used by permission of Pfizer Inc.

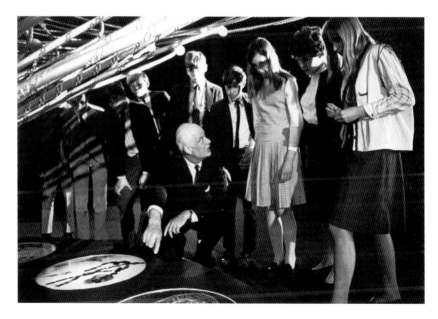

Figure 90
Genes in Action: Burtin explains to biology students the relationship between electron-micrograph 'blueprints' (transparencies recessed in the floor) and the overall superstructure.
Photo © Robert Isear.

it for doctors to take home from the AMA convention and become a background reference guide in their libraries. He sometimes called it a "book," one that maintains a 3-column format throughout, whether the content be text, multi-part figures, or graphics. *Genes in Action* shows Burtin's fine command of typography, and of Helvetica. His 3-column format keeps lines short (they seldom exceed 38 characters); and, unusually, he compresses the leading, effectively keeping one's eye running on rails as it moves through technical copy.

Not until page 23 does the brochure explain the process which Burtin's massive model demonstrates. Long-strand DNA molecules ensure the continuity of life and the basic patterns taken by different forms of living things. However, DNA never leaves the cell nucleus, so it has to transmit genetic information by forming shorter messenger-RNA (Ribonucleic acid) molecules (red in the model). These relay coding instructions to sites that produce proteins outside the cell nucleus. *Genes in Action* describes this sequence:

> It is necessary for the DNA fibers to loosen up and untwist in order for RNA synthesis to take place ... In the insect chromosomes which are many stranded, the loosening up process takes the form of a 'puff' ... There is much evidence to indicate that there are strands of DNA bowing out in all directions ... In other words, when the gene located in a band becomes active the band is transformed into a puff.

> Ulrich Clever[10] has correlated the expansion of two particular bands into puffs with the beginning of the molt which transforms the larva to a pupa [in a certain insect]. It is because of the importance of the chromosomal puff as a signal of gene activity that it was chosen as the central theme of the Upjohn exhibit '*Genes in Action*,' and appears on the cover of this book as well as on the following pages.[11]

Those "following pages" (26 and 27 in the brochure) show Ezra Stoller's photograph of the *Genes in Action*

model as a double-page spread, without text. This puffing up, this loosening and untwisting of long-strand DNA that precedes the active manufacture of RNA, is what Burtin's massive model brought to life dynamically for the doctor-delegates attending the annual meeting of the AMA.

The model itself (Figure 92) needed space – not just because, at 18 by 30 feet (5 by 9 meters), it was larger than many school classrooms – but because, like a grand country house, it gave its best first impression when one came upon it from a distance; and, in the case of the model, when it was fully lit within a surround of limbo.

The first thing one noticed from afar was that the top six feet appeared redundant: a thicket of aluminum rods supporting tightly coiled blue nodules rose vertically through an eerie blue light into darkness above the model.

In fact, the top section represented the normal, tranquil state of a gene that is not puffing. This top third set the contrast with the hive of biochemical activity taking place in the lower section, the actively puffing gene. The lower section, twelve feet high, comprised a swirling mass of rods that rotated almost horizontally as they pushed out from the core, their dynamic outpouring of energy bathed in the red light that made these active nodules glow.

Visitors threaded a passage which opened up in the center of the model, the winding course defined by the curvature of the puffing rods that bordered it within the active zone. The passage led people into the core of the "Chromosome Puff", where moving submodels showed four biochemical processes that take place while the gene is flaring out in its active, puffing state.

Shapes, colors, symbols, and light animated the four dynamic submodels at the heart of Burtin's giant genes. It was here that moving molecular clusters combined

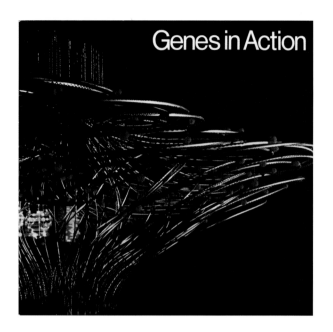

Figure 91
The brochure for *Genes in Action* updates readers on discoveries since Watson and Crick won the Nobel Prize.
Used by permission of Pfizer Inc.

Figure 92
This view of *Genes in Action* shows how the form expanded upright. A visitor had an inside view of one of the tiny bodies determining size, shape and structure of living cells. Swirling aluminum tubes, moving lights and animated molecular models showed genetic coding in action.

and then separated to show: phosphates and sugars forming the famous double helixes of DNA while pairs of bases bridged the gaps between them; here, too, a DNA molecule duplicated itself; RNA formed from DNA; and messenger-RNA, transport-RNA and ribosomal-RNA took different shapes. Mounted on panels at the approach to the large model, time-lapse photographs by Stoller prepared visitors for the dynamic demonstrations they would see in three dimensions at the core of the puffing chromosome. The brochure shows several of Stoller's movement-via-time-lapse photographs.

Burtin's large-scale models stretched Stoller's genius as a photographer to the limit. People from The Displayers, Inc. and Burtin's studio were called on to help. Howard Mont recalls Stoller taking the master shot of *Genes in Action*. Former design team members

still call the model by the working title they used for two years, the "Chromosome Puff":

Ezra Stoller did the photography for the Chromosome. He had studied the model and its lighting systems for hours ahead of time. He timed the things to go on and off. Then he sent us out to dinner while he set up for a two-hour exposure. Within that two hour exposure we did a lot of two minute, five minute, one minute exposures, in order to get all the different kinds of lights onto the photographic plate. We lay on the floor and pulled plugs. Ezra would call, 'Pull plug 1,' and we'd time it; 'Pull plug 2' and we'd time it. He did it in the [Displayers' Inc.] studio to eliminate reflections. Stoller was just phenomenal.

Genes in Action received good coverage in scientific publications such as *Weekly Science Newspaper*[12] and in the general interest press, notably *Life*, which gave the exhibit a five-page feature, including a retrospective on the *Cell* and the *Brain*. Without doubt, Stoller's extraordinary photographs contributed to editors' enthusiasm for Burtin's models and accompanying releases. (*The Illustrated London News* had virtually said as much in 1959, when it promoted the *Cell* Mark 1 under Stoller's photo of the *Cell* Mark 2, devoting a full page under the headline, "Unusual photographs.")

Life states that *Genes in Action* cost $100,000. It cost more. Burtin strove for perfection, often at financial cost to himself. Not for the first time, he ran over budget and triggered a debate about cost versus value. Here's Howard Mont:

"What saved Will was his personal relationship with Jack Gauntlett, Upjohn's chairman. I'd have to go to Kalamazoo; I'd be working with one of the VPs, and he'd say, 'Howard, you're twenty-five percent over my budget. Go back and tell Will he better work a different way.' So I'd go back and say, 'Listen, Will, here's the pressure.' One telephone call to Gauntlett and that was the end of it. The other people never had the foresight Gauntlett had. We got five pages (along with my name and Edgar Levy's name) in *Life* magazine for the Chromosome Puff. Five pages! How much was it worth to the corporate people to have the Upjohn name on a five-page spread in *Life*? That's what the lower tier managers could never understand'.

By 1967, Mont felt that he had no option but to leave Will Burtin, Inc. He and Cipe Pineles spoke at length in their shared space at the 58th Street office. "She was crying, because she wanted me to run the office and be made an associate: because Cipe knew that I could help Will make money; because he never made a lot of money or at least the money he should have been making." Impassioned debate among the three of them went on for months. But, in the end, "Will just couldn't share his name. He finally told me that, openly."

Before he left, Mont helped transform *Genes in Action*. The model adopted the title, *Heredity and You,* in keeping with a new venue. In early 1967, *Genes in Action* was "strikingly visible from the street" as one passed the Time-Life Building at 1271 Avenue of the Americas. The model looked even more impressive, because visitors had the benefit of a mezzanine, giving them an elevated, orthographic view over the puffing, spiraling strands of DNA (Figure 92): the structure took on the appearance of a spiral galaxy as if seen from some forty degrees above its equator. The exhibit's supporting material was "translated into non-technical language" to explain "fundamental biological structures" to a new audience, "the man who walks in from the street." "In effect," Burtin wrote to Time-Life,

the statement [introducing the exhibit] will be that all the wondrous varieties of life on this planet can be recorded – 'coded' – in rearrangements of very few, relatively simple and identical basic substances. … No museum or science pavillion has ever exhibited as clearly organized and comprehensively detailed a display of recent biological findings concerned with the basis of life and the passing of hereditary forms through the generations.[13]

Again Burtin was explaining new science by representing it as a visual icon that "the man who walks in from the street" could grasp – and then take away in his head. Meanwhile, Mont was walking out into the street to set up Howard Mont Associates. Years later, long after Will Burtin's death, Cipe Pineles was still expressing regret for the loss of Mont's commercial sense.

Figure 93
Will Burtin at his desk in 1971.
Portrait © A.V. Sobolewski.

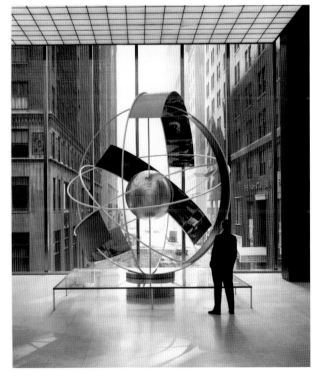

Figure 94
In 1968, Will Burtin proposed a dramatic exhibit,
to be housed in a metallic dome in front of the
McGraw-Hill building on Sixth Avenue.
Photograph by Ezra Stoller © Esto.

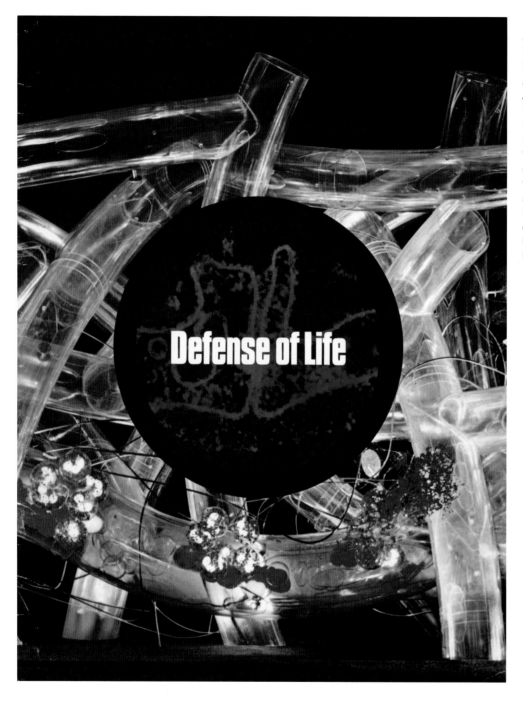

Figure 95
Defense of Life combined the large walk-in model with a film and brochure, *Monograph on Aspects of Acute Inflammation*. Dean of Harvard Medical School Dr. Robert Ebert wrote the keynote: "Inflammation is fundamental to survival of the organism for without it there would be no protection against noxious external stimuli nor repair of damaged tissue."
Used by permission of Pfizer Inc.

13

DEFENSE OF LIFE –
THEN AN END

In February 1967, IBM delivered its first System/360 Model 91 computer, the most powerful to date. The 360/91 was a high-speed processor for theoretical astronomers, atomic physicists, global weather researchers and Space Race engineers. (The first moon landing was 29 months away, and counting.) The 360/91 also guided Minuteman missiles and tracked intercontinental ballistic missiles. These were the days of "mutual assured destruction" (MAD). The "missile gap" mindset was hot.

We mentioned earlier "the pall of unease that marked the mid-1960s," when Marshall McLuhan greeted *Vision 65* with a welcome from "Canada, the country of the DEW line," and announced, "We are baffled because we are driving into uncertainty." Will Burtin had told the same audience that "communications professionals … are baffled and even frightened by [the impact of electronics]." Such was the climate in 1967, when IBM harnessed an algorithm written by Robert Tomasulo that gave its 360/91 the most advanced internal architecture of any System 360 computer. Thus supercharged, the thing fairly flew.

That did nothing to salve public anxiety. Technology was suspect. "Big" risked being viewed as "bad" as advances seemed to rush beyond human control. A short story by author Fredric Brown captured the

mood when an engineer asked the very latest computer, "'Is there a God?' and the machine replied without hesitation …'Yes, now there is a God.'"[1]

Sensitive to the public mood, IBM had called for proposals to design a pavilion and exhibits for Expo '67 in Montreal. Burtin's *Memorandum on the 'IBM Showcase' exhibition*[2] (Figure 96) pulls no punches. He opens by describing "the consequences of science and technology" resulting in "human adjustment problems of a profound depth":

> Especially the advances of electronic technology have shaken a confident belief in the feasibility of human control over man-made conditions.… The consequence of a basically doubtful attitude is retreat from reality, while a confident and positive attitude will not permit failures to interfere with trying again and again to assure problem-solving achievements in science or art or in commerce.

Burtin's "confident and positive attitude" to science and technology caused him to propose to IBM a massive structure, a transparent sphere 60 feet high, containing three floors of exhibits. The lowest stood about 10 feet above ground level, the second at 20 feet. The top floor, 30 feet up, formed the equator of the sphere. A wide stairway hugged the inner, transparent wall of the

Figure 96
This proposed globular exhibit hall for IBM, never built, remains a grand plan resembling the U.S. pavilion that Buckminster Fuller, with Chermayeff and Geismar, created for Expo '67, in Montreal.

pavilion, curving up, connecting floors, the ceilings of which (i.e. the floor above) appear "unsupported by columns." Being at the equator, the top floor was the largest, designed to house most of IBM's exhibits. These included a bank of evenly spaced television screens hung around the perimeter. The wall itself, being the upper half of the sphere, narrowed as it rose above visitors' heads, so that the screens pointed slightly down, a convenient angle for viewing from the exhibition floor. Burtin was adamant: These wall-mounted displays

> should not appear to "lean for memory comparison on the Renaissance idea of universal man. Rather, the esthetic potential of the visual manifestations of the new sciences and technologies *themselves* should be *felt* as art elements and thus set the signal tone of the exhibition."[3] [Emphasis in the original]

In Burtin's opinion, the modern world in general and IBM in particular had enough bragging rights to put its own Renaissance on show without concomitant fear of the new. In place of fear he advocated:

> The soft reflections of the stationary color images on floor and ceiling [of the giant sphere] will produce an overall sensation of serenity, beauty and comfort reminiscent of an art exhibition of classical beauty.[4]

He writes, "A softly reflective silver color will be used throughout," and goes on to describe "large architectural columns which dissolve into gravity-defying arrangements in space." These suggest a white marble and silvery cloister – a Greek stoa? – transformed to the service of science (or space) exploration.

IBM did not bite, but a similar mood and style took the world by storm the following year, in sets for Stanley Kubrick's *2001: A Space Odyssey* (1968). Ironically, *2001* was dominated by HAL, an all-knowing psychotic computer.

These were years when The Upjohn Company was committing major resources to researching inflammation. Acute inflammation is a normal, defensive process by which the body combats infection. But if the body forgets to turn it off, inflammation becomes chronic, as in rheumatoid arthritis, rheumatic fever and conditions resulting from hemolytic anemia. Upjohn manufactured several of the steroid hormones used to treat chronic inflammatory reactions.

The company's grand old man of special projects, Dr. A. Garrard Macleod, announced that better knowledge of inflammation could lead to major breakthroughs in medicine. The Upjohn Company commissioned Burtin to create an exhibition that would impress doctor-delegates to the AMA convention opening at the New York Coliseum on Sunday July 13 1969. Dr. Macleod published his own monograph on aspects of acute inflammation,[5] timing its release to coincide.

Figure 97
A card for a grandson's second birthday, March 1969, signed in pencil 'Happy birthday, Eric! Will' Burtin recalls either Italian Futurist style (*c.*1915) or Dada (*c.*1923) here. His plays on "two" include Cologne's dialectic, *zwo*.

When the convention opened, patent holders of the Plexiglas used in the model, Rohm and Haas, issued a glowing "news" release: "Upjohn's Model of Blood Vessels Highlights AMA Convention." The text describes a structure of "Bunyonesque proportions."[6] Upjohn's release was more restrained:

```
     GIANT MODEL SHOWS HOW BODY
     FIGHTS OFF HARMFUL INVADERS

NEW YORK, July 13--A massive model of a
microscopic portion of the human blood
vessel system depicting inflammation, one
of the body's most basic and mysterious
processes, was unveiled to physicians …
here today.[7]
```

By the time Burtin's massive model reached the Coliseum it had acquired a formal name: *Defense of Life* replaced "Inflammation" (Figure 98) on working documents and file tabs.

Researching designs for the model involved fewer specialists than previous exhibits: Upjohn itself employed experts on immunity and supported research. Nevertheless, the design component took almost a year. Conny Raitzky had left to work for two years with James Rorimer at the Metropolitan Museum, returning after Rorimer died. Raitzky recalls, 'Will, Edgar [Levy] and I would go to a meeting with clients. Will was the distinguished fellow with the German accent. I was the design advisor, and Edgar looked like a college professor. We made a formidable team.'

The team, with industrial designer David Sutton, set out to create a model that guided audiences through ten major steps. Phased lighting drew viewers' attention to each step in turn. Lights were synchronized to the narration playing in 74 ear phones set in an amphitheater. This was slightly raised to let visitors look across the giant model. The exhibition started thus:

> Before the viewers' eyes, the explosive sequence of inflammatory events begins with the cells in a normal state, in a three-foot-wide venule at the left of the model. As bacteria symbolically invade the tissue, destructive enzymes are released, damaging the vessel walls themselves and causing gaps through which scavenger cells – leukocytes – escape to attack and digest the invading bacteria.[8]

To reinforce Upjohn's impact on a medical audience, Burtin asked Sy Wexler to produce a 13-minute film[9] that "demonstrates the *process* while the three-dimensional models show the *stages* of inflammation [emphasis in original]."[10] (Cipe Pineles and Wexler's wife Helen had been friends since before the war, when they all lived in Brooklyn.)

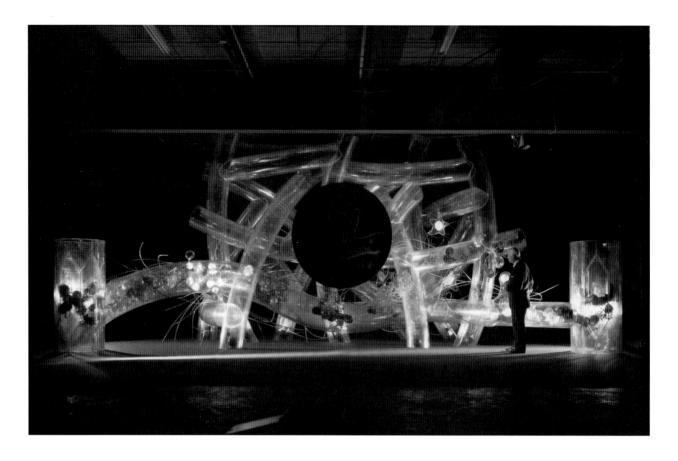

Figure 98
Burtin in 1969 with *Defense of Life*, which demonstrated features of micro-circulation, magnified 25,000 times, showing principal events in acute inflammatory response. Photograph by Ezra Stoller © Esto. Used by permission of Pfizer Inc.

Figure 99 (right)
Burtin with *Defense of Life*.

Rohm and Haas's reference to "Bunyonesque proportions" fairly describes the model's 11.3m width, 4.6m depth and 4.6m height (37 ft x 15 ft x 15 ft). The model's enormous ganglion of Plexiglas and aluminum tubing represented a patch of human tissue just one fiftieth of an inch (0.5 mm) long, a magnification of 25,000 times. The model demonstrated, in sequence, ten distinct phases of inflammation: the first phase began with bacteria attacking human tissue, which then staged a counter-attack. Each phase had individual lighting and modeling challenges. Rohm and Haas emphasized the scale of the project in order to market its product, Plexiglas, to industrial users:

Almost 100,000 feet of interlocking tubing of transparent Plexiglas is used to simulate the capillaries and venules (tiny blood vessels) in the exhibit. The acrylic plastic tubes vary in length from four to six feet, and in diameter from one to three feet. A total of 2,000 feet of aluminum rods was woven around the acrylic tubes to indicate strands of connective tissue, principally the protein collagen.

In addition, 896 formed parts of colored Plexiglas depict red blood cells, white blood cells, platelets and other bodies that pass through capillaries and venules. Most of these acrylic units are eight inches in diameter. The

exhibit utilized more than 97,000 colored Plexiglas beads to portray the smaller bodies that exist within blood cells.[11]

While Rohm and Haas stressed the model's physical structure, The Upjohn Company was addressing its medical audience, describing a

> twisting, soaring network of plexiglass [*sic*] tubing [which] depicts what scientists refer to as the acute phase of inflammation. In this process, a virtual war takes place in the small blood vessels, as the body mobilizes its defenses – various types of blood cells and potent chemical enzymes – against disease or injury.[12]

Burtin's team had to simulate the strange, step-by-step war being fought in his model's small Plexiglas blood vessels (venules, inches across) and major veins (feet in

diameter). The designers had to show that, after the initial fight backstage, the inflammatory process became self-destructive. They did this in an early phase by showing how intracellular bodies (lysosomes) release powerful enzymes that attack not only foreign bodies, but healthy tissue of the human host, too: "Hence, the term 'suicide sacs' applied to the lysosomes. The result: the pain, redness, heat and swelling associated with inflammation."[13] To stage this war within the model:

> Normal red and white blood cells – scavenger leukocytes, lymphocytes and other forms – are blown up to six- to eight-inch dimensions and change in shape and function as the inflammatory process proceeds. Weaving through the exhibit are 2,120 feet of aluminum rods representing strands of connective tissue, largely collagen, the main supportive protein of skin, tendon, bone and cartilage.[14]

When it came to designing these components, especially small working models of the major exhibits, designer David Sutton recalls in a letter that,

> Will's precise approach to typography (the point, the pica, the Burtin) carried over into his exhibit work. The exhibit scale models we made using illustration board, plastic and paper, were works of art in themselves. Our tools were Exacto knives, tweezers, and hypodermic needles. We used the needles to apply acetone onto Plexiglas to bond pieces together. That was the only way to glue the stuff. Will designed with the models. He would study them for hours, having us move an element an eighth or sixteenth of an inch, or less. We would then take the models to Ezra's studio whose work really brought them to life.[15]

Raitzky concurs. *Defense of Life* was "a bit of fun and a bit of an ordeal at the same time. I did the model. The design model was made of vinyl tubing which was hard to cement together." There was also the usual Burtin-inspired structural challenge. Raitzky comments, "We all breathed heavily to the end. We were depicting blood vessels enlarged greatly. Some were 91.4cm (3 ft)

wide. Plexiglas was really the only thing to use, and it took a lot of finessing to make this thing look floating. We had literally hundreds of pounds up in the air, with minimal support. When I said that we breathed heavily right up to the end, during construction we had a support right under the middle and that [temporary] support had to be removed. It was taken away and the thing held together!" (Figure 99)

Defense of Life may have been the most complicated of Burtin's large models to form and assemble. Structural Display Company, Inc. of Long Island City, built the model. The tubing that formed the veins, some three feet across, "had to be curved, like bananas, to achieve the desired appearance," according to Ronald Abbate, the company's CEO and design manager. "We had real trouble with those molds."

As well as building seemingly air-balanced Plexiglas veins (Figure 100) the designers made cells that "come into play" after the first phase of apparent self-destruction: macrophages digested blood clots and waste materials; fibroblasts produced new collagen and repaired ruptured venule walls.

Burtin's model and Wexler's film of the complete process complemented each other. The film helped "connect the dots" between phases the physical models displayed, such as these, from a typed brief:

Model 3-a: A venule in its normal state shows 'the composition of leukocytes, lymphocytes, platelets, blood cells and endothelial cells'

Model 3-b: A mast cell, above the venule, 'releases enzymes, which marks the beginning of the inflammatory process'

Figure 101
In May 1971 Henry Wolf presented Will Burtin with the prestigious Medalist Award of the American Institute of Graphic Arts for his professional accomplishments.

Model 3-c: 'A thrombic blockade inside a capillary' prevents cell movements and "may destroy the capillary itself"

Model 3-d: 'A "budding" capillary' shows 'that the process of repair is under way.' Star-shaped fibroblasts come together, often at the site of a thrombus, producing collagen where a new capillary will grow.

The individual models light up in a sequence determined by [Wexler's] motion picture. Each of the ten models shows an individual <u>stage</u>, and the motion picture the complete <u>evolution</u>, of the inflammation response in the vascular tissue of man or bird or fish.[16]

Eleven years earlier, a physician had walked through the model of the *Cell* (Mark I), commenting, "It reduces six months of detailed study to six minutes of visual and physical exercise." Burtin intended *Defense of Life* to have the same effect. Rohm and Haas quote him:

Upjohn's unique inflammation exhibit [Figure 95] gives physicians and medical researchers a dramatically visual explanation of what is known about the process of acute inflammation in the blood vessels ... Many of the physicians who examine the model remark that it gives them a much better understanding of the inflammatory process than medical textbooks have been able to do.

The Sixties drew to a close with Burtin in high esteem. Harvard University appointed him Research Fellow in Visual and Environmental Studies at its Carpenter Center; the *Alliance Graphique Internationale* elected him President, American Sector; the American Institute of Graphic Arts awarded him its medal (Figure 101); he was in demand as a speaker, as at *The Roving Eye and the Constant Image* conference, in Chicago. He continued teaching at Pratt. In 1970 he began preparing for a solo exhibit at the AIGA the following year, while working with Raitzky on an exhibition, *The Biosphere*, designed to greet delegates to the United Nations Conference on the Human Environment (the Earth Summit), in Stockholm, 1972 .

Towards the end of 1970 Burtin received a letter from Yves Zimmermann, who had worked for him in 1957. Zimmermann was asking Burtin to contribute the keynote article for the first edition of a Spanish-language periodical, *Documentos de comunicación visual*. There was some history here. In 1956, Josef Mueller-Brockmann had accepted Burtin's invitation to speak at Aspen. Later that year, Burtin wrote him, offering to employ a promising Swiss student in his New York office for one year. Mueller-Brockmann passed the invitation to teacher and typographer Emil Ruder. Ruder offered the place to Zimmermann, who spent part of 1957–8 at Will Burtin, Inc. By 1970, Zimmermann was established as the art director for Geigy Pharmaceutical Company in Barcelona, where he was also setting up a quarterly periodical.[17] The essay that Burtin wrote for the first edition of *Documentos de comunicación visual* (1971) – he called his paper "Enough"– may be among the most perceptive pieces

that a designer has written on the importance of design in presenting science, and on future trends. Short clips from his 3000-word essay show prescience, especially since echoes of the first moon landing still resounded while he was writing, and the second accomplishment he mentions here went underreported:

> With the first step by which the first man made the first human footprint on the moon, mankind became conscious of a new era in its evolution. … A few weeks later, three young medical scientists, at a Harvard University laboratory, isolated and photographed one single gene … This breakthrough in the science of biology may in the course of time surpass the importance of man's moon venture … .

Looking back, it is clear that Burtin was quick to predict the order of importance that has prevailed since those scientists photographed a lonely gene in 1969.

In 1970 he was also involved with a friend, British film maker John Halas, in setting the agenda for a conference to be hosted by the International Council of Graphic Design Associations (ICOGRADA). Entitled "The Designer in the Teaching Industry," Burtin would have been the keynote speaker but, by the time it was held, he was too ill to travel to Vienna.

By 1971, the long post-war business boom had slowed, becoming a full-blown recession. Even large advertising agencies were losing major accounts and scrambling for business. David Sutton remarks, "That was the end of an era in design. The big names got paid retainers. I don't think that outlasted the Sixties. It became much more competitive. Big studios became much more marketing oriented."

The Upjohn Company severed its relationship with Will Burtin in the spring of 1971. The senior managers who had valued the crossover links between marketing, sales, branding, corporate identity and design were gone. George Klauber comments in *Print* magazine on the lunch to which Burtin invited him after that break.[18]

Judging from the date on a one-page typescript, 'Profile: Will Burtin, April 15, 1971,' Burtin may have returned to his office after that lunch to update his résumé.

In 1971, Burtin's health began to fail. He was well in April when he and Cipe Pineles visited his daughter's family in Toronto. He discussed the Stockholm project with his son-in-law; and he spoke about another, in Caracas, for which no notes have ever been found. In July, he and Pineles made a final trip to Europe that included visits to his sisters' families in Cologne. Back in New York he felt unwell. Cancer was diagnosed. Conny Raitzky and Pineles continued to work in the 58th Street office until the fall, when Pineles began winding down the affairs of Will Burtin Inc.

Meanwhile, *The Biosphere* project for Stockholm headed for disaster. Their client was replaced before Burtin and Raitzky made their presentation to Canadian businessman Maurice Strong, just named interim head of the United Nations Environmental Protection Agency. Raitzky explains: "We finally got a meeting. Will and I were there, with Will's secretary, and they gave us a meeting room that had a tiny desk and chairs against a wall. No table. We were forced to set up our model on chairs. Ruined the effect. I felt terrible because we couldn't set anything up to look like much, and we had worked very hard on the idea. Maurice Strong came in and Will went through his routine; and we all sensed that this guy wasn't in tune. It died right there. Will was terribly upset and so was I. But what could we do?"

By the late summer of 1971 Burtin was in hospital for surgery. Either of his own volition, or urged by Pineles, he summoned Howard Mont, who had opened his own business five years before. According to Mont, Burtin handed him the Stockholm project in four words: "Howard, it's all yours." Mont was able to win belated approval in principle from Maurice Strong, with enough initial funding to start building *The Biosphere*. But a donor agency failed to deliver, leaving the project

Figure 102
In addition to receiving the AIGA's Medalist Award, the AIGA gallery hosted Burtin's *Communication of Knowledge* exhibition. He displayed his major projects while explaining his philosophy about "designs for mass communication in the science era." The sketch above shows the sequence plan for the exhibit.

Figure 103
Text on a panel at Burtin's AIGA exhibit reads: "[A] new sense of responsibility ... is drawing a new charter for the employment of communications and media ... Designers ... and the entire educational establishment therefore face a totally new challenge. They have to make people aware and prepare them for a fundamental change from the non-scientific to the science era –the new human environment."

Figure 104
Chicago-based Container Corporation of America was
America's leading manufacturer of paperboard
packaging, and a progressive advertiser. The company
ran a campaign, "Great Ideas of Western Man." An
artist, designer or photographer was given a quote and
asked to visualize it. Burtin was assigned lines by
John Milton about education (1644).

Figure 105
Burtin supported several worthwhile causes. In 1970, he designed
the "Care and Share" poster for the United Fund Westchester.
A photographic pattern overlays dynamic diagonal elements. The
common diagonal repeats angles from both photography and
typography, unifying his layout.

$400,000 short, and behind schedule. Mont comments:
"That would have been enough to build it. At the last
minute I was stuck with a project that was beautiful,
just right for Stockholm, but I had no money. So we
hired [a fund-raiser], but we raised only half, so the
project got killed."

If his final year was one of disappointments, it left
Burtin free to think in original ways. He designed "a
'new world' brochure on environment control" for IBM

that borrowed from Buckminster Fuller's Dymaxion™
map projection. Like Bucky's map, Burtin's New World
brochure was a three-dimensional object, a 20-sided
"pre-folded icosahedron" commissioned by IBM as
"a game or learning tool or memory test." The icosahe-
dron had several transparent components. Burtin
likened this three-dimensional creation to another
product, a wire-bound catalog he had designed for the
German Association of Glass and Mirror
Manufacturers (*Spiegelglas*) forty years before. In the

spring of 1971, when the AIGA honored Burtin with a retrospective exhibition of his work, he used the occasion to compare his two "transparent book[s]":

> The transparent book informs instantly. The 1931 'Spiegelglas' catalog and the 1971 'new world' brochure on environment control have this in common: each reveals instantly and reminds constantly of its total content Aside from an interplay between solid and transparent components there is also a thematic widening of interest that changes from vista to vista – or page to page.[19]

Burtin and Fuller had known each other before they collaborated on *Vision 65*. Fuller had coined Dymaxion™ (DYnamic MAXimum tensION) as a trademark. For Burtin, this composite word triggered memories of another. He had earned his first regular pay as a teenage typographer working for Dr. Knöll on jobs for *GeSoLei*, the Dusseldorf Expo., in 1926.

Holding in one's hands Burtin's "transparent book" for IBM makes it easier to sense the "widening of interest that changes from vista to vista." The more one unfolds the icosahedron's opaque and transparent onionskin layers, the more printed images (one per facet) meet the eye. Burtin himself had seen many vistas, conquering most.

Will Burtin died in Mount Sinai Hospital on January 18 1972, nine days before his 64th birthday. George Klauber was with him when he died. Burtin had had surgery months earlier, but doctors could do nothing. The diagnosis: mesothelioma, a cancer induced by exposure to asbestos. His physician, Dr. Louis Siltzbach, thought it likely that the same disease had killed Hilda Burtin in 1960, before mesothelioma was identified and named. That possibility increased after Siltzbach consulted his colleague Dr. Irving Selikoff, the pioneer who had established the link between asbestos and cancer.

Exposure to asbestos? Will, but not Hilda, had grown up in an industrial suburb of Cologne. However, it seems more likely that asbestos fibers entered their lungs when, as young designers, they were building Entwurfe Bürtin from their flat on Balthasar Street. Exhibit designers favored asbestos paper until it was shown to be unsafe: it was strong, practically indestructible, pure white, and never darkened. Designers also pulped asbestos fibers with water to make models: it was easier to work than papier-mâché. Photos of Burtin's exhibit for the Federal Works Agency at the 1939 World's Fair suggest that signage might have been cut from asbestos.

Given the fate of Burtin's last proposed exhibition, *The Biosphere*, for the United Nations, it is ironic that his memorial service was held in the United Nations' ecumenical chapel. Saul Bass delivered the eulogy to a crowded chamber. (Given in full after the Postscript.)

POSTSCRIPT

"The best is the enemy of the good," wrote Voltaire, meaning that there is a point beyond which the quest for perfection becomes a waste of time and resources. Will Burtin was afflicted by the need to throw resources into his personal quest for perfection. This showed itself in several ways; first, with money. Too often his fees and retainers went into production. He was also convinced that, if he could conceive of a concept it was capable of being built; that any vision could be rendered in material form.

David Sutton makes an astute observation: "Will's precise approach to typography (the point, the pica, the Burtin) was carried over into his exhibit work."[1] Burtin tried to impose the same precision on three-dimensional modular space that he brought to typography. This trait led his colleagues to recall:

"Will had no structural sense, really. He didn't want to know that a thousand pounds can't be held up by piano wire" (Howard Mont);

"Will's intuition seldom failed but on some occasions it did. He insisted that [support rails] could be made of three-quarter inch pipe. Union Carbide's Don Stewart said he was sure they couldn't. There was a big battle. Don tried to do them in three-quarter round. We set them up, and sure enough they collapsed" (Conny Raitzky, re. the *Atom*);

"We would work on things, work on things, work on things, till Will decided it was right. And only then was it right" (David Sutton);

"One of my reasons for leaving Will [after four months in 1961], I admired him but he was very dictatorial and I don't mean that in a negative way. He wanted things a certain way, and if you would deviate from that … I remember working long hours when he was away, and he would come back, and look, and say, 'That's nice,

Figure 106
Burtin taught from his earliest career days. Here he explains human cell structure.

but I was thinking on the plane, and let's do it this way'" (Ruut Van den Hoed);

"It was a structural challenge. We all breathed heavily to the end. … It took a lot of finessing to make this thing look floating. We had literally hundreds of pounds of Plexiglas up in the air, with minimal support. … During construction we had a support right under the middle, and we all knew sometime it had to be removed. It was taken away and the thing held together" (Conny Raitzky, re. *Defense of Life*)

Burtin's relative lack of business sense – rather, his discounting of values other than design – did not help. His reputation attracted major clients, but his quest to achieve perfection at any price cost him sorely. Few clients could *afford* perfection; certainly not by the time the economy tipped into recession, in 1971.

Figure 107
Burtin was an ardent supporter of the Alliance Graphique International (AGI), an organization of the world's finest graphic designers. President of AGI's American section, and a close friend of many members, he attends the 1964 AGI Congress in Alpbach with his friend F.H.K. Henrion.

Would Will Burtin have established his reputation without The Upjohn Company? One might ask the same about artisans working during the Italian Renaissance, composers in eighteenth-century German states, or playwrights whose works were sponsored by nobles and royal courts. All worked in the service of merchants or aristocrats. For the sake of argument, let us set aside Upjohn's corporate support for the major models (1957–1969) and examine Burtin's early career. His youthful reputation in Cologne had brought him the unwelcome attentions of Nazi leaders, forcing him to flee Germany at the age of 30. The same prodigious talent then launched his second career: within months of landing in New York he won a major contract for the 1939 World's Fair; he earned the Art Directors' Club gold medal within three years; his gunnery manuals achieved outstanding results for Air Force training programs; he was head-hunted onto the masthead at *Fortune*, enhancing that magazine's reputation for excellence.

As for his giant models, "He was fortunate in finding a large American laboratory ready to finance these ideas," wrote F.H.K. Henrion in *Tribute to Will Burtin*.[2]

Fortunate, yes, but the large models came after a mature career in which, "like Leonardo da Vinci, he learned to grasp science in order that he might communicate its mysteries to the world."[3]

For two weeks starting on Tuesday September 5 1972, the United States Embassy in London opened its doors to the *Will Burtin Memorial Exhibition*. Britain's Society of Typographic Designers (STD) organized the event, with Saul Bass the rock on whom Cipe Pineles Burtin leaned for support. Many Americans came for the opening, making Durrants Hotel an *ad hoc* Burtin conference site for several days. Holding the *Memorial Exhibition* in the embassy was appropriate: the serving ambassador, Walter Annenberg, had hired Cipe Pineles as his art director at *Seventeen* magazine after she returned from war work in France in 1945.

F.H.K. Henrion (Figure 107) began his tribute that evening by saying that he felt he had known Will Burtin even before they met. He told his audience that during the war he had worked at the U.S. War Information Office in London with John Peters,

who told me that his whole professional life had changed since Will had been his teacher. As we shared a room I often remember how, when solving a problem, [Peters would say[4]] 'I wonder how Will would have tackled it.' So Will Burtin was an idea to me long before I met him. This happened in 1949, after the war, when I first came to New York and he was Art Editor of *Fortune* magazine.[5]

Henrion met Burtin for the first time after Burtin's work at *Fortune* had helped him refine his ideas about corporate identity (Chapter 3). The two German emigrés met in Burtin's office, on the 50th floor of the Empire State Building. Burtin showed Henrion his 14-page layout for "The American Bazaar," the creation of which had reinforced Burtin's conviction that "a constant, consistent image would serve a company as a powerful multiplier … ."

Figure 108
Will Burtin in his office. Photo © Arnold Newman, Getty Images.

If Henrion carried Will Burtin around as an idea "long before I met him," Burtin's influence would loom even larger after the British designer returned to London. Within a few years, Henrion would become the acknowledged pioneer of corporate identity in the U.K., and a powerful influence in Europe.

Addressing the same audience at the U.S. Embassy, BBC Television's Aubrey Singer, who had produced the *Cell* programs, described Burtin as having "a first class intellect and one of the most exciting conceptual minds. He was a unifier, way ahead of his time." John Halas, president of the International Council of Graphic Design Associations (ICOGRADA), remarked on the loss of "a great colleague and good friend, a man of two cultures and of universal vision." And Saul Bass, who had given Burtin's eulogy in New York, now spoke of "a much loved and revered friend who was hard on himself and scrupulously honest both with himself and his colleagues." Bass's comment recalls another, by former employee Jack Condon, whose response on hearing that Burtin had died was to dial Conny Raitzky and sob into the phone, "Such integrity, such integrity!"

Burtin influences live on (Figure 108). Not surprisingly, they have evolved. Corporate identity blossomed; so has branding, the simplest definition of which is "giving products meaning'" His early and sustained advocacy of Helvetica in North America has been repaid, if the success of that font is any measure. Indeed, once it took root, Helvetica gained converts and impetus so fast that the many variants threw its specifications into disarray until Linotype acquired it, redrew it, renamed it Neue Helvetica and added a numbering system. Helvetica was among the first fonts to migrate to desktop publishing and personal computing, trends that even Burtin, a man "way ahead of his time," according to Aubrey Singer, could not have anticipated.

Burtin's career-long emphasis on the importance of visualization (Figure 109) in the sciences has matured in ways he could not have predicted. His major models served as instructional tools which, in retrospect, formed the thin edge of a very broad wedge. Post-Burtin, computer systems have taken over the educational role of visualization. Twenty years after Burtin died, Dr. Malvin Kalos, Director of the Cornell Theory Center, told one of the present authors, "Scientific visualizations are powerful tools for communicating results. Scientists can sit and stare at these pictures, manipulate images or computations, and think about the basic science that way. … Visualizations are metaphors, and in science metaphors have real value. We can wrap our intuition around them, and that's very important. Even the reality of simple things is complex … ."[6]

The reality of simple things is indeed complex. The Burtin team discovered that when trying to get experts to agree on three-dimensional shapes for a cell or a puffing chromosome, objects that scientists had only seen as microscopic images in two dimensions. Burtin's three-dimensional reality, of physical, tangible models, eventually took on a new, computer-age form: *virtual* reality. Since the early 1990s, the rising power of computer-assisted visualization systems and computer-assisted virtual environments (CAVE) has justified Burtin's early emphasis on visualization. The voice of the pioneer has become a chorus.

The year after Burtin died, Cipe Pineles legally adopted Carol Burtin Fripp as her daughter, thereby officially gaining two grandsons, Eric and Will Fripp. (Pineles would not live to see Tom and Carole Golden's son, Myles.) Burtin's doctor, Louis Siltzbach, bought the Burtin family home on South Mountain Road in New City.

In 1989, authors R. Roger Remington and Dr. Barbara Hodik gave a chapter to Burtin's work in *Nine Pioneers in American Graphic Design*.[7] After Pineles died, in 1991, her archives, together with those of Will Burtin and William Golden, moved to the Wallace Library at the Rochester Institute of Technology.

Perfectionist that he was, Will Burtin made no attempt to specify the headstone that would mark his and Hilda's mortal remains. Fortunately, his second wife was a designer who cared about such things. Many years after Burtin died, Pineles contacted the John Stevens Shop in Newport, Rhode Island, a business older than the Republic. The fact that John Stevens were master stone carvers should have been sufficient qualification to cut a headstone, but Pineles was thrilled to discover that the son of the owner had studied at the *Kunstgeweberschule* in Basel, where one of the tutors had been Armin Hofmann – whom Burtin had invited to Aspen in 1956. Pineles commissioned the stone. Being sensitive about her age in her later years, she instructed the mason to carve the year of her birth as 1910, rather than 1908. The Burtins and the Goldens are remembered together in a Nyack, New York cemetery. The form of wording is fascinating. Their joint headstone declares, in superb calligraphy:

Figure 109
Researched and designed by Burtin, this "automatic information structure" illustrated chemical properties, manufacturing processes and industrial applications for a new synthetic, Urethane. This design informed technicians and product designers; reduced paper flow; made topics easier to understand. Pushing a button caused light to travel from one production stage to another, showing how the basic material transformed to a gas, flexible or rigid foam, transparent plates, solid sheets, or film. Sequences ended when images and data appeared in the colored cubes near the exterior transparent walls.

In memory of
Hilde Munk Burtin
1910–1960
wife of Will Burtin
1908–1972
who married Cipe Pineles
1910–1991
widow of William Golden
1911–1959

EULOGY
by Saul Bass

Saul Bass gave this eulogy at the memorial service for Will Burtin held in the ecumenical chapel of the United Nations, in January 1972. Apparent ellipsis marks [...] do not represent edits. They appear to be Bass's pause cues.

First I must say how utterly inadequate I am to the task of expressing what a man's life was about (maybe nobody can really do that). And this is particularly true of Will's life, which was so full of richness and accomplishment. Words come easily. But meanings come hard. A man lives a long life. Nobody gets more than a glimpse of it. Long as I have known Will … as much time as I have spent with him … all I know are a few fragments. I want to share them with you. Will was part of the cultural and scientific infusion which the New Order in Germany inadvertently gave us in the late Thirties. As such he brought with him the design currents developing at the Bauhaus and elsewhere in Europe. This gave him a unique historical role – one that he played out to its fullest potential. … His work in the 1939 New York World's Fair … . His famous design course at Pratt … . His startling training manuals for the Air Force during the Second World War. His transformation of *Fortune* Magazine as its art director … . And finally his explorations of visual techniques for the expression of scientific subject matter, culminating in the unprecedented "Cell" … followed by the brilliant series of successors, "The Brain", "The Chromosome", and "Metabolism" … all attest to this. All these achievements (and many others) have been acknowledged by the vast number of significant awards, medals, and honors properly showered on Will. But beyond the meaning of this formal recognition of Will's work is the impact of his work on all of us … who, in observing it – measured ourselves by it – and by the man from whom it came. Will's work was perhaps more important to him than to most designers. In thinking about Will, it's hard to separate him from his work. It seemed so much a part of him. It was characteristic that all conversations with Will seemed to be test-runs of his then current state of thought in general – or specifically in connection with an ongoing project. Over the years I had many opportunities to observe his work process. He began with a relatively elliptical, speculative, at times abstruse verbal formulation (the kind often made by people who deal in words exclusively). And then he proceeded (in a

very simple workmanlike manner) to lay down, brick by brick … the specific data, the myriad ideas … patiently, methodically … Until it evolved in a spiral back to its apparent starting point. But now in some magical mix, (and I am thinking particularly of "The Cell" and the others) some magical mix of data and poetry … a magnificent concrete poetic form. He was rigorous and disciplined in his work. He was hard on himself. In reaching his results he (like all of us) made wrong turns. But he spent little time in regretting these bad turns. In patching them up. Or clinging to them. The moment he became aware of his position he quickly reached an assessment. And one could sometimes hear the quiet click … as he shifted gears … swept past the debris, and went down the new road. Sometimes the clicks were so quiet you couldn't hear them. These battles were fought internally. They were not always visible (except in the expression of the conclusions). I remember a project we collaborated on, when he went through this process right in front of me. It proceeded so quietly, so much concerned with the correct path … (seemingly indifferent to consequences) … so calmly considered in the context of process … that it took me a few minutes to realize what had happened. In recent years we have experienced tremendous pressure towards newness and novelty in design … And in an atmosphere of nervous excitability where it seems so important to astonish the crowd every time out … Will hewed to his belief and dedication to coherence and clarity … unhurried, unpressured. By seeing what resulted he gave us a sense of balance. Over the years I observed Will in professional situations. I was again and again struck by his toughness not only about his own work – but that of others. I personally experienced the form that his criticism took – in relation to my own work. And it was a sensitive probing for a form for expressing his thoughts without demolishing the creator in the process. His was not the "I must be honest with you" school of criticism. No. Will was first compassionate and within that context found a place for the truth as he saw it. In the years I spent working closely with Will on the Aspen conference, I learned how deeply he felt about the importance of our craft … how important it was to Will to see the decisions in our work as having moral implications … . And how important he felt it was to anchor the designer to larger concepts. Yet this utter seriousness and formality (Will was a very formal man) did not prevent him from joyously and madly charging up and down the Aspen meadow (outside the tent) trying to get his kite aloft in the kite flying contest one year. (A memory I will always cherish.) Finally: Will's life was one of great achievement and great frustration. In this sense, Will's was a complete life. As much as any life is complete. He was a beautiful man. A good example of the best of what is possible in us. There was a piece of us in Will … and there is a piece of Will in us. He was a teacher. A friend. A man. I loved him. I miss him.

ENDNOTES

Chapter 1

1 Howard Myers, publisher of *The Architectural Forum*, wrote and signed this Introduction in *A/D presents: Will Burtin*. The supplement celebrates the first three-and-a-half years of Will Burtin's work in the U.S. and his award of the Art Directors' Club Gold Medal. Photographer Ezra Stoller placed an advertisement in this supplement. Stoller would work with Burtin throughout his career.

2 Ibid., p.2.

3 Translated from http://www.duesseldorf-today.rp-online.de/cityguide/stadtrundgang/

4 Client: Deutscher Gußrohr-Verband GmbH (DIV), Köln 1.

5 Translated from http://www.duesseldorf-today.rponline.de/cityguide/stadtrundgang/tour4/english/tour401.shtml

6 Had Burtin worked for the Nazis, he would have taken charge of designing the Working People's Exhibition (1937), intended to show the might of resurgent Germany under National Socialism. State support was unlimited.

7 *AIEA Journal*, No. 18, 1971. Burtin's final interview.

8 David Sutton, in a note to Robert Fripp, December 7 2005.

Chapter 2

1 The Smithsonian Institution houses the Munk archive.

2 Celia Brody (later Celia Mitchell). Celia's son, Daniel Mitchell, was among 3,500 babies whom Dr. Greenberg delivered. Professor Mitchell, who teaches economics at UCLA, comments: "Visiting the Leslies' home was special. They were the only times in my life when I was admitted by a butler."

3 "The architectural photographer Ezra Stoller, 88, did almost as much to spread the gospel of modernism as any modern architect. …" Matt Tyrnauer, "Modern's masters," *Vanity Fair*, January 2004, p.113. Stoller's daughter, Erica, runs Esto, the agency promoting the work of her father and other architectural photographers (http://www.esto.com/).

4 This was the cover for *The Architectural Forum*'s special "Design decade" issue, for October 1940. Burtin also designed a double spread for the HOME section in this issue.

5 Will Burtin and Lawrence P. Lessing, in "Interrelations," *Graphis*, no.22. pp 108–122. This text from a typescript carbon copy is

headed "Final Draft" and dated April 12 1948.

6 Interview with Robert Fripp, November 2005.

7 From Will Burtin's tribute to William Golden. Burtin's essay, "The passionate eye," introduces *The Visual Craft of William Golden*, published in Golden's memory, ed. Cipe Pineles Golden, Kurt Weihs and Robert Strunsky (George Braziller, New York, 1962).

8 From a typescript headed "Profile" and "Not for publication," dated September 15, 1971. Another, undated typescript, "Profile / Will Burtin," is more expressive. It states that in the OSS "he designed analytical and 'time-saving' presentations of economic, scientific and strategic problems related to military tactics and post-war developments."

9 Designed for the Training Aids Division, Office of the Assistant Chief of Air Staff, Training Headquarters, Army Air Forces; in collaboration with AAF Instructor's School (Flexible Gunnery) and the U.S. Navy. Air Forces Manual Number 20, May 1944, Restricted.

10 Will Burtin and Lawrence P. Lessing, from "Interrelations," for *Graphis*, no.22, p.109.

11 Roy Stevens gave much of the information in this paragraph to Kay Reese and Mimi Leipzig during an interview for the American Society of Media Photographers, 1992.

12 Burtin's team included designer Max Gschwind and writer Lawrence Lessing. Gschwind had extraordinary talent for designing charts and diagrams. Both men contributed to *Fortune* after the war, Gschwind as a staff artist, Lessing as an award-winning science writer. Gschwind remained at *Fortune*. Well versed in illustrating gunnery, he returned to that subject for the story, 'NASA's moon-shot calculations: a problem in celestial gunnery,' June 1962.

13 Burtin and Lessing, op. cit.

Chapter 3

1 William Owen, *Modern Magazine Design*, Rizzou International Publications, Inc., N.Y., 1991.

2 William Golden, from remarks at the forum "Typography–U.S.A." hosted by the Type Directors' Club at the Hotel Biltmore, April 18 1959. A booklet issued after the event reprinted the remarks of the thirteen speakers, including Golden. His essay was reprinted after his death in *The Visual Craft of William Golden*, p.23. op. cit.

3 Ezra Stoller to Professor Chris Mullen, in a

letter dated October 1984.

4 Ladislav Sutnar, Section b/24, *Visual Design in Action*, Hastings House, New York, 1961.

5 William Owen, op. cit.

6 Will Burtin, from a "Profile" typescript *c.* 1960. Burtin archive, Wallace Library, R.I.T.

7 William Golden, "Comments at Typography–U.S.A.," *Print*, January 1964, p.26. Quoted by R. Remington and B. Hodik, *Nine Pioneers in American Graphic Design* (Cambridge, Mass.: MIT Press, 1989), under Beall, p.91.

8 *Print* magazine, 1954.

9 *Print* magazine, op. cit.

10 Ezra Stoller, in an interview, Copyright 1992 by Kay Reese and Mimi Leipzig, reproduced on the website of the American Society of Media Photographers, 2004. Reese and Leipzig report that the first part of this interview took place in a restaurant across from Stoller's studio in Mamaroneck, N.Y. A restaurant "across the street" was where Stoller discussed projects with Burtin, Conny Raitzky and other designers on Burtin's staff.

11 Celia Brody remarried, to William Mitchell, in 1955. Robert Fripp interviewed Celia Mitchell in 2004.

12 Hananiah Harari, artist, in a letter to Chris Mullen, November 1984. Co-authors Chris Mullen and Philip Beard quote this passage in *Fortune's America, the Visual Achievements of Fortune Magazine 1930–1965*, p.13. University of East Anglia Library, 1985.

13 Ezra Stoller to Chris Mullen, op. cit.

14 William Owen, op. cit., p.62

15 Ezra Stoller, 1992, in an interview Copyright by Kay Reese and Mimi Leipzig, for the American Society of Media Photographers.

16 *Print* magazine, 1954. Curiously, the story does not name the spokesman.

17 *Print* magazine, op. cit., p.36.

18 *Print* magazine, op. cit., p.36.

Chapter 4

1 George Klauber, interviewed by Roger Remington. Burtin archive, transcript 14783.txt., Wallace Library, RIT.

2 R. Roger Remington, *Lester Beall: Trailblazer of American Graphic Design*, p.70.

3 *Print*, introducing George Klauber as the author of "Remembering Will Burtin," *Print*, 26, p.79, May 1972

4 George Klauber, "Remembering Will Burtin." The editor of *Print* asked Klauber "to write a combination memoir and assessment of the man and his work," op. cit.

5 Klauber, in *Print*, op. cit.

6 *Graphis*, no.27, Zurich, 1949.

7 Klauber, interview with Remington, transcript, op. cit.

8 Will, Hilda and Carol Burtin had crossed the country by rail. After side-trips to diversions such as the Grand Canyon, Carol was in no mood to hear Daddy give a speech. To entertain her, the head of the Art Center School, Edward "Tink" Adams, took her out and showed her his rattlesnake bite. Fortunately for Burtin's reputation, his audience was more impressed by *Integration*.

9 Steven Heller, *Rudolph de Harak*, a biography for the AIGA website.

10 Burtin's principal client had his own views on varying sensory inputs in *Scope*. On Friday June 26 1954, Burtin opened the morning session at the fourth IDCA by introducing Upjohn's Dr. A. Garrard Macleod, the first speaker on the theme, "How can we improve communications with our fellow men?" Dr. Macleod delivered a folksy approach to publishing *Scope*: "When I became concerned with writing a medical magazine … to go to all the doctors in the United States … . We have to lure this fellow [doctors] to read, consequently we better change his pace from time to time … . We have to consider the arrangement of [text, illustrations with captions, diagrams, graphs, tables] … In the end these [story treatments] often turn out to have a kind of beauty of their own … Many of them … have been highly effective." (Source: Document 15202.txt, transcript, Burtin archive, Wallace Library, RIT.)

11 *Graphis*, no.22, p.109, "Interrelations," See Chapter 2.

12 Steven Heller, op. cit.

13 Quoted on http://www.olgafisch.com/folklore.html

14 The ADC also awarded diplomas of merit to Nagata and Inada. Six years later, Nagata described *gyotaku* techniques in his Japanese-language book, *Gyotaku*, Geibi Shuppansha, 1960. In this, Nagata writes about Burtin and *Scope*. Nagata was a master of the nineteenth-century technique, using *washi*, Japanese rice paper. In 1948, Inada began to use silk as the medium taking the image. Carol Burtin Fripp has the copy of *Gyotaku* which Nagata inscribed, very formally, to "Mr. Will Burtin" with calligraphic brush. Nagata also sent Burtin an original *gyotaku* of a fish caught in 1950. This is framed.

15 Arthur Leydin's archive includes "2003/44/1–2/2 Letter to William Shaunessy, District Director, Immigration and Naturalization Services," appealing against the decision not to extend Arthur Leydin's U.S. visa. Will Burtin wrote the letter, dated New York, September 20 1956. The authors are grateful to Anne-Marie Van de Ven and Jill Chapman of the Powerhouse Museum, Sydney, for supplying this letter.

16 Arthur Leydin, in a personal letter to Robert Fripp, January 9 2007

17 Undated. Probably written to members of IDCA's executive and program committees in late 1955, given the response from Saul Bass, dated January 9 1956.

18 *Program Memorandum Number 1* is co-signed by Robert Hunter Middleton, chair of IDCA's executive committee, and Burtin, program committee chair. Middleton, appointed IDCA's chair in 1954, was director of typeface design at the Ludlow Typograph Company, in Chicago.

19 Documents relating to AIGA conference program development circulated among executive and program committee members: Saul Bass, Harry L. Baum, Herbert Bayer, Will Burtin, George D. Culler, D.S. Defenbacher, Garrett Eckbo, James M. Fitch, William Friedman, Marshall Lane, Gordon Lippincott, R. Hunter Middleton, Dr Albert Eide Parr, Herbert Pinske and DeForest Sackett.

Chapter 5

1 F.H.K. Henrion, "A Tribute to Will Burtin," *Typographic*, the journal of the Society of Typographic Designers, London, autumn 1972, p.2. This issue reported the *Will Burtin Memorial Exhibition* organized by the Society and open to the public at the U.S. Embassy, September 5–19 1972. Henrion's tribute was reprinted and distributed later that month at the Alliance Graphique Internationale (AGI) meeting in Amsterdam. Burtin was President of the Paris-based AGI's "American Sector." Cipe Pineles Burtin attended both events.

2 Burtin discusses trademark and tradename design in general, as well as Will Burtin, Inc.'s work for The Upjohn Company, in a chapter he wrote for *Seven Designers Look at Trademark Design*, ed. Egbert Jacobson (Chicago: Paul Theobald, 1952).

3 Warhol presented Burtin with a numbered copy of *25 cats name* [*sic*] *Sam and one blue Pussy* (Copy 91).

4 Burtin, from his opening remarks as program chairman, to the International Design Conference at Aspen, 1955. Donations from industry that year allowed IDCA to cover expenses for the first time and plan ambitious expansion for 1956.

5 Henrion, op. cit.

6 Burtin on Burtin, in his final CV: "Will Burtin's three-dimensional designs introduced new communications perspectives." Source: "Profile / Will Burtin" typescript, *c*. September 1971.

7 Henrion, op. cit.

8 From the brochure, *The Cell: A Millionfold Model of Life's Basic Unit*, distributed at the AMA conference, San Francisco, 1958, and at other locations displaying the *Cell*.

9 Henrion, op. cit.

10 George Klauber, *Print* magazine, op. cit.

11 George Klauber, interviewed by Roger Remington, op. cit.

12 Color brochure, *The Cell*, op. cit., p.3

13 Without attribution, Burtin's profile in the Art Directors' Club Hall of Fame.

14 Burton Kramer, interviewed by Robert Fripp in Toronto, September 2000.

15 *Life* magazine was receptive to Burtin's work. Art director Bernard Quint had served with Burtin on the gunnery manual design team.

16 Color brochure, *The Cell*, op. cit., p.4.

17 George Klauber, op. cit.

18 *Industrial Design*, Whitney Publications, Inc. vol.5, no.8, August 1958.

19 *The Illustrated London News*, November 28, 1959, p.767.

20 Burtin on Burtin, in his final CV, op. cit.

21 *Observations on the Development of the Brain Model (Upjohn) 10 April, 1960*. Carbon copy of a five-page typescript in the Burtin archive, Wallace Library, RIT.

22 Burtin, in a typescript draft called "Design Responsibility in the age of science."

23 Philip Meggs, *A History of Graphic Design*. Wiley, 1998.

24 Jon W. Benjamin, Design History Seminar, RIT., November 3, 2000. Benjamin later founded Ideation, a company creating "Visual communication tailored to the scientific community."

Chapter 6

1 Betti Broadwater Haft, in an email to Robert Fripp, March 16, 2006.

2 David C. Macleod, in a signed five-page type script, headlined in handwriting: "A Report on the British Tour of the U.S.I.S. Exhibition." Macleod, one of Dr. Garrard Macleod's sons, describes himself in the document as "the Information Officer who traveled with [the exhibit] for the last six showings on the scheduled British tour."

3 Betti Broadwater Haft, op. cit. Helen Gee, proprietor of the Limelight Coffee House and

Photography Gallery (1954–1960 at 91 7th Avenue South) nurtured writers, photographers, artists.

4 *Industrial Design*, March 1959, pp. 42–5. No byline.

5 Translation: "A middle-sized city in the Middle West."

6 Gerhard J. Drechsler, Exhibits Officer, in a letter from the American Embassy, Bad Godesberg, Germany, to Burtin, dated October 28 1958.

7 Drechsler, op. cit.

8 Burtin, from his office in New York, to Gerhard Drechsler, November 5 1958. "Marshall Haus" is George C. Marshall House, the exhibition site in West Berlin.

9 Constantine Raitzky, interviewed by Robert Fripp.

10 Bill and Mueller-Brockmann accepted Burtin's invitation to speak at *Vision 65*.

11 *Typography–U.S.A.* 1959. A one-day forum: "What's New in American typography?"

12 The Type Directors' Club of New York published a booklet of opinions voiced at *Typography–U.S.A.*

13 Two months later, Golden read extracts from Burtin's *Integration* essay to delegates at Aspen. Without naming the author, he read it with text by two others to show that designers were assigning themselves too much self-importance in society. The Burtin archive at RIT preserves a voice recording.

14 This passage launches Golden's address, "Type is to read," printed later in *The Visual Craft of William Golden*, ed. Cipe Pineles *et al.* (New York: George Braziller Inc. 1962), p.13.

Chapter 7

1 This sentence opens "Observations on the development of the brain model (Upjohn) April 10, 1960." From a carbon copy of a five-page typescript in the Burtin archive, Wallace Library, RIT.

2 Roger Remington, *Information Design Journal–Document Design*, Vol.13, No.3, 2005, p.251.

3 *Observations*, op. cit.

4 *Observations*, op. cit.

5 Remington, op. cit.

6 Curiously, the singers are never named, even in background papers.

7 Remington, op. cit.

8 Typescript: "Revised Script – Popular Version Draft #6 Upjohn Second Brain, June 23, 1961." The archive contains several drafts, including "Lay script for Brain

showings in Amsterdam, London, Paris and Brussels. June 21, 1962." Burtin archive, Wallace Library, RIT.

9 Remington, op. cit.

10 Remington, op. cit.

11 Requests to use aspects of Burtin's models came from many quarters. The King's College London Archives and Corporate Records Services cites correspondence from the Nuffield Foundation Science Teaching Project, including "Ian Hills" correspondence with Upjohn Ltd, relating to the use of material from The Upjohn Brain, for a film loop on feedback in the human nervous system, and correspondence with Everett Anderson and H.W. Beams relating to permission to use their print, "'Figure 16' from an Upjohn Cell monograph." Reference: KCLCA CNU/PBN3/130 (1964–1965).

Chapter 8

1 Celia Brody Mitchell.

2 Howard Mont, interviewed by Robert Fripp on December 2 2004.

3 The building has gone through several name changes: After Union Carbide's tenure it became the Manufacturers Hanover Trust Company Building, then the Chemical Bank Building, then the Chase Building.

4 Rohm and Haas, owners of the Plexiglas trademark.

5 Howard Mont, op. cit.

6 The authors are grateful to designer David Sutton for relaying this story in a note to Robert Fripp, dated December 7 2005.

7 *The Visual Craft of William Golden*, ed. Cipe Pineles Golden *et al*. The book is dedicated, "For Tom Golden."

Chapter 9

1 A partial list includes: Ben Shahn, Kurt Weihs, Henry Koerner, Feliks Topolski, Pearl Binder, John Groth, Jacob Landau, Joe Kaufman, Tom Courtos, Ludwig Bemelmans, Jan Balet, Rudi Bass, David Stone Martin, Joseph Hirsch, Lucille Corcos, Edgar Levy, George Grosz, Antonio Frasconi and Arik Nepo.

2 Will Burtin, from his tribute in *The Visual Craft of William Golden*, pp10–11.

3 From an obituary published, without attribution, by the University of Georgia, 1997.

4 The brochure for *Metabolism* gives credit for the electron micrographs to: Dr. Russell T. Barrnett, at Yale; the Harvard University Department of Anatomy; and Dr. Paul E.

Lacy at Washington University, St. Louis.

5 Burtin describes making science visible with respect to his three (to date) Upjohn models, in his essay, "Design and communication," published in Gyorgy Kepes (ed.), *Education of Vision*, for the Vision+Value Series (New York: George Braziller, 1965), pp78–96.

6 From an unsigned two-page document with the working title, *Metabolism – the Cycle of Life*. Beginning with the phrase "In construction at present … " this draft must predate June. It is likely an early draft for a press release. Burtin's handwriting on the first page gives filing instructions to his secretary, Ruth Ellowitz.

7 Constantine Raitzky, interviewed by Robert Fripp, November 2005. This information came in a follow-up email from Raitzky.

8 The film for the Kodak pavilion, *The Searching Eye* 1964, was co-produced by Saul and Elaine Bass, Sy Wexler and Elmer Bernstein. The Academic Film Archive of North America (AFA) describes it as a high-water mark in the annals of modern documentary film making.

9 Lou Dorfsman, interviewed by Robert Fripp, December 29 2004. Dorfsman had good reason to know that Burtin could put listeners to sleep. A colleague of William Golden, and a good friend of Cipe Pineles, he was a panelist at the 1959 Type Directors' Club forum, where "the four guys who sat in the 18th row" were moved to write their anonymous letter to Burtin about the length of his speech.

10 Dorfsman took a New Yorker's pragmatic view of Kodak's roof: "The point of the crazy cloud of a roof was to give people a Kodak photo-op where they could buy Kodak film, Kodak instant cameras and take their pictures from."

11 Howard Wexler, in a note to Robert Fripp, December 2005.

12 Burtin, to an executive at Eastman Kodak, July 24 1962.

13 Howard Mont, interview transcript.

14 From an undated memo by Burtin: "Description of steps in the design of the Illinois State Pavilion at the New York World's Fair 1964–1965." Though the memo is undated, it makes clear that "the time left for design and construction is extremely short. The need for a crash program exists now already" (*jezt schon*). Dictating this Germanic construction to Ruth Ellowitz suggests either stress or the urgency of the situation.

15 From an undated memo: "Design procedures in the development of the Illinois State Pavilion at the New York World's Fair, 1964–1965."

Chapter 10

1 Burtin, in the Introduction to his brochure, *Visual Aspects of Science*.

2 Stoller's time-lapse photo of the *Atom* became a *leitmotif* representing not only Burtin's design, but his writings. Around this time he designed a spread for *Comment 200*, featuring the *Atom*. In 1966 he would halftone the same image behind his text in the American Institute of Graphic Arts' presentation booklet, *Fifty Years AIGA Exhibition*.

3 The brochure acknowledges comments from several clients, in sequence: Roy Tillotson, Manager of Art, Design and Photography for the Public Relations Department of Union Carbide; Dr. A. Garrard Macleod, Director of Special Science Projects, The Upjohn Company; and Bruce MacKenzie, IBM's Director of Scientific Information and editor of the IBM *Journal of Research and Development*. Burtin wrote his own copy about the upcoming Kodak pavilion. His design on the back cover, "a simplified diagram of a DNA molecule," taken together with "white hieroglyphic shapes" on an inside page foreshadow a large model which still lay in the future, the "Chromosome Puff".

4 Bruce MacKenzie, in *Visual Aspects of Science*, 1963.

5 A press release brings us up to date on the wandering exhibits. The *Cell* and the *Brain* "were included in comprehensive exhibitions of Burtin's work as a designer at the Stedelijk Museum in Amsterdam (1962), at the Royal College of Art, London (1963), and at 'documenta 2' in Kassel, Germany (1965 …)," source: a press release "Genes in Action" May 17 1966.

6 Soon after this, the walk-through Upjohn Cell (Mark 1) moved into the Museum of Science and Industry in Chicago where, during the next seven years, 21.8 million people would visit it. (Source: a press release issued by Farley Manning Associates for The Upjohn Company, July 13 1969. The release cites this figure while announcing *Defense of Life*.) The *Cell* eventually went to the Museum of Health, Cleveland.

7 From an untitled document, perhaps dictated by Burtin for his team, written after meeting the advertising manager of one Brunswick division in Atlantic City, February 18 1964.

8 The authors are grateful to Howard Mont, whose archive from seven years of work with Will Burtin includes: the full floor plan of Brunswick's lobby with exhibits in place (scaled at 1.24cm to the meter; 3/16 of an inch to the foot); a comprehensive set of Ezra Stoller's photographs of exhibit spheres; and a prospectus for Brunswick's many divisional managers who were stakeholders in this exhibition. The floor plan is dated "14 Feb 64" and "Revised 24 July '64." The July date reflects changes made after a meeting with architects Skidmore, Owings & Merrill in Chicago on 13 July.

9 From an untitled document, op. cit.

Chapter 11

1 Josef Mueller-Brockmann, Armin Hoffman and Max Frisch. See Chapter 4.

2 Introduction, *Vision 65, New Challenges for Human Communications*. One of the two major sponsors, the International Center for the Typographic Arts, Inc. published the proceedings, Copyright the International Center for the Typographic Arts, Inc. 1966.

3 The theme of *Vision 65* was "New Challenges for Human Communications"; of *Vision 67*, "Survival and growth."

4 Will Burtin, Chairman's introduction to *Vision 65*, October 21, 1965

5 Op. cit.

6 Umberto Eco. Collected transcripts, *Vision 67*.

7 Burtin, in a typed "Memorandum on the 'IBM Showcase Exhibition, 1966.'"

8 Marshall McLuhan, *Vision 65*, op. cit. p.212.

9 Isaac L. Auerbach, *Vision 67*, op. cit.

10 Wim Crouwel, *Vision 65*, op. cit. p.193.

11 Herbert Spencer, *Vision 67*, op. cit.

12 Will Burtin, Chairman's introduction, *Vision 65*, op. cit.

Chapter 12

1 George Klauber, *Print*, vol.26, no.79, May 1972, p.84.

2 *Fifty Years of Graphic Arts in America*. Produced for the AIGA in a black presentation sleeve, sponsored by Champion Papers, Inc. Copyright Champion Papers 1966.

3 Burtin's text is superimposed on a graphic he designed to commemorate AIGA's fiftieth anniversary.

4 Burtin's essay, "Design and communication," is published in Gyorgy Kepes (ed.), *Education of Vision*, for the Vision+Value Series (New York: Braziller, 1965), pp78–95.

5 Published by Pantheon Books, a division of Random House, 1966.

6 Burtin was impressed by the work of a Japanese design team led by Masaru Katzumie, some of whose iconic symbols for the 1964 Tokyo Olympics were later adopted into Japan's modern urban and traffic signage. Katzumie, or one of thirty young volunteer designers working with him on the Olympics, created the universal wheelchair symbol, among others. Katzumie made a visual presentation at *Vision 65*.

7 *Will Burtin Designs Giant Model of "Genes in Action"*. Press release "from Lawrence Creshkoff and Alfred Katz," datelined New York, N.Y. 5/17/66.

8 The *Genes in Action* brochure: 36pp, self-cover, 20.3cm x 20.9cm (8 in vertically by 8.25in).

9 As with other major brochures for the models, no writer's credit is given.

10 Ulrich Clever, at Purdue University, Lafayette, Indiana, was among the 17 scientists credited as consultants to *Genes in Action*. Dr. Clever provided a photomicrograph of a puffing chromosome from a midge, *Chironomus tentans*. Burtin reproduced this green-stained image inside the brochure's front cover. The image served as a visual guide for the design team, and as an example that helped general audiences compare Clever's cross-section of life to Burtin's giant representative icon of it. *Life* magazine reproduced this image beside Stoller's photo of the model for its feature story about *Genes in Action* which included flashbacks to the *Cell* and the *Brain* (*Life*, July 8 1966).

11 *Genes in Action*, p.23. This 36-page brochure accompanied the model. Copyright The Upjohn Company 1966.

12 *Weekly Science Newspaper*, vol.LII, no.12 (Special color issue, Current Science, "Giant gene") December 7 1966.

13 "'Genes in Action' A proposed Upjohn exhibit on the ground floor of the Time & Life building / New York City / January 14 to March 4, 1967." This undated document is a four-page typed proposal with handwritten alterations. Burtin archive, Wallace Library, RIT.

Chapter 13

1 Fredric Brown, Angels and Spaceships (Dutton, 1954).

2 The first of seven pages is typed on Will Burtin, Inc. letterhead, undated, with "Old copy" pencilled in Burtin's handwriting.

3 Ibid.

4 Ibid.

5 A.G. Macleod, *Scope Monograph on Aspects of Acute Inflammation* (Kalamazoo, Mich.: Copyright Upjohn Company, 1969).

6 Rohm and Haas, an undated "news" release, *Upjohn's Model of Blood Vessels Highlights AMA Convention.*

7 Press release "For: The Upjohn Company, For Release Sunday, July 13," under the letterhead of Farley Manning Associates, Inc., Public Relations, New York.

8 Ibid.

9 Sy Wexler, Wexler Film Productions, Los Angeles, produced the 13-minute film for *Defense of Life*. The length permitted four screenings each hour to accommodate the several thousand delegates. Five years earlier, Wexler had co-produced the film for the Kodak pavilion with Saul Bass.

10 Rohm and Haas, op. cit.

11 Ibid.

12 Press release "For: The Upjohn Company," op. cit.

13 Ibid.

14 Ibid.

15 David Sutton, in a letter to Robert Fripp, December 7 2005.

16 Typed on Burtin's office machine, *Inflammation Structure "Defense of Life"* was a draft that evolved into the text of a hand-out.

17 Yves Zimmermann wrote to Robert Fripp in December, 2005: "[Already employed by Geigy in Basel in the 1960s] I was offered the opportunity to go to the Geigy Pharmaceutical Company in Barcelona as art director. There I got to know Francisco Casamajó ... [I proposed that he should edit] a magazine. He agreed to this so I started *Documentos de comunicación visual* in 1971, with some colleagues. It occurred to me to contact Will Burtin and ask him for a contribution. He agreed and wrote a text which appeared, in Spanish of course, in the first issue. The title was *Basta ya.*"

18 George Klauber, "Remembering Will Burtin," *Print*, vol.26, May 1972, p.79.

19 Text by Burtin on a panel he designed for the Will Burtin retrospective exhibition hosted by the AIGA in 1971. He completed the icosahedral brochure for IBM not long before his AIGA exhibition opened.

Postscript

1 David Sutton, in a letter to Robert Fripp, December 7 2005.

2 F.H.K. Henrion, from "A tribute to Will Burtin" in *Typographic 1*, the journal of the Society of Typographic Designers, London, autumn 1972, p.2. This edition reports on the *Will Burtin Memorial Exhibition* at the American Embassy, London, 5–19 September 1972.

3 *Typographic 1*, op. cit. Unsigned, from an Introduction to the *Will Burtin Memorial Exhibition*.

4 John Peters is best known for creating the font Castellar™ 1957.

5 Henrion, op. cit.

6 Dr. Malvin Kalos, interviewed by Robert Fripp for *IBM Visions*, a magazine about high-performance computing applications, which Fripp created and edited for IBM. no.3, 1993.

7 R. Roger Remington and Barbara Hodik, *Nine Pioneers in American Graphic Design* (Cambridge, Mass.: MIT Press, 1989).

BIBLIOGRAPHY

"Armin Hoffman." *Graphis* 26.148 (1971): 110–21+.

Art Full Text. H.W. Wilson. Wallace Library.,
Rochester, N.Y. Jan 25 2007
<http://hwwilsonweb.com/>.

The Artist in the Service of Science. Ed. W Herdeg.
Zurich: Graphis Press, 1973.

Burtin, Will. "*Basta ya.*" (Enough.). *Documentos de
comunicación visual*, Barcelona, first edition,
1971/2.

—. *A/D presents: Will Burtin*, a supplement
published with the February–March 1942
edition of *A/D* magazine.

—. "The Brain." *Industrial Design* (Aug. 1964): 66–9.

—. "Burtin and Upjohn." *Print* 9 (May 1955): 36.
Art Retrospective. Wilson Web. Wallace
Library, Rochester, N.Y. Jan. 22 2007.

—. "Design and Communication." *Education of
Vision*. Ed. Gyorgy Kepes. New York: George
Braziller, 1965. 78–95.

—. "Design Responsibility in the Age of Science."
Undated. Design Archive Online. Full text,
<http://dao.rit.edu/dao/designers/speech.html>.

—. Foreword. *Type and Typography. The Designers
Type Book*. Ben Rosen, New York: Reinhold,
1963.

—. "Human Brain; A Medical Exhibit." *Industrial
Design* 7 (Aug. 1960): 66–9. *Art Full Text*.
H.W. Wilson. Wallace Library, Rochester, N.Y.
Jan. 25 2007 <http://hwwilsonweb.com/>.

—. "Integration, the New Discipline in Design."
Graphis 5.27 (1949): 230–7+. *Art Full Text*.
H.W. Wilson. Wallace Library, Rochester, N.Y.
Jan. 25 2007 <http://hwwilsonweb.com/>.

—. "International Design Conference." *Print*
(July 1955): 8ff.

—. "Means and Ends of Packaging Designing."
Graphis 15 (Sept. 1959): 392–403+.

—. "On Corporate Images." *Graphis* 18 (Nov.
1962): 630+. *Art Full Text*. H.W. Wilson.

Wallace Library, Rochester, N.Y. Jan. 22 2007
<http://hwwilsonweb.com/>.

—. "Passionate Eye, The." Introduction in *The
Visual Craft of William Golden*. Ed. Cipe
Pineles Golden, Kurt Weihs and Robert
Strunsky. New York: George Braziller, 1962.

—. *Seven Designers Look at Trademark Design*.
Chapter by Burtin on Burtin. Ed. Egbert
Jacobson. Chicago: Paul Theobald, 1952.

—. "Vision 65 – New Challenges for Human
Communications." *Opening Address,
Vision 65*. International Center for the
Typographic Arts: n.p., 1966. 7–10.

—. *Visual Aspects of Science*. New York: Upjohn
Company, 1964.

Burtin, Will, and L. P. Lessing. "Interrelations: Modern
Graphic Presentation." *Graphis* 4.22 (1948):
108-17+. *Art Full Tex*t. H.W. Wilson. Wallace
Library, Rochester, N.Y. Jan. 22 2007
<http://hwwilsonweb.com/>.

"Cover for Scope (Art Reproduction)." *Graphis*
11.58 (1955): 148. *Art Full Text*. H.W. Wilson.
Wallace Library, Rochester, N.Y. Jan. 22 2007
<http://hwwilsonweb.com/>.

"Cover of the House Organ of the Upjohn
Company." *Graphis* 12 (Sept. 1956): 404. *Art
Full Text*. H.W. Wilson. Wallace Library,
Rochester, N.Y.. Jan. 25 2007
<http://hwwilsonweb.com/>.

"Eastman Kodak Exhibition for the 1964 New York
World's Fair." *Industrial Design* 9 (Aug. 1962):
52–5.

Eckstein, Linda. "Outrageous Fortune." *Print* 59
(Mar.–Apr. 2005): 80–7. ARTbibliographies Modern.
Wallace Library, Rochester, N.Y. Jan. 22 2007

"Excerpts from Chairman's Opening Address,
International Design Conference in Aspen." *Print*
(July 1955): 8.

"Exhibition at the A-D Gallery in New York."
Architectural Forum 90 (Feb. 1949): 128. *Art Full
Text*. H.W. Wilson. Wallace Library, Rochester, N.Y.

Jan. 22 2007
<http://hwwilsonweb.com/>.

"Federal Works Agency Exhibit at New York Fair; W. Burtin, Designer." *Architectural Forum* 73 (July 1940): 40–2. *Art Full Text*. H.W. Wilson. Wallace Library, Rochester, N.Y. Jan. 25 2007 <http://hwwilsonweb.com/>.

Henrion, F.H.K., "A Tribute to Will Burtin," *Typographic 1*, the Journal of the Society of Typographic Designers, London, autumn 1972, p.2. Henrion's "Tribute" with a report on the *Will Burtin Memorial Exhibition* at the American Embassy, London, September 5–19 1972.

"Homage to Science." *Print* 18 (July 1964): 46. *Art Full Text*. H.W. Wilson. Wallace Library, Rochester, N.Y. Jan. 22 2007 <http://hwwilsonweb.com/>.

Illustrated Dictionary of 20th Century Designers, p.64. New York: Mallard Press, 1991.

Klauber, George. "Remembering Will Burtin." *Print* (May 1972): 79.

"Light on Flushing Meadow: The Eastman Kodak Exhibit by Will Burtin, and the Hawaii Exhibit by Reino Aarnio and William Katavolos." *Industrial Design* 9 (Aug. 1962): 52–7. *Art Full Text*. H.W. Wilson. Wallace Library, Rochester, N.Y. Jan. 22 2007 <http://hwwilsonweb.com/>.

Müller-Brockmann, Josef. *A History of Visual Communication*, pp265, 278. Arthur Niggli Ltd. Teufen AR, Switzerland, 1971.

"New York: Offices." *Industrial Design* 7 (Oct. 1960): 60. *Art Full Text*. H.W. Wilson. Wallace Library, Rochester, N.Y. Jan. 25 2007. <http://hwwilsonweb.com/>.

"Obituary: Will Burtin" *Graphis* 27.157 (1971–1972): 514.

"Obituary: Will Burtin." *New York Times*, Sunday Jan. 22 1972.

Owen, William. "Wheels of Fortune." *Eye* (U.K.) 1.2 (Winter 1991): 32–47. ARTbibliographies Modern. Wallace Library, Rochester, N.Y. Jan. 22 2007.

"Portrait." *American Artist* 17 (Feb. 1953): 8. *Art Full*

Text. H.W. Wilson. Wallace Library, Rochester, N.Y. Jan. 25 2007 <http://hwwilsonweb.com/>.

Remington, R. Roger. 'Coming to America.' *ID* 36 (May–June 1989): 51–7. *Art Full Text*. H.W. Wilson. Wallace Library, Rochester, N.Y. Jan. 22 2007. <http://hwwilsonweb.com/>.

—. and Barbara J. Hodik. *Nine Pioneers in American Graphic Design*. Massachusetts Institute of Technology, Chapter: "Will Burtin." 104–18, 1989.

—. "Will Burtin's Brain Exhibit for Upjohn." *Information Design Journal* 13 (2005): 249–54. ARTbibliographies Modern. Wallace Library, Rochester, N.Y. Jan. 22 2007.

Scotford, Martha. *Cipe Pineles: A Life of Design*. New York: W.W. Norton, 1999.

"Showing Metabolic Movements, Exhibition by Will Burtin, Inc." *Industrial Design* 10 (Oct. 1963): 56-9. *Art Full Text*. H.W. Wilson. Wallace Library, Rochester, N.Y. Jan. 22 2007. <http://hwwilsonweb.com/>.

"To Facilitate Understanding Is the Task of Design." *Print* 14 (Jan. 1960): 71–2. *Art Full Text*. H.W. Wilson. Wallace Library, Rochester, N.Y. Jan. 22 2007. <http://hwwilsonweb.com/>.

Typographic 1, the Journal of the Society of Typographic Designers, London, autumn 1972, p2. Unsigned report on the *Will Burtin Memorial Exhibition* at the American Embassy, London, September 5–19 1972.

"Typography; Looking Ahead." *Print* 18 (Jan. 1964): 71. *Art Full Text*. H.W. Wilson. Wallace Library, Rochester, N.Y. Jan. 25 2007 <http://hwwilsonweb.com/>.

Wild, Lorraine. "The 1950s: Design in Gray Flannel." *Print* 43.6 (Nov.–Dec. 1989): 90–111. ARTbibliographies Modern. Wallace Library, Rochester, N.Y. Jan. 22 2007.

INDEX